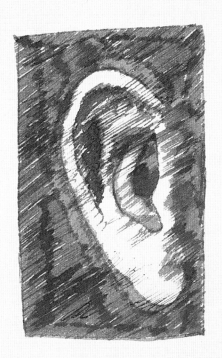

hANND 83

4    Juan Muñoz with *Spiral Staircase (Inverted)* 1984–99

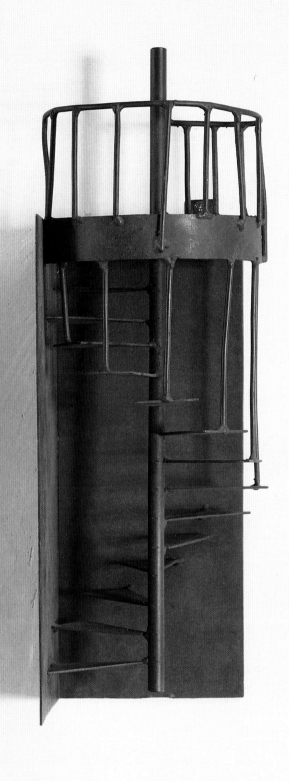

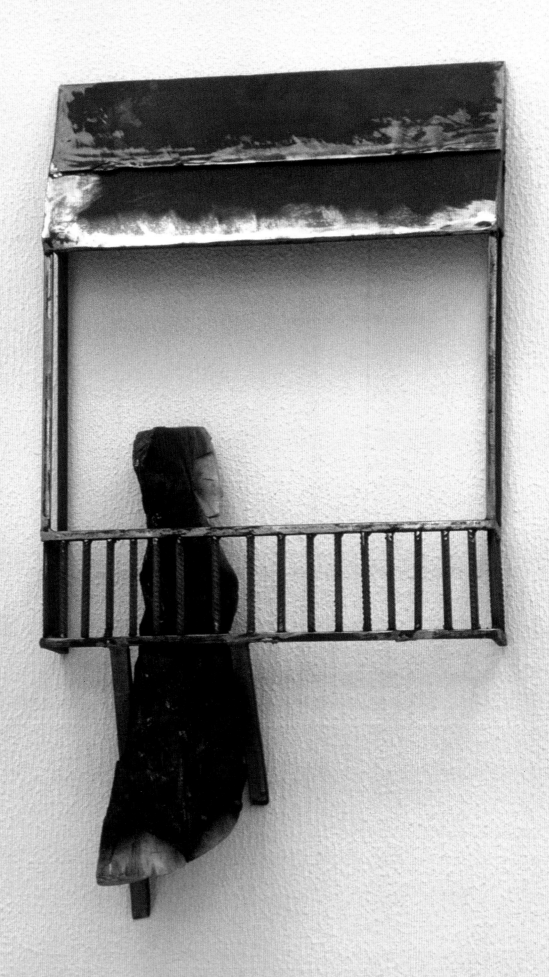

*Used Balcony (Small Balcony with Figure)* 1984    7

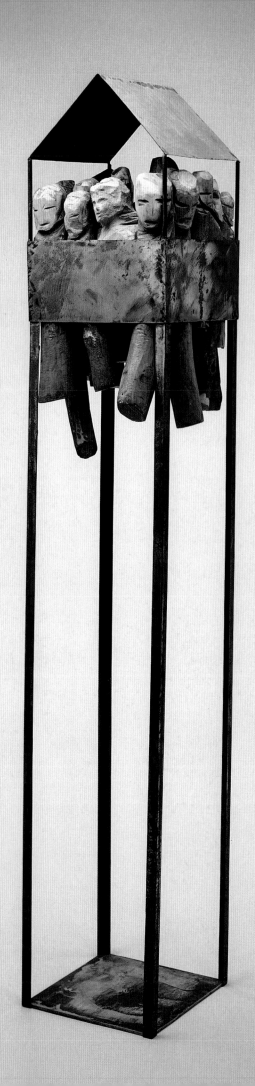

*If Only She Knew* 1984

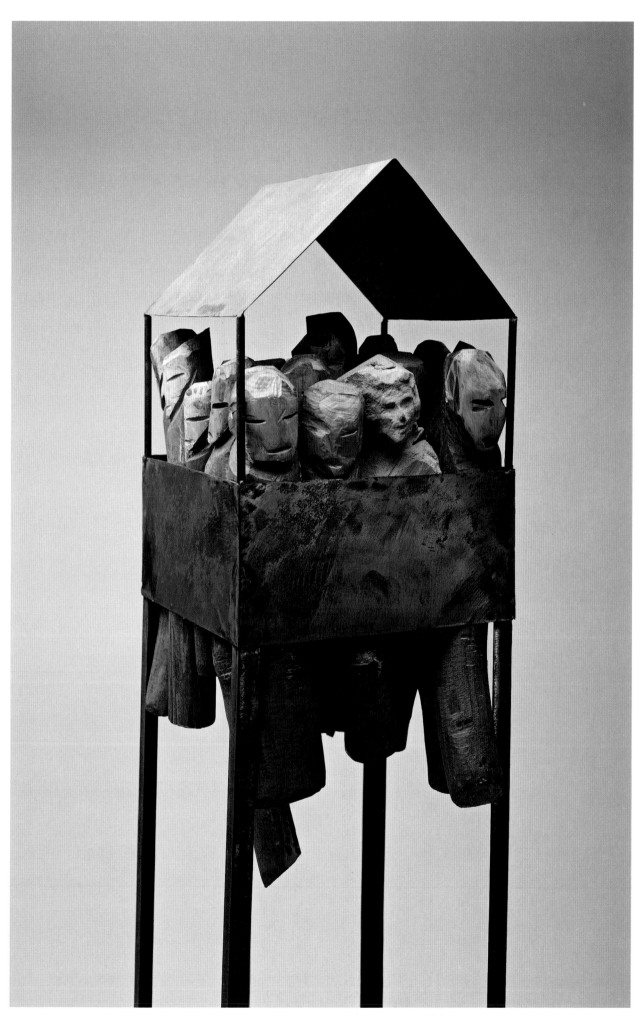

*Untitled (Balcony with Fire)* 1984

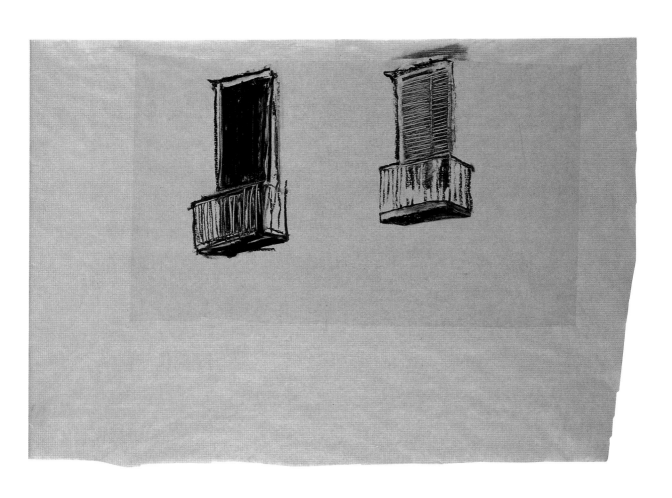

12     *Untitled (Balcony with Smudged Right Side)* 1984

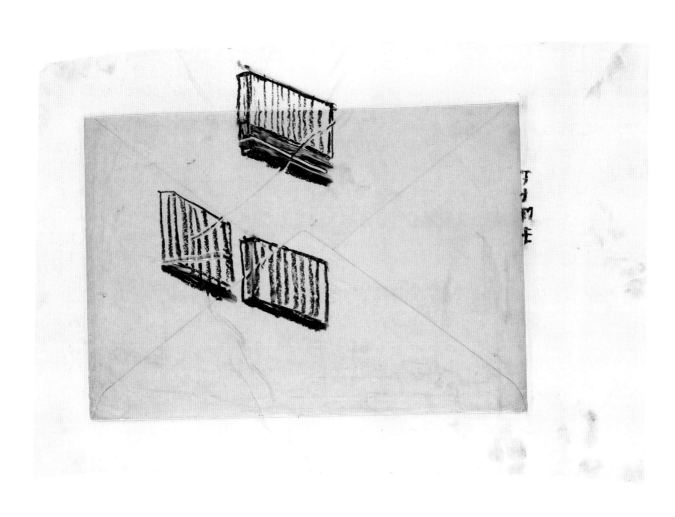

14    *Untitled (3 Balconies with Time)* 1984

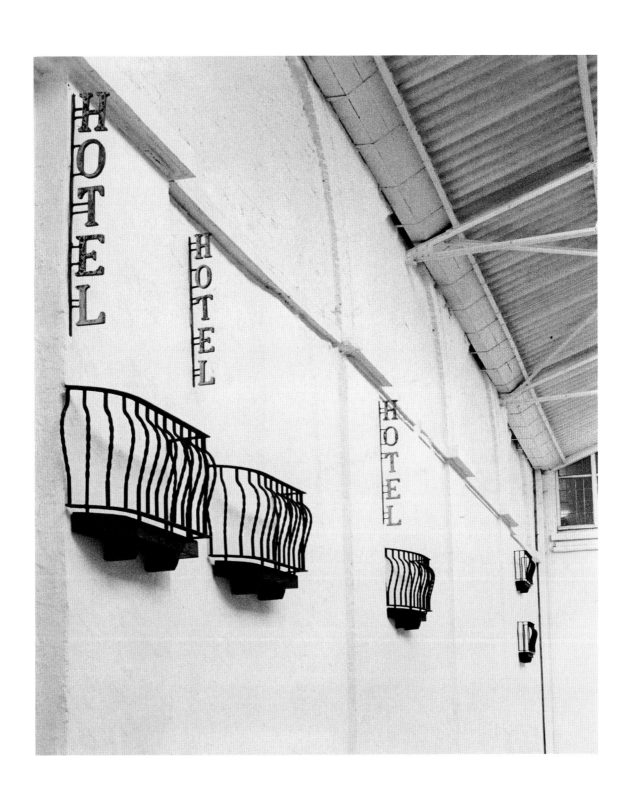

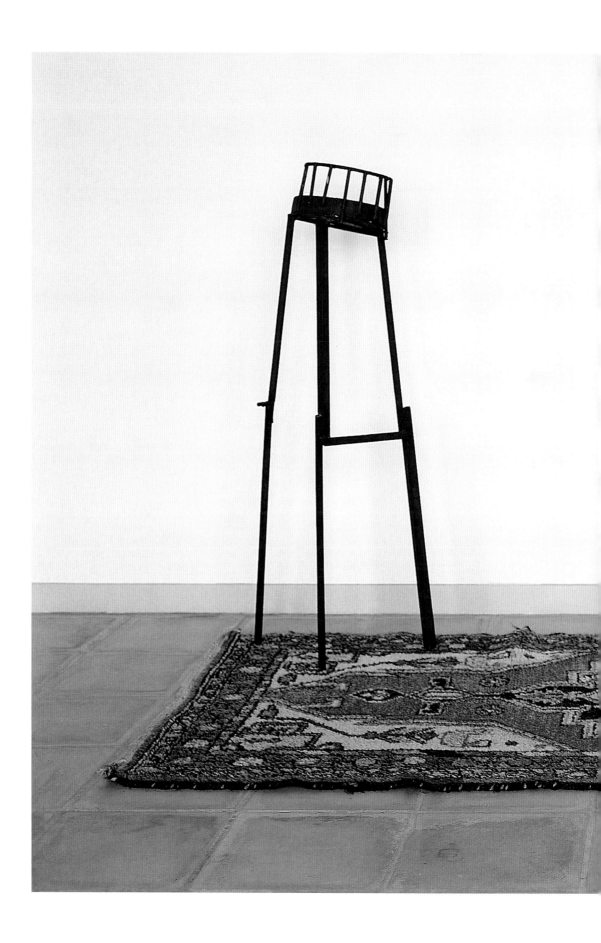

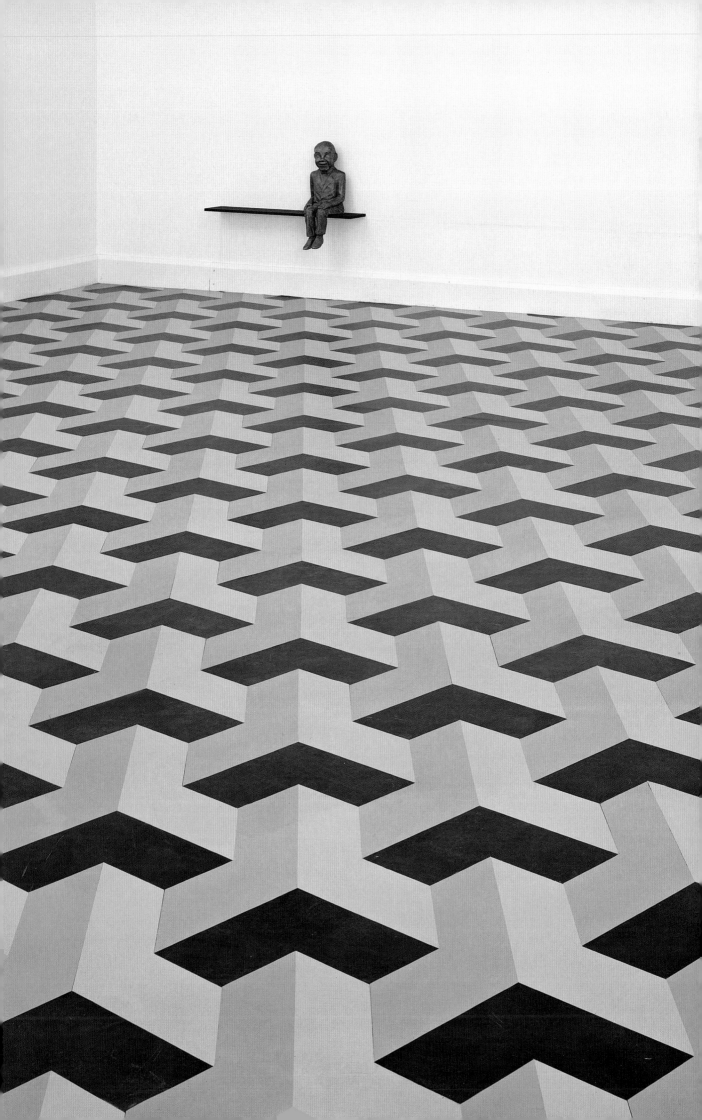

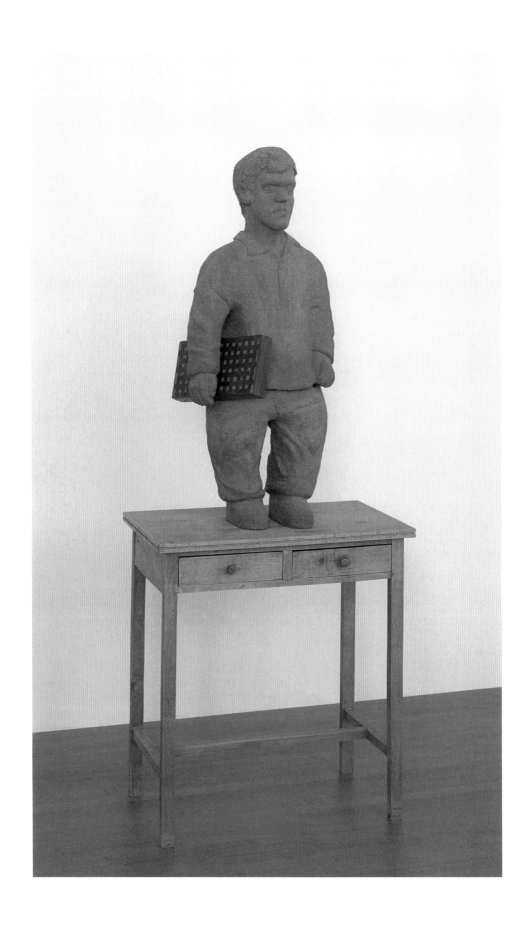

*Dwarf with a Box 1988*

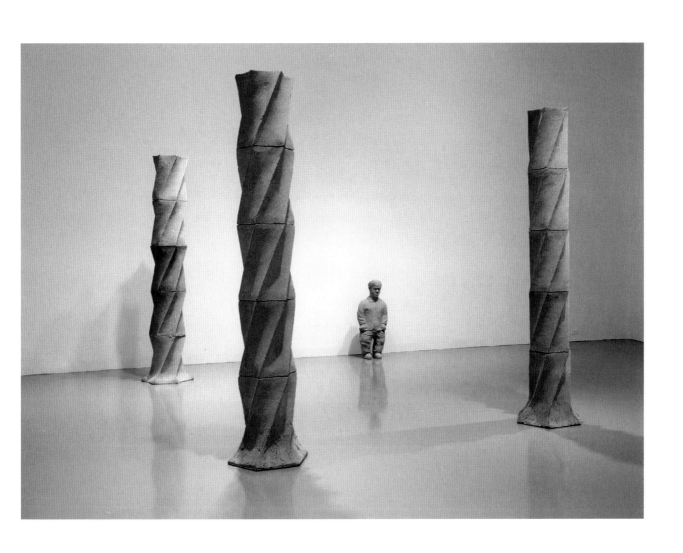

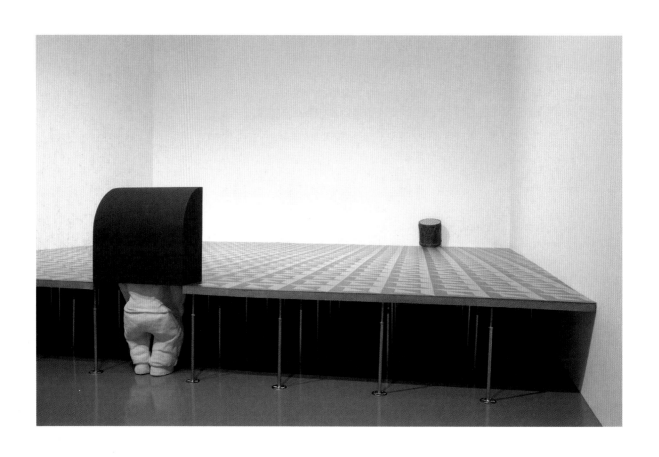

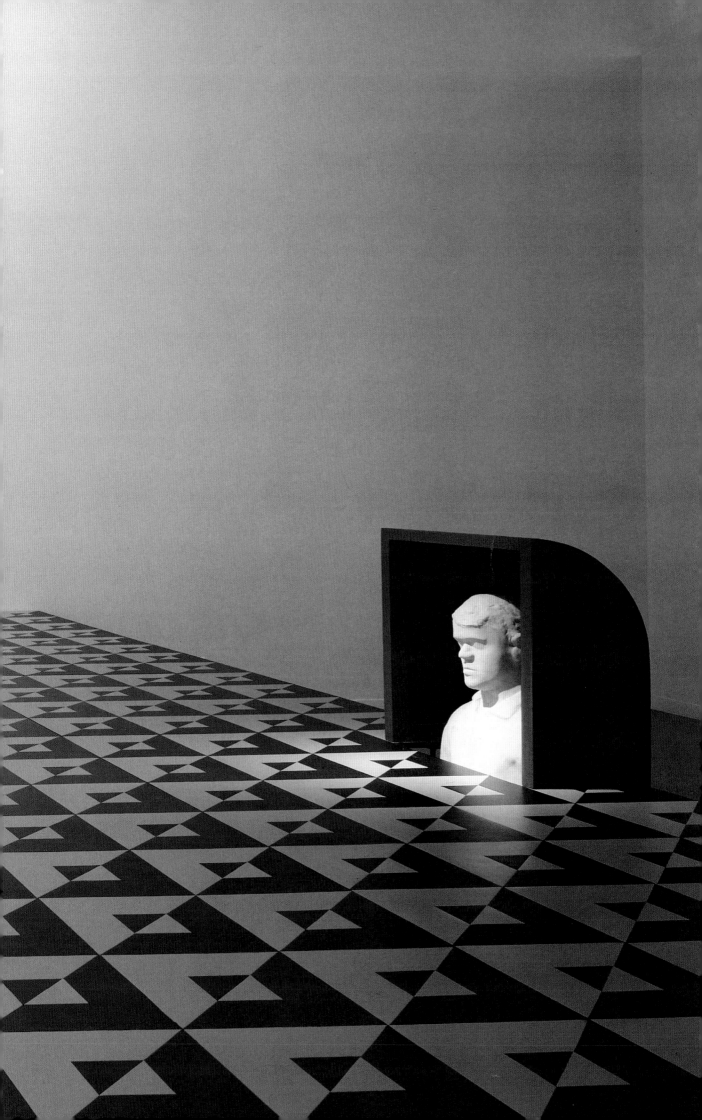

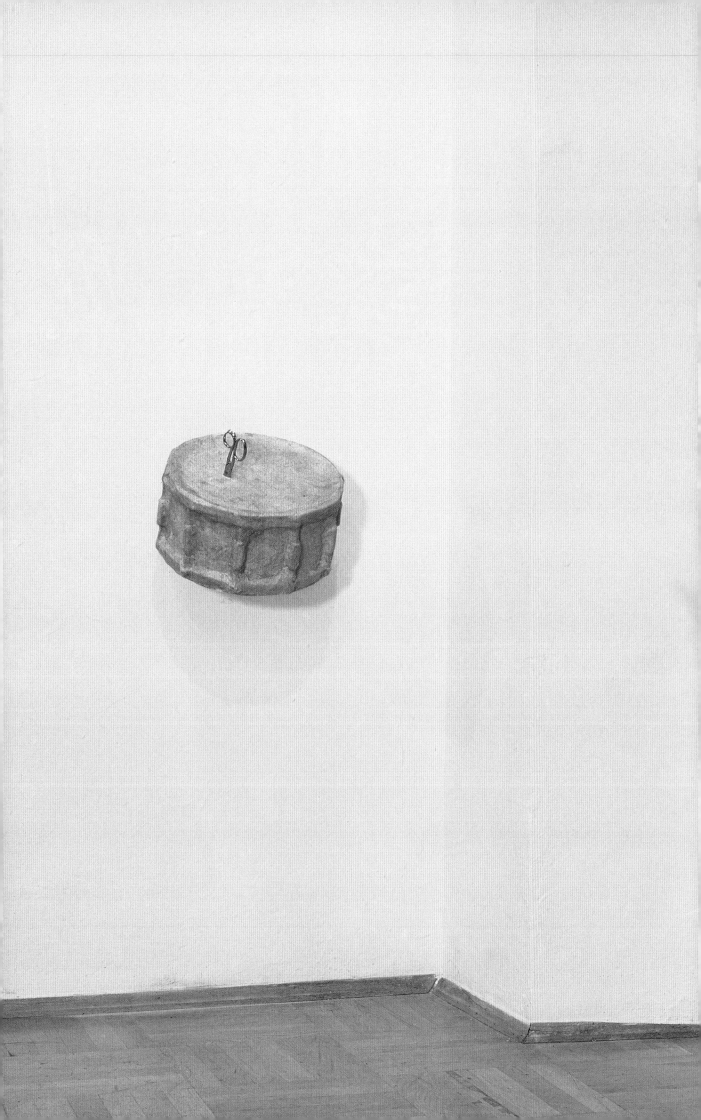

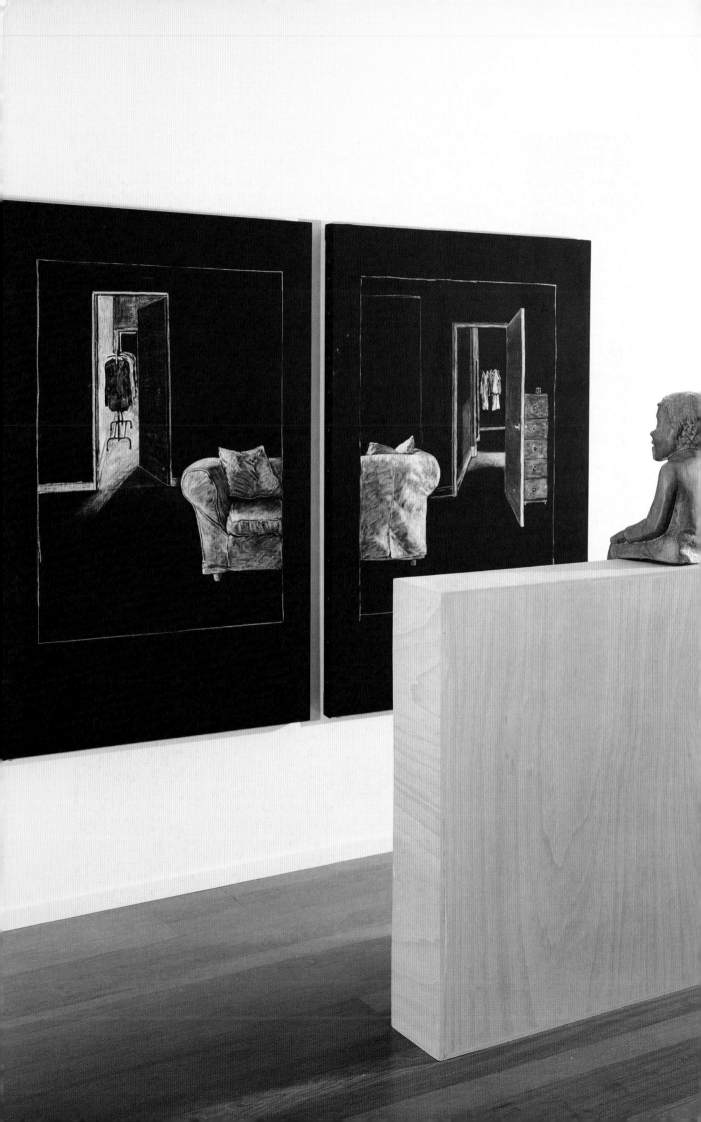

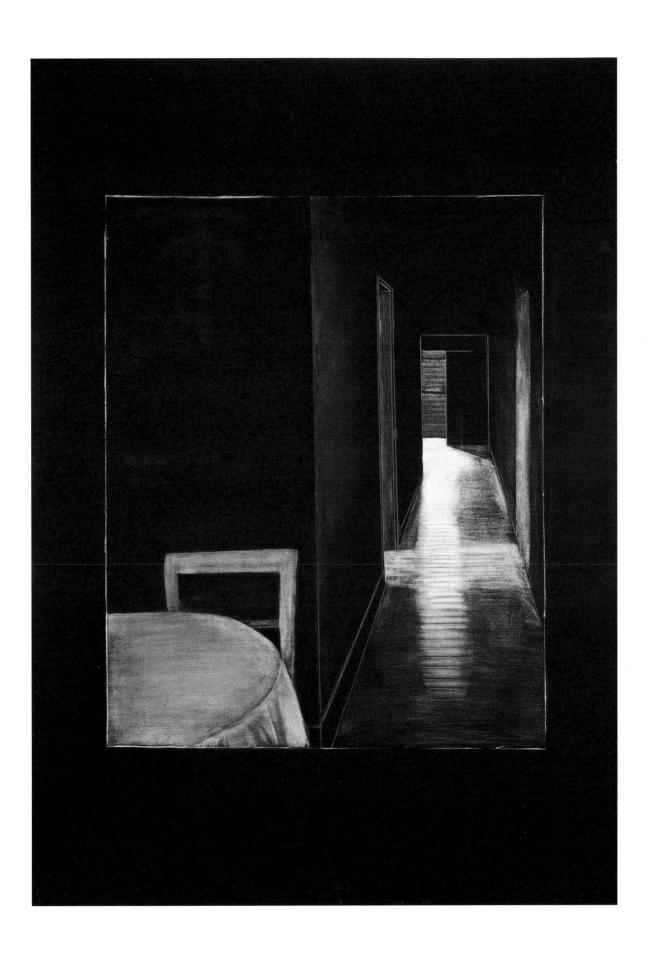

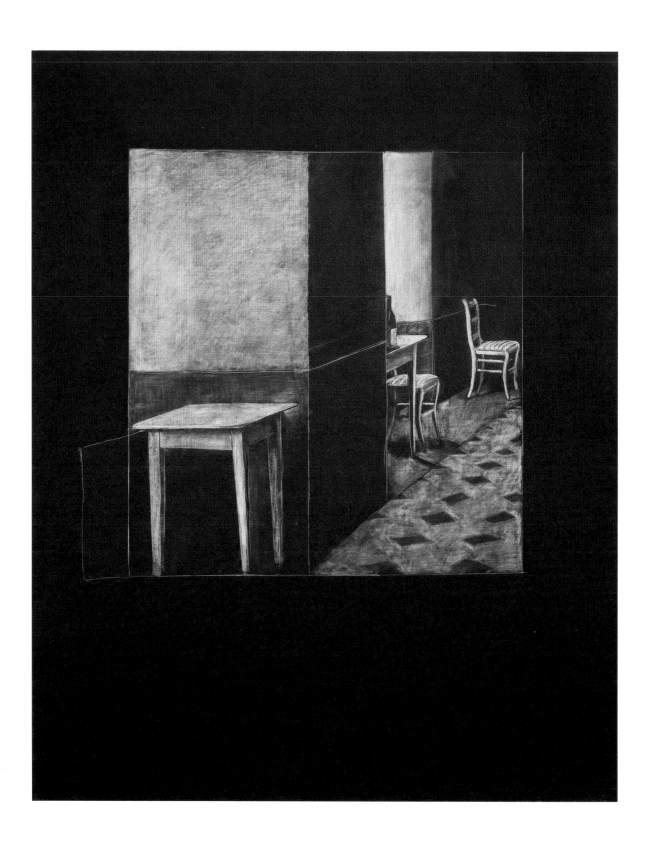

*Raincoat Drawing* 1990

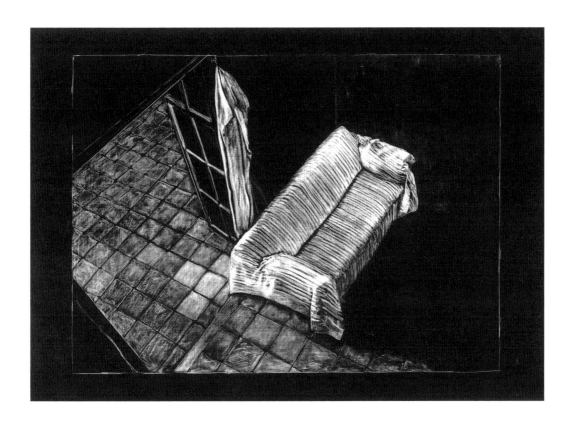

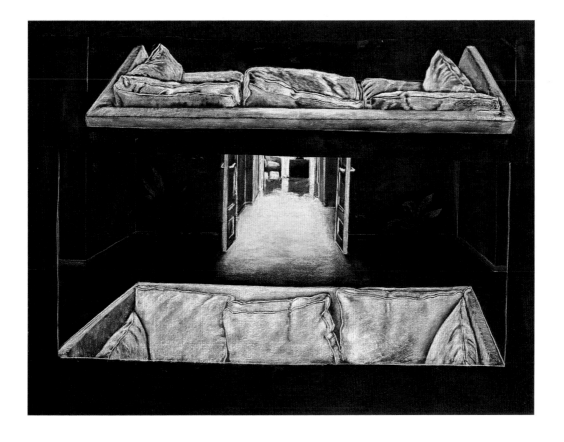

Top: *Raincoat Drawing* 1991   Bottom: *Raincoat Drawing* 1995   33

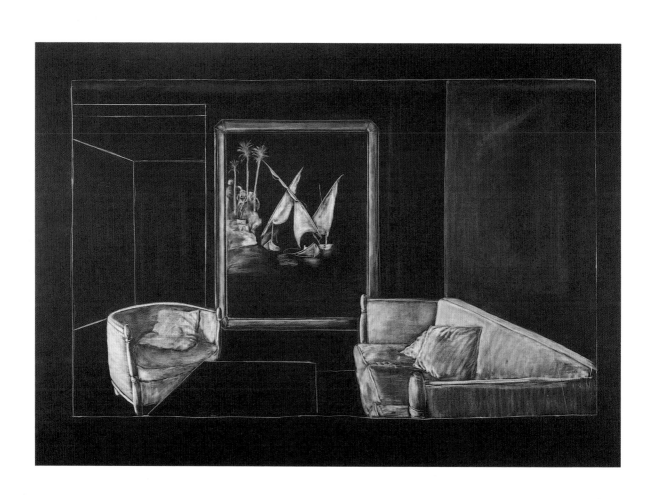

*Raincoat Drawing* 1989

*Raincoat Drawing* 1989

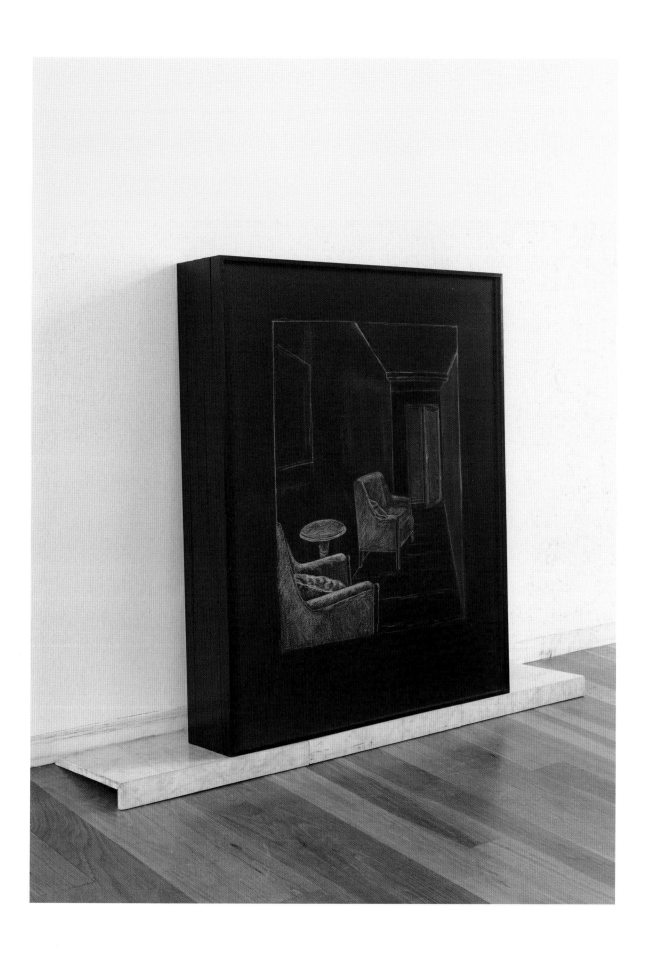

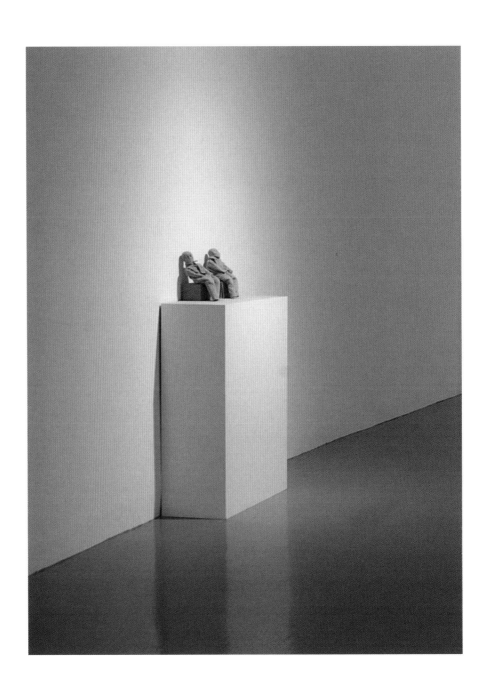

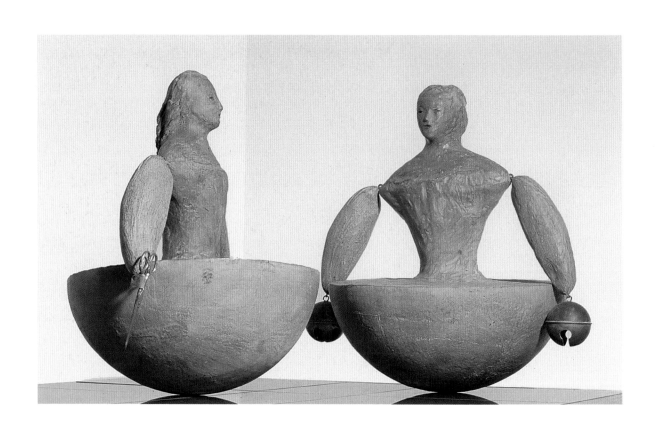

*Dos Bailarinas (Cocina)* 1989

Right: *Ballerina on Optical Floor* 1989

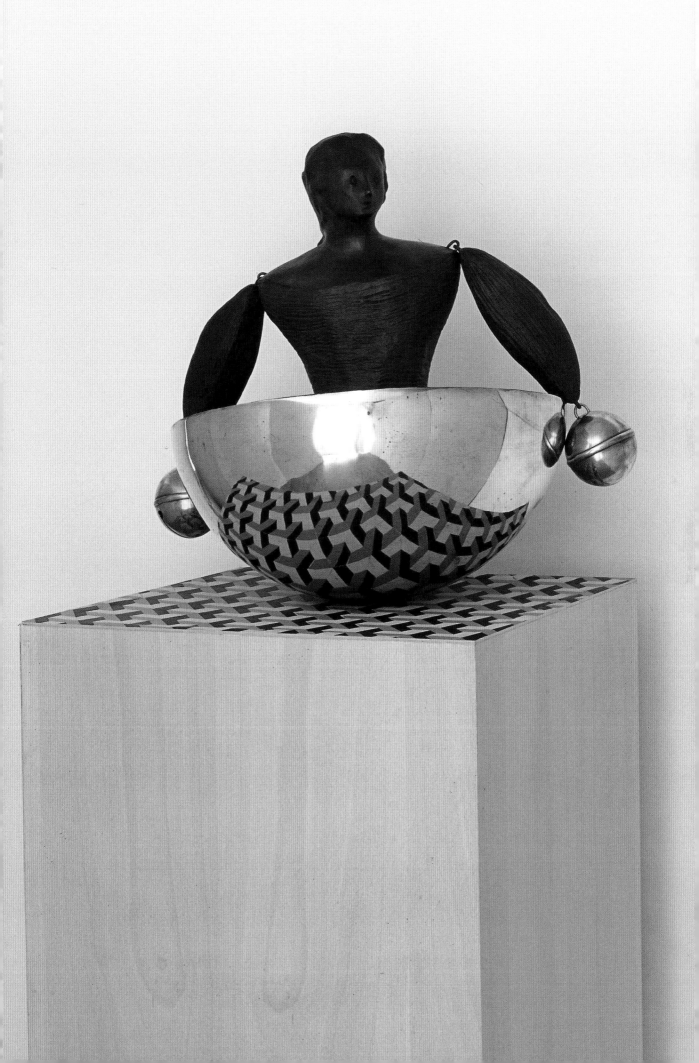

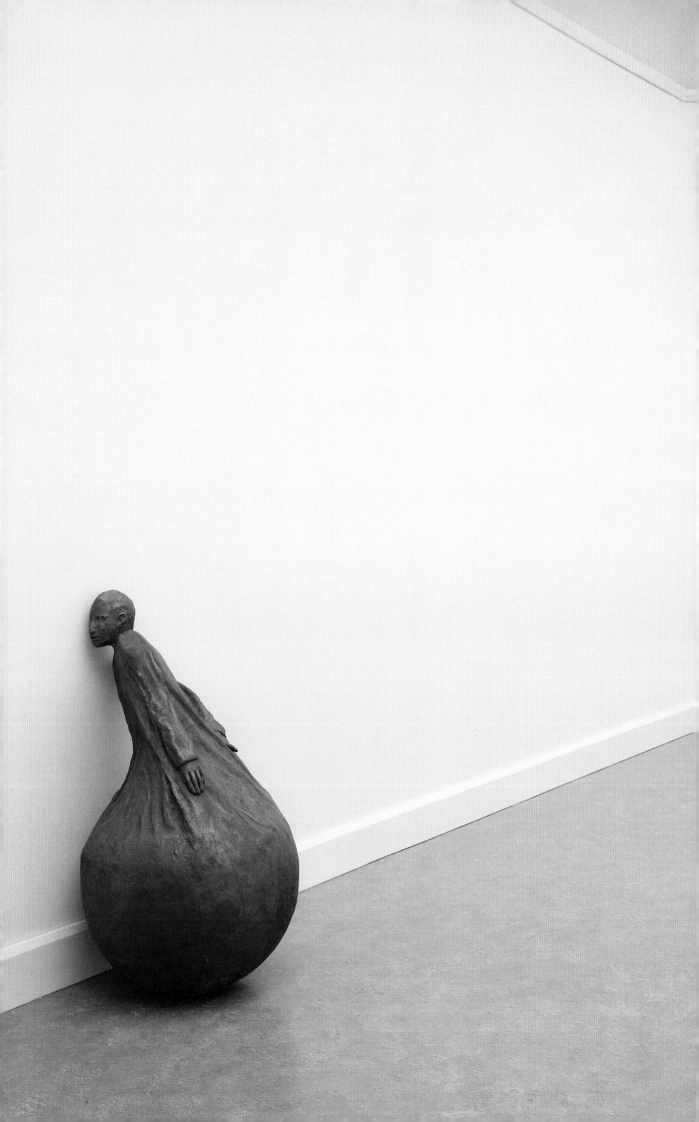

*Back Drawing* 1990

*Back Drawing* 1992

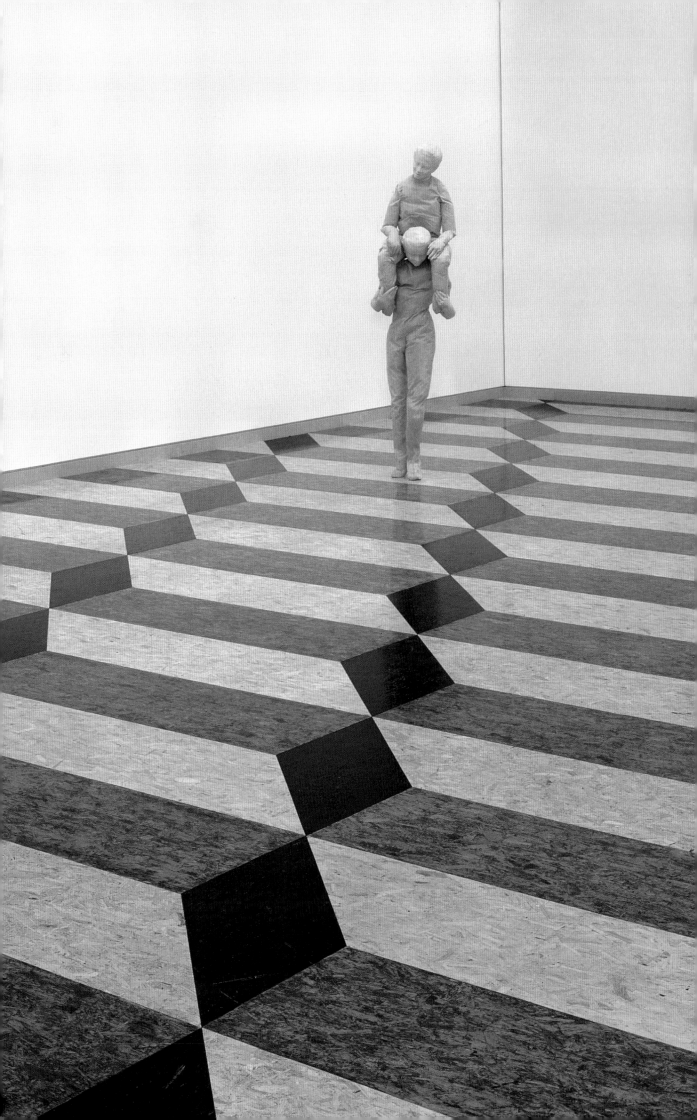

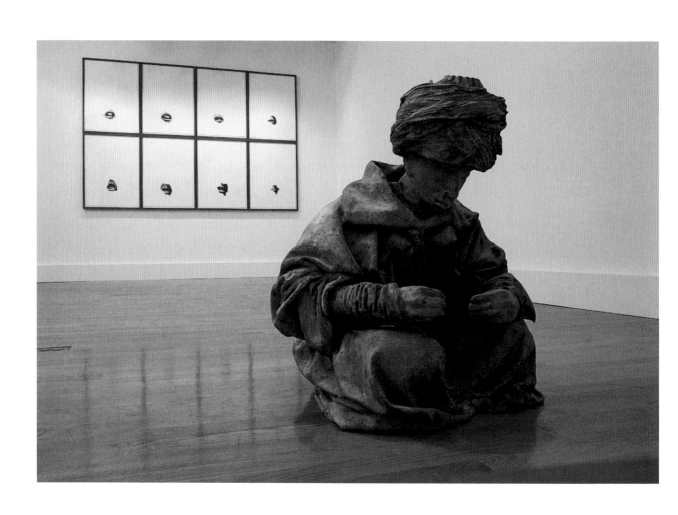

*Portrait of a Turkish Man Drawing*, installation at Isabella Stewart Gardner Museum 1995          *Right: Untitled (Mouth Drawing)* 1995

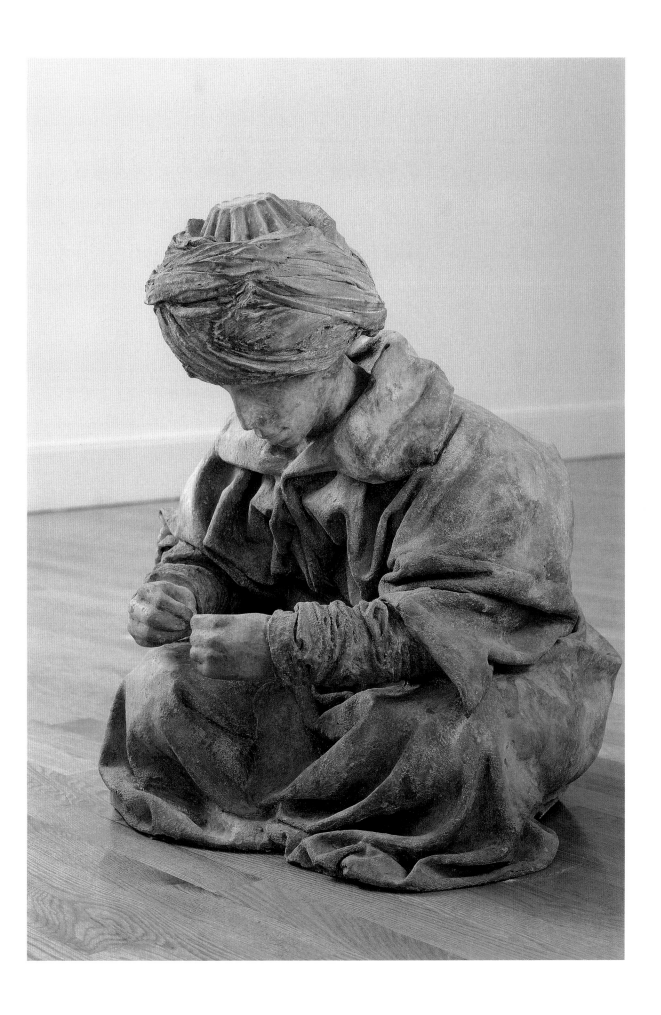

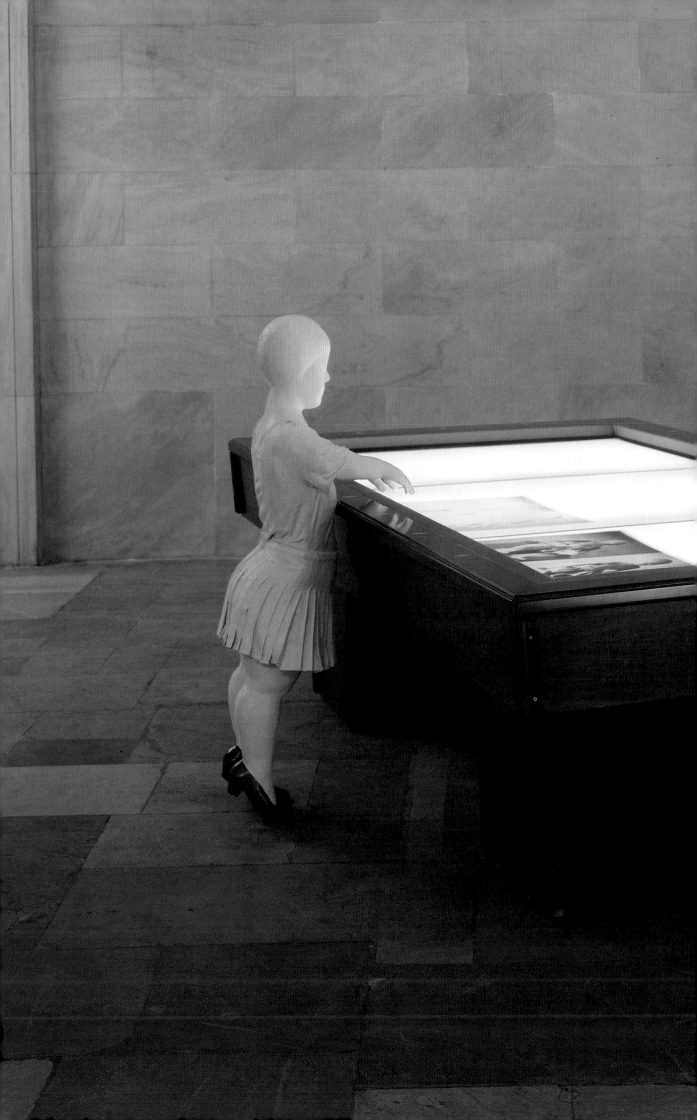

*Sara with Billiard Table* 1996    65

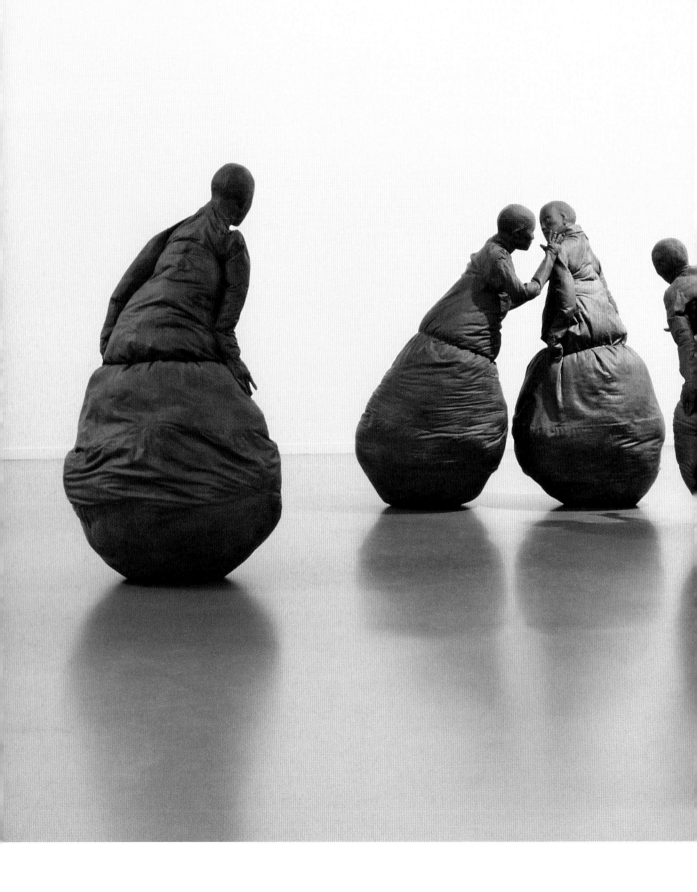

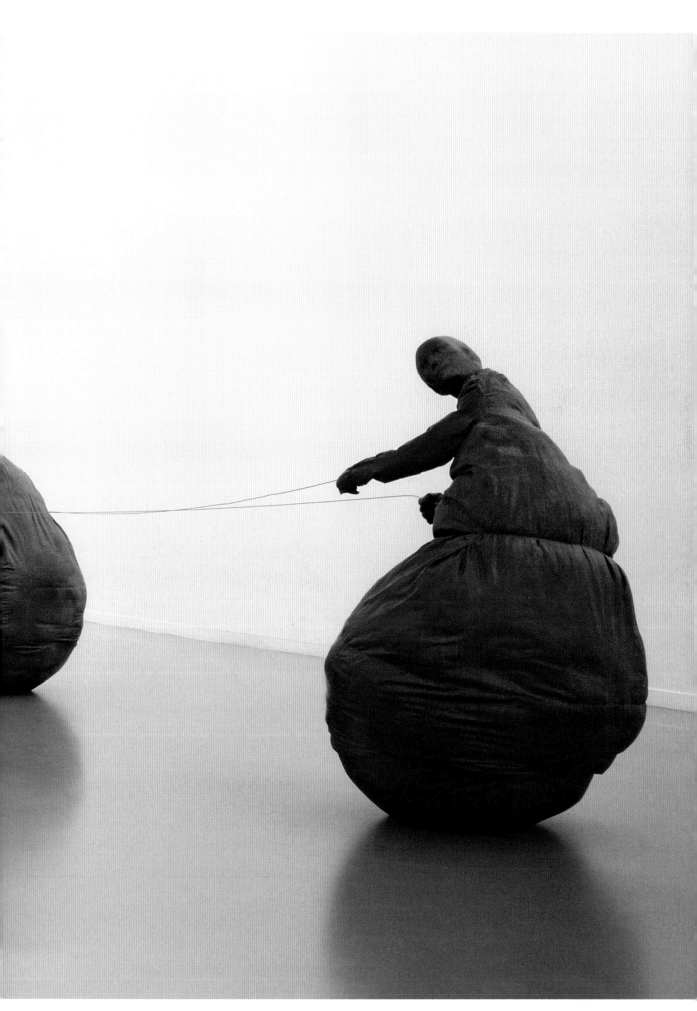

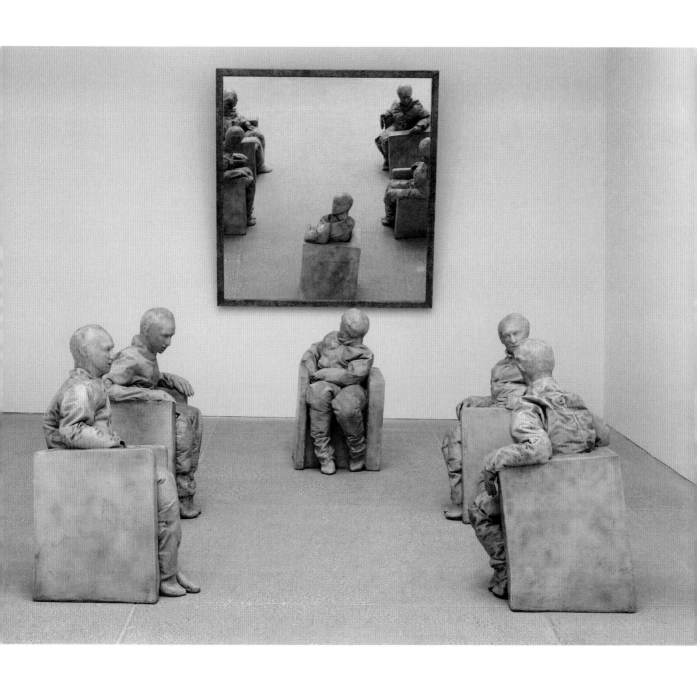

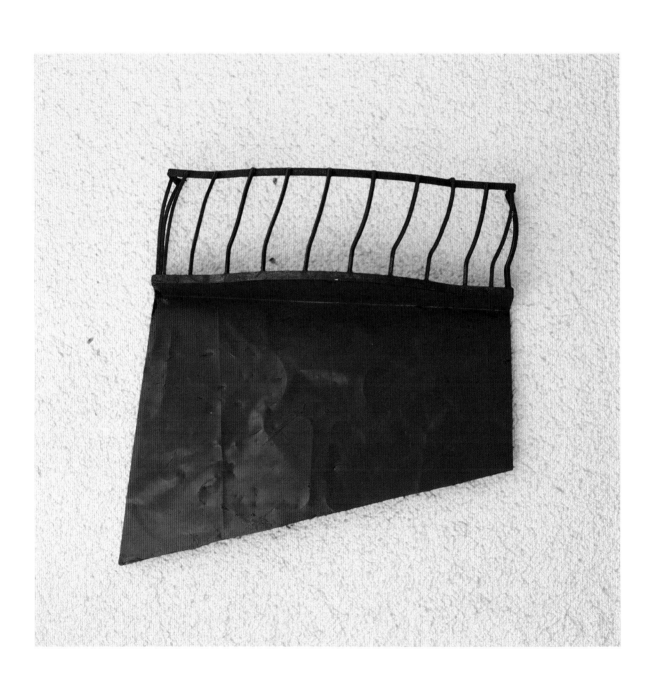

*Balcon para desear a Tatlin* 1987

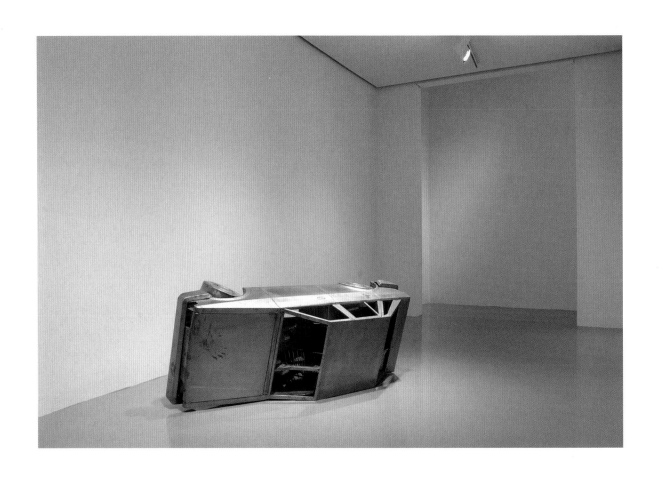

*Right: Loaded Car* 1998 (detail)    *Overleaf: Shadow and Mouth* 1996

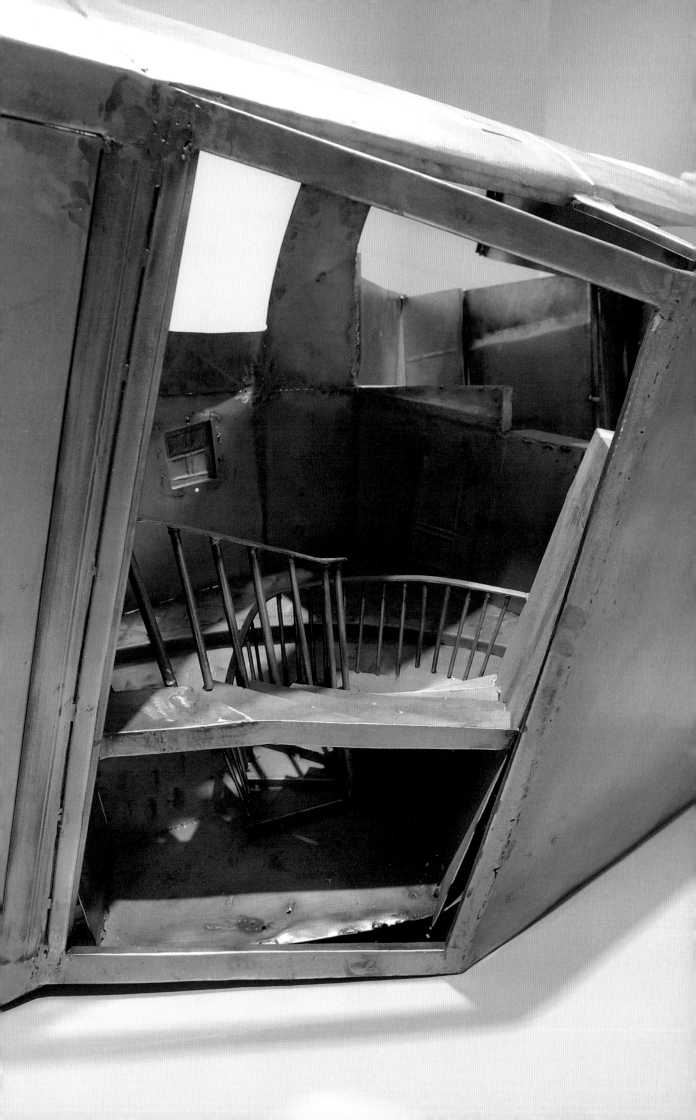

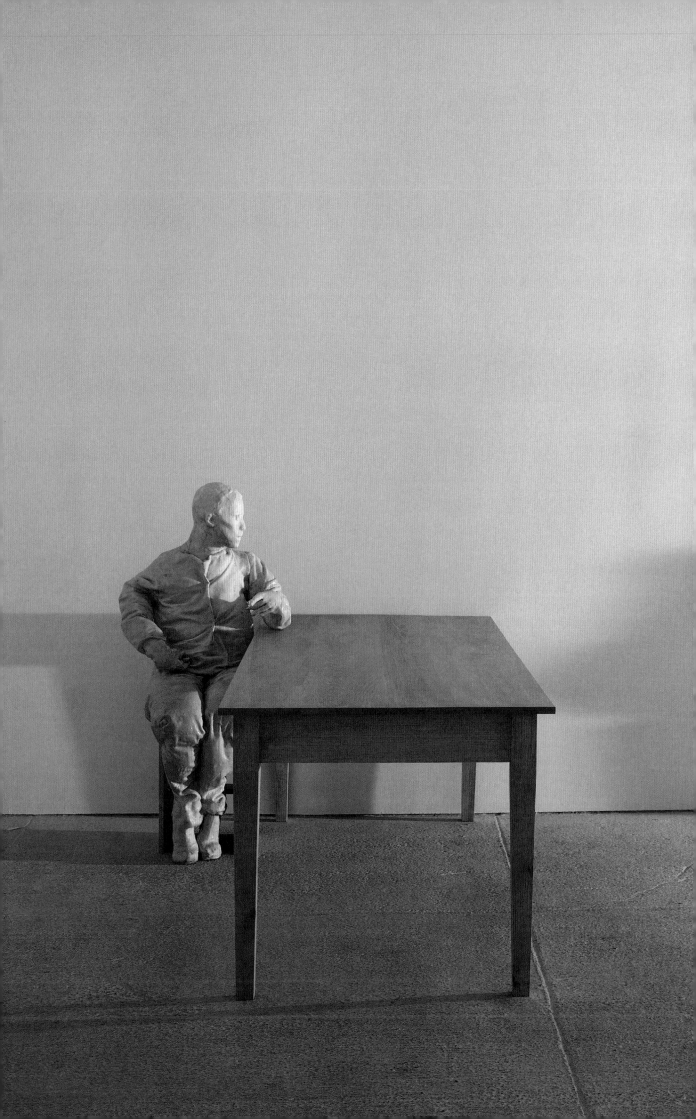

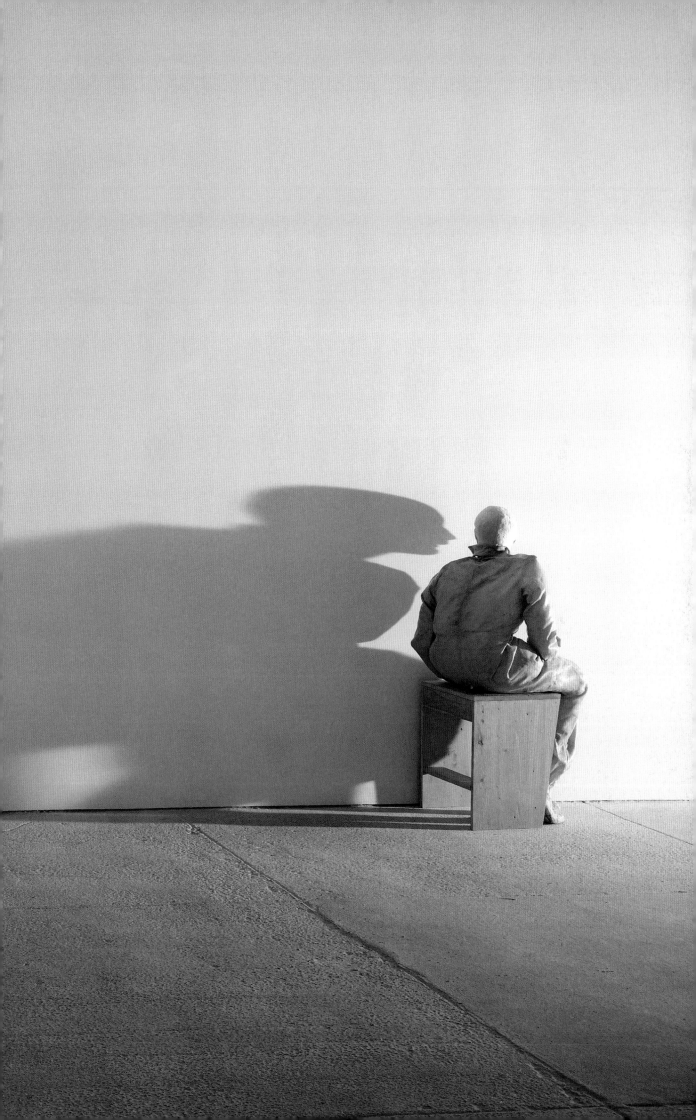

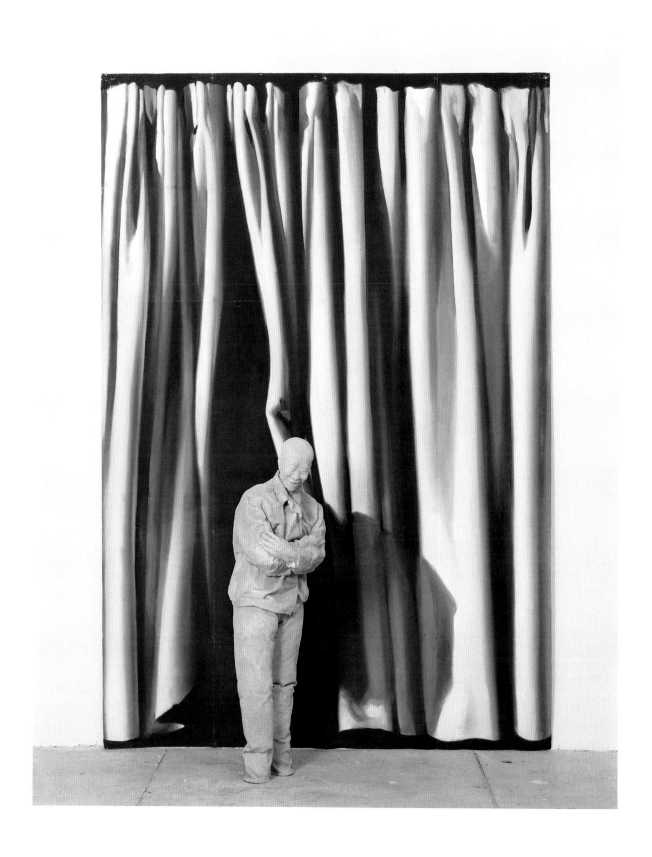

*End of the Road: Chinese Figure with Curtain* 1997

*Right: Staring at the Sea I* 1997–2000

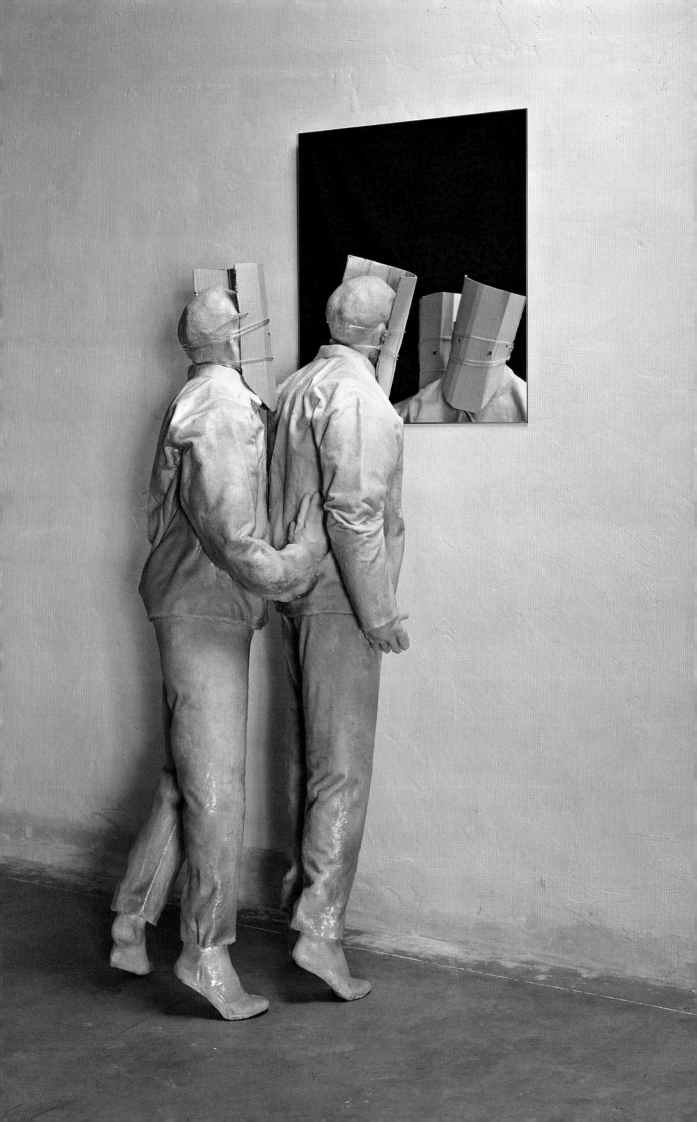

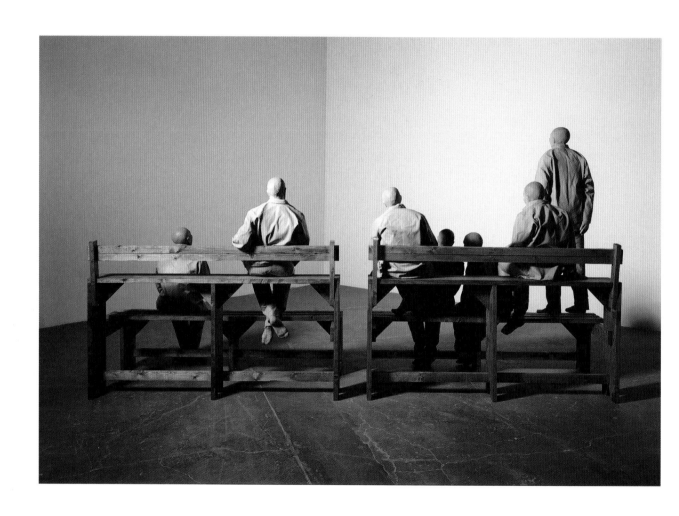

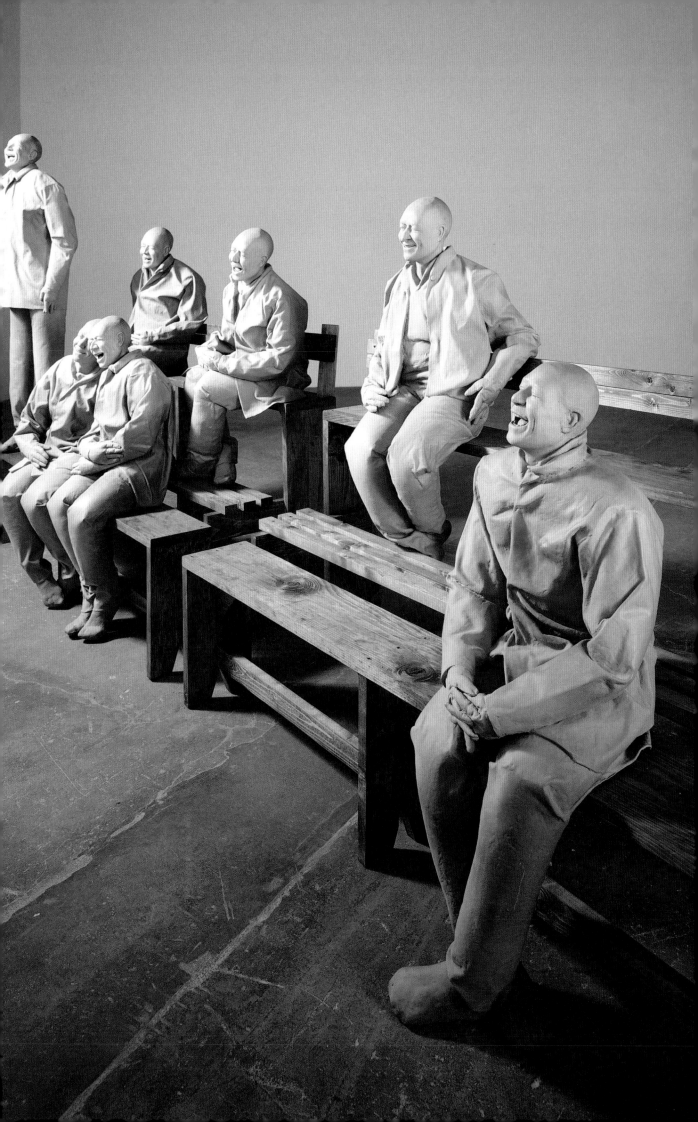

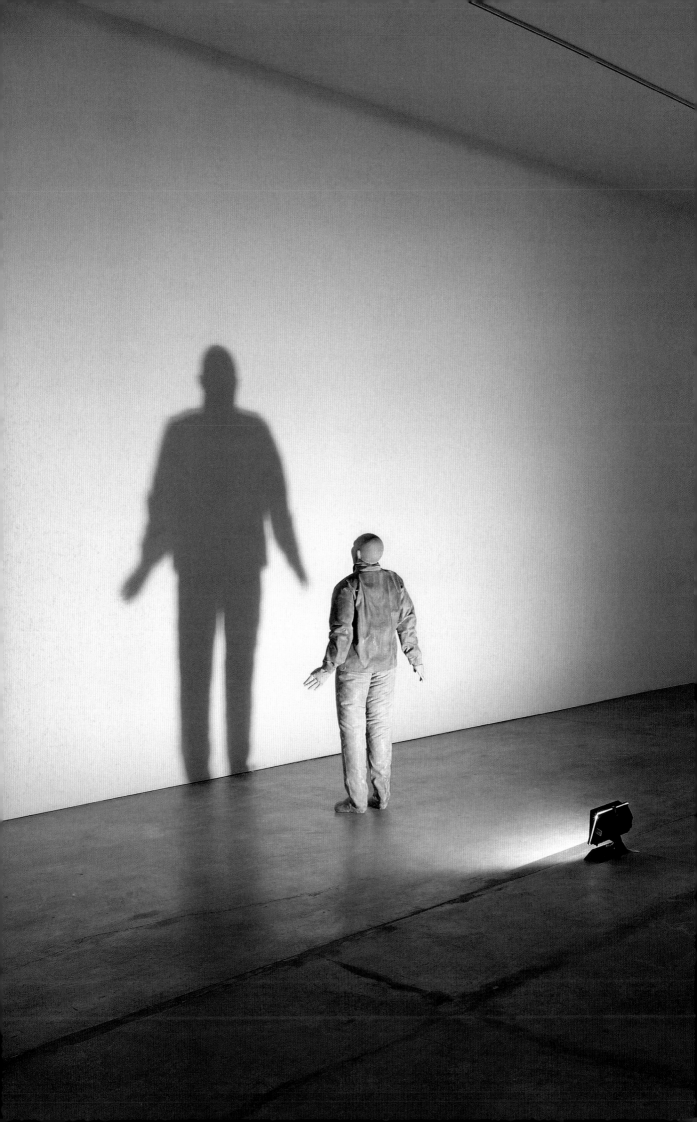

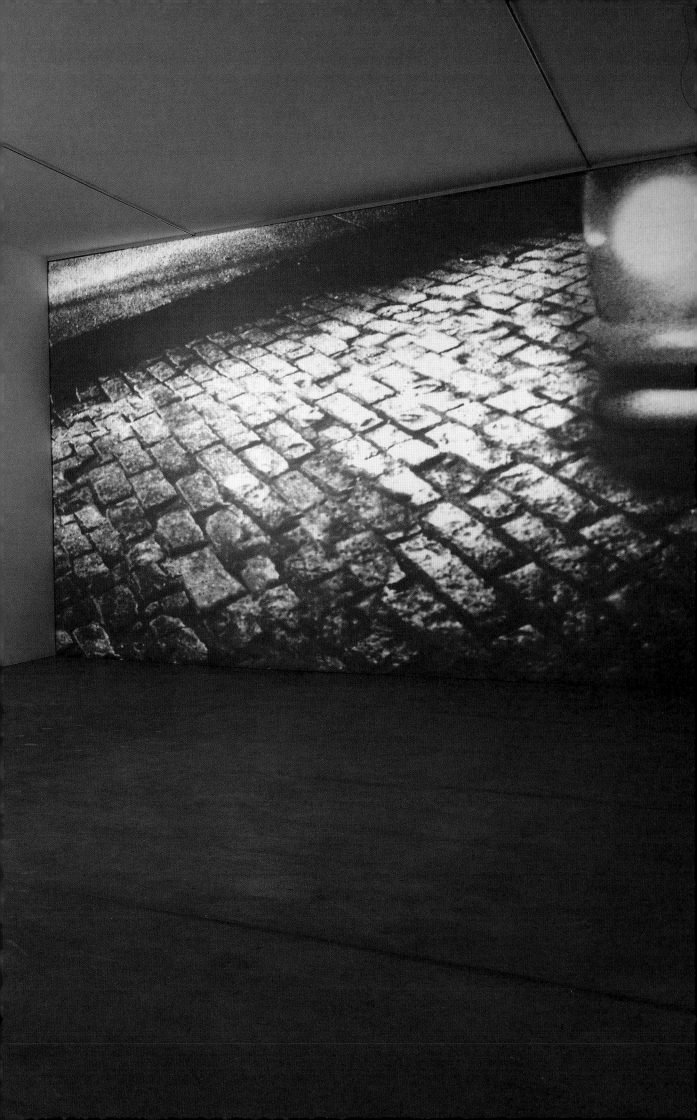

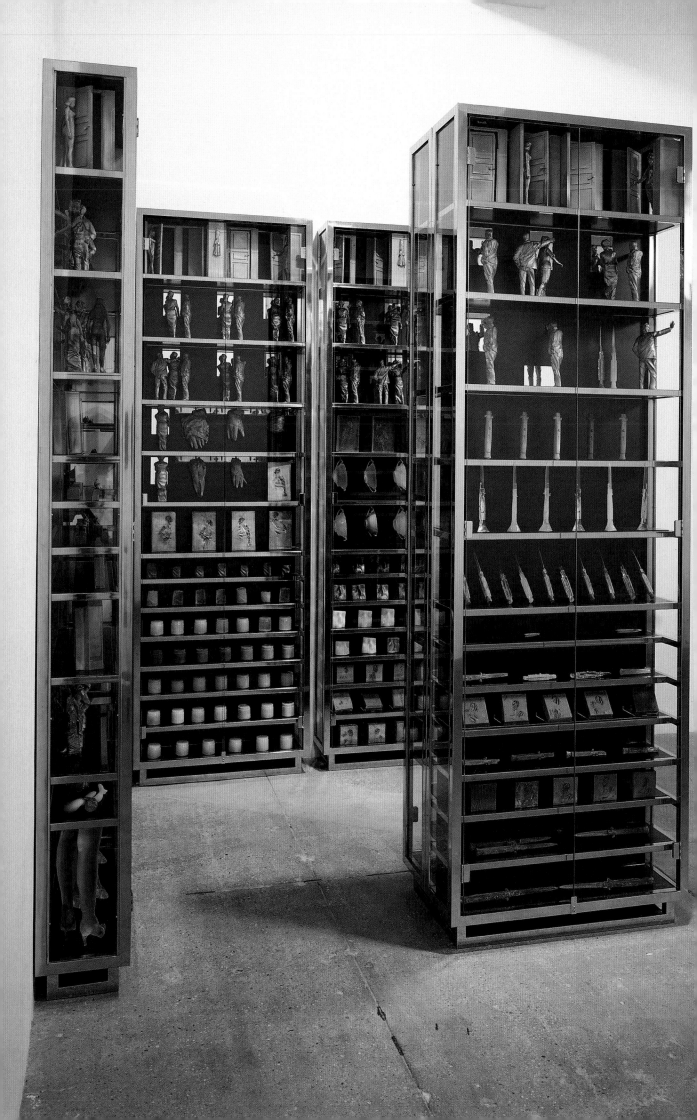

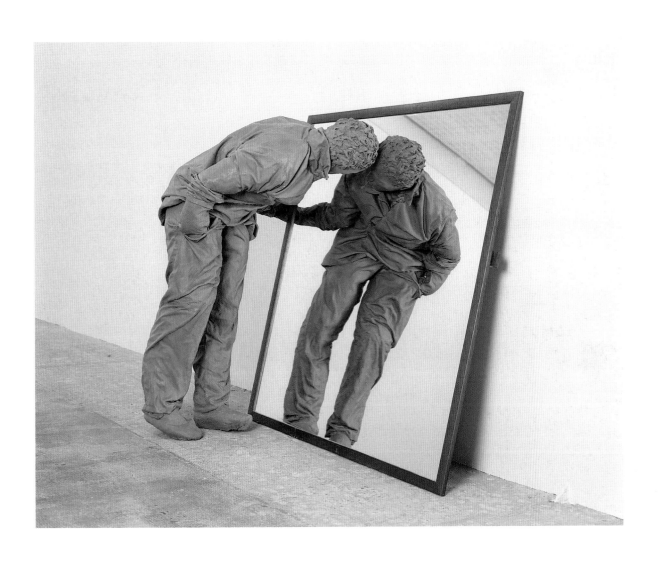

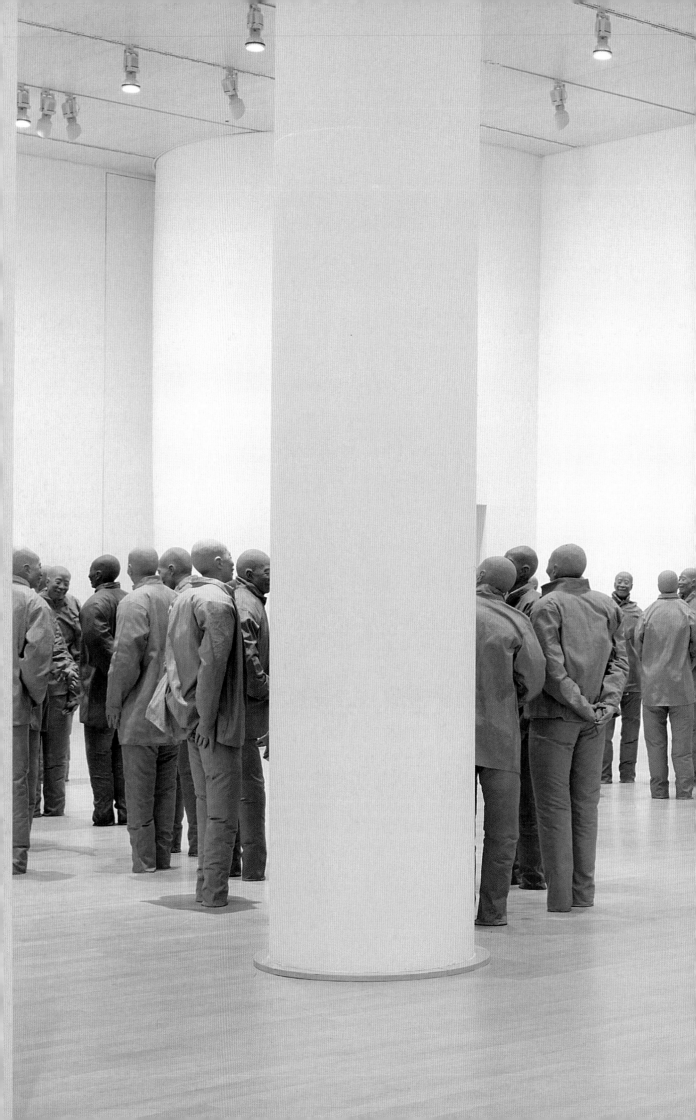

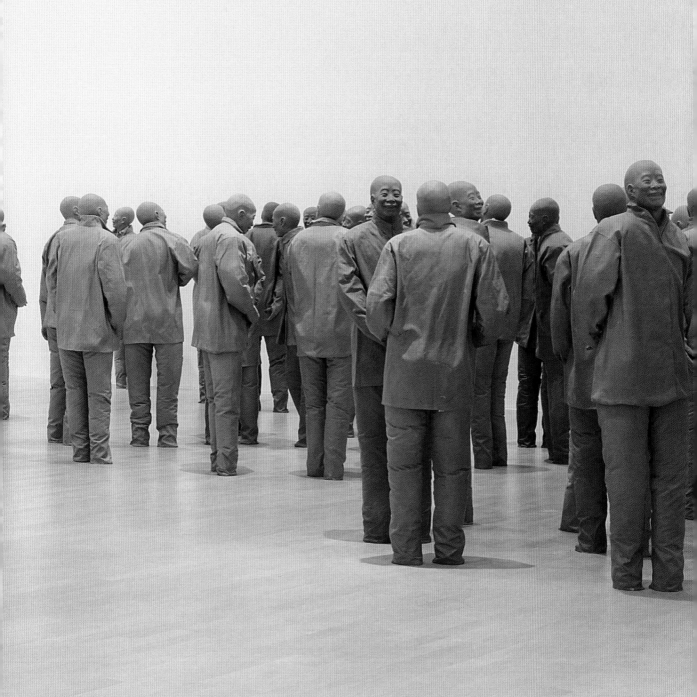

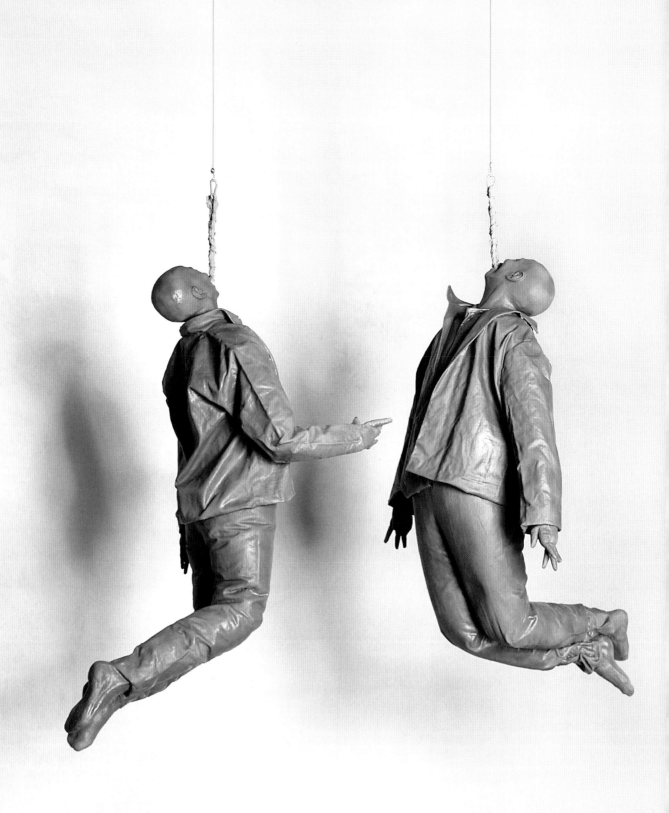

# Juan Muñoz
## A Retrospective

EDITED BY

Sheena Wagstaff

WITH CONTRIBUTIONS BY

John Berger

Gavin Bryars

Alberto Iglesias

James Lingwood

Manuela Mena

Alex Potts

Richard Serra

Sheena Wagstaff

Michael Wood

TATE PUBLISHING

CO-PRODUCED WITH

Sociedad Estatal
para la Acción
Cultural Exterior

IN COLLABORATION WITH

 GOBIERNO     MINISTERIO               MINISTERIO
DE ESPAÑA    DE ASUNTOS EXTERIORES    DE CULTURA
             Y DE COOPERACIÓN

First published 2008 by order of the Tate Trustees
by Tate Publishing, a division of Tate Enterprises Ltd,
Millbank, London SW1P 4RG
www.tate.org.uk/publishing

on the occasion of the exhibition

*Juan Muñoz: A Retrospective*

Tate Modern, London
24 January–27 April 2008

Guggenheim, Bilbao
27 May–28 September 2008

Museu Serralves, Porto
31 October 2008–18 January 2009

© Tate 2008

British Library Cataloguing in Publication Data
A catalogue record for this book is available from
the British Library

ISBN 987 185437 732 6

Distributed in the United States and Canada
by Harry N. Abrams, Inc., New York

Library of Congress Cataloging in Publication Data
Library of Congress Control Number: 2007934792

Designed by The Studio of Fernando Gutiérrez
Printed by Graphicom SPA, Italy

Cover: Juan Muñoz, *Two Seated on the Wall* 2000

# Contents

03 Plates

90 Forewords

95 *A Mirror of Consciousness*
Sheena Wagstaff

105 *To Double Business Bound*
Michael Wood

111 *Muñoz's Sculptural Theatre: 'the gap in-between is the territory of meaning'*
Alex Potts

121 *Juan Muñoz: Insights and Interpretations*
Manuela Mena

127 *Lecture given at Isabella Stewart Gardner Museum 1995*
Juan Muñoz

131 *Will it be a Likeness?*
John Berger and Juan Muñoz

139 *Juan Muñoz*
Richard Serra

141 *A Conversation, May 2001*
Juan Muñoz and James Lingwood

149 *On A Registered Patent*
Alberto Iglesias

150 *A Man in a Room, Gambling*
Gavin Bryars and Juan Muñoz

156 Chronology
157 Notes
159 Select Bibliography
165 Exhibition History 1984–2008
170 Artist's Writings
171 Interviews with the Artist
172 Exhibited Works
174 Lenders and Credits
175 Index

# Forewords

The first major retrospective of the work of Juan Muñoz focuses our attention on one of the most significant Spanish artists of recent times. Despite his untimely death in 2001, Muñoz continues to occupy a very important place in contemporary Spanish art, thanks to his brilliant ability to create tension between imaginary and real worlds.

His metaphorical expressions are manifested through his sculptures, drawings, sound works, installations and performances, and reveal the solitude of men and women today, in-effectual attempts at communication, and the disorientation of people throughout the world.

This exhibition consists of a selection of Muñoz's most iconic sculptures and installations, together with lesser known, but equally important works and has been co-produced by Tate Modern and the State Corporation for Spanish Cultural Action Abroad (SEACEX) in collaboration with the Spanish Ministry of Foreign Affairs and Cooperation and the Ministry of Culture. This retrospective encourages us to consider the full scope and richness of Juan Muñoz's artistic production.

This exhibition is part of the Spanish Government's mission to promote awareness abroad of the most important figures in Spanish art, even though many of these artists, including Muñoz, form part of the international artistic vanguard. *Juan Muñoz: A Retrospective* recognises this artist's contribution to international contemporary art, and immerses us in his passion for the reflexive act of looking.

Miguel Ángel Moratinos
MINISTRY OF FOREIGN AFFAIRS AND COOPERATION

César Antonio Molina
MINISTRY OF CULTURE

The State Corporation for Spanish Cultural Action Abroad (SEACEX) is a public institution, which promotes and exhibits Spain's rich artistic and cultural heritage and contemporary creativity.

This exhibition, co-produced by SEACEX and Tate Modern offers spectators the opportunity to experience the originality of Juan Muñoz's work, an artist who has had one of the most consistent careers in our contemporary art scene. It seems like the right time, seven years after his untimely death, to show the public in different European cities the full scope of his work. Challenging the relationship between viewer and artwork is an inherent characteristic of the various sculptures and installations in this exhibition. These works reflect the richness and complexity of an artistic career to whose recognition SEACEX has wanted to contribute, in line with its goals of promoting Spanish culture. Juan Muñoz's work is a powerful exponent of contemporary art's capacity to communicate, not only on formal and expressive matters but also on intellectual issues developed in our country during recent decades.

Likewise, in co-producing this exhibition with Tate Modern, we are fulfilling our promise to encourage collaboration with institutions whose ambitious and rigorous approaches channel cultural dissemination, which is the inspiration behind all of our activities. Indeed, SEACEX has taken on many challenges to date, and will continue to take on new challenges in Europe as well as on other continents around the world. The exhibiting activities have arisen out of broad policies for the promotion of Spanish culture, and it is for that purpose that travelling exhibitions such as this one are organised. This exhibition, after opening in London, will travel to Guggenheim Bilbao and Museu Serralves in Porto.

State Corporation for Spanish Cultural Action Abroad, SEACEX

# Director's Foreword

We are very proud to present a retrospective devoted to the work of Juan Muñoz, one of the most significant artists in the final decades of the twentieth century working with the figure in sculpture. Muñoz's extraordinary artistic achievement lies in the full spectrum of his work, including sculpture, installations, drawings, collages, scripts, essays, texts and other important works with sound, light and mechanical elements. As the most significant of the first generation of artists to achieve maturity in post-Franco Spain, Muñoz's artistic project was unprecedented, looking beyond the cultural scope of international contemporary practice to inflect his work with inspirations from literature, architecture, mythology, philosophy, music, film, poetry, theatre and the history of magic and illusion.

It is entirely appropriate that the first major retrospective of the work of Juan Muñoz in Europe should begin at Tate Modern. London was always a significant place for Muñoz, where he 'found a language I could deal with … and a culture that allowed me to respect myself as a contemporary European'. Following his brother to the city in the 1970s, Muñoz won a scholarship in 1976 to study at Central Saint Martins College of Art and Design and then in 1979 at Croydon College. In an essay written in the mid-1980s, Muñoz recalled that he visited the Tate Gallery and the National Gallery 'almost every weekend', fondly remembering his first encounter with Jacob Epstein's *The Rockdrill*:

'For years it was necessary to make one's way past rooms full of allegorical images of ladies and horses and down a flight of stairs to reach a corridor that was neither wide nor narrow nor particularly well-lit. Once there, surrounded by paintings by Turner's disciples, or by friends of Vorticism or others of uncertain pedigree, one would find the sculpture of a man's trunk. Half human, half image of the future. In that peculiar limbo, the piece seemed to have found its own true locus. Between "history" and "oblivion". (It is worthwhile to remember, as Borges is so fond of doing, that oblivion is a form, perhaps the highest form, of memory.)'

More than a quarter of a century later, Muñoz revisited some of the same places he knew from his days as a nascent artist in order to invest with 'an interior quality' his grand opus, *Double Bind*, the 2001 commission for the Turbine Hall in Tate Modern. A complex, affective and memorable installation which set the standard for all subsequent commissions, *Double Bind* was both the apotheosis of his career and his legacy. It is on his remarkable contribution to contemporary art that this retrospective builds.

We are delighted that *Juan Muñoz: A Retrospective* is travelling to the Museo Guggenheim Bilbao and Museu Serralves, Porto, and appreciate the support of our colleagues in those institutions.

Major support was provided by SEACEX (Sociedad Estatal para la Acción Cultural Exterior), our co-producers of the exhibition, for which we express our sincere thanks. Our profound gratitude is also extended to Tate International Council and The Henry Moore Foundation for their support. In addition, many thanks to Armstrong Floor Products for supplying the linoleum for *The Wasteland*. We are most grateful to the Department for Culture, Media and Sport for granting government indemnity to the exhibition.

For the enormous goodwill and generosity of all the lenders – private collectors, galleries and public institutions – who have kindly relinquished their Muñoz works to the exhibition, we are very grateful: they are listed on page 174. In particular, our deep gratitude is extended to the artist's Estate, which has been exceptionally generous in lending works to the show. It has also been a particular pleasure to work with the Muñoz Estate team, in particular Ana Fernandez-Cid, Sandra Feio, Julian Lopez and Ruben Polanco. We are also most appreciative of the assistance given by Marian Goodman and her colleagues at the Marian Goodman Gallery.

We are happily indebted to authors Alex Potts, Manuela Mena and Michael Wood, each of whom has contributed commissioned essays to the catalogue which broaden the critical field for understanding Muñoz's work. In addition, our grateful thanks are extended to the other contributors, John Berger, Gavin Bryars, Alberto Iglesias, James Lingwood and Richard Serra, whose strong unwavering commitment to and involvement with Muñoz's art continues. Special appreciation is due to Fernando Gutiérrez and his team for their sensitivity to Muñoz's work resulting in a beautifully designed catalogue, as well as graphics for the exhibition.

We would like to single out Kerryn Greenberg in heartfelt thanks for her extraordinary achievement in handling every aspect of the complex organisation of this exhibition: her prodigious project management ability, curatorial perception and sense of humour have inflected this exhibition project at every turn.

Special appreciation goes to other Tate colleagues who have worked to bring this retrospective to fruition. Chief amongst these is Stephen Mellor, Coordinator: Exhibitions & Displays and exhibition registrars, Hillary Taylor and Stephanie Bush, whose essential role has been to solve the contractual and logistical challenges of the show. Sincere thanks are also due to Nicola Bion for her sympathetic editorship of the catalogue and to her colleagues Sarah Brown and Beth Thomas for all their hard work and dedication to the project. For her administrative support throughout the development of the exhibition, warm thanks are extended to Alison Kennedy. We would also like to recognise the efforts of other Tate colleagues who have contributed to the exhibition in myriad ways. Installation arrangements have been ably handled by Phil Monk, Sam Clarke, Marcia Ceppo and the art handling team. Elizabeth McDonald, Julia Nagle, Rachel Crome and Katharine Locket have given considerable conservation expertise to the project, assisted by other members of Tate's conservation team. Others who have expedited development, event and communication tasks associated with the show include Jenny Lea, Billie Lindsay, Brad MacDonald, Daisy Mallabar, Louise Ramsay, Livia Ratcliffe, Nicky White, and Rebecca Williams. Marko Daniel, Jane Burton and Simon Bolitho have worked on exhibition interpretation and public programmes. Intern Jenine McGaughran has assisted the curatorial team.

In developing the Juan Muñoz retrospective, we have counted upon the knowledge and counsel of friends and colleagues, all of whom have a passion for Juan's work and knew him well. We are sincerely grateful to Placido Arango, Neal Benezra, John Berger, Paloma Botin, Pepe Cobo, Gavin Bryars, Borja Coca, Lynne Cooke, Hilde Daem, Mark Francis, Carmen Giménez, Richard Hamilton, Jane Hamlyn, Julian Heynan, Alberto Iglesias, Marta Ruiz Jarabo, Valeria Liebermann, James Lingwood, Nicholas Logsdail, Gloria Moure, Manuela Mena, Paul Robbrecht, Juliao Sarmento, Paul Schimmel, Adrian Searle, Nicholas Serota, Richard Serra and lastly Olga Viso, who has been particularly generous in her support.

It has been a privilege and delight to work with Cristina Iglesias. Her generous spirit and unwavering enthusiastic commitment to this project have created the best of collaborations. She has given the exhibition the benefit of a unique insight and as genuine an interpretation of his work as that of Juan himself. We offer her our deep gratitude.

Vicente Todolí
DIRECTOR, TATE MODERN

Sheena Wagstaff
CHIEF CURATOR

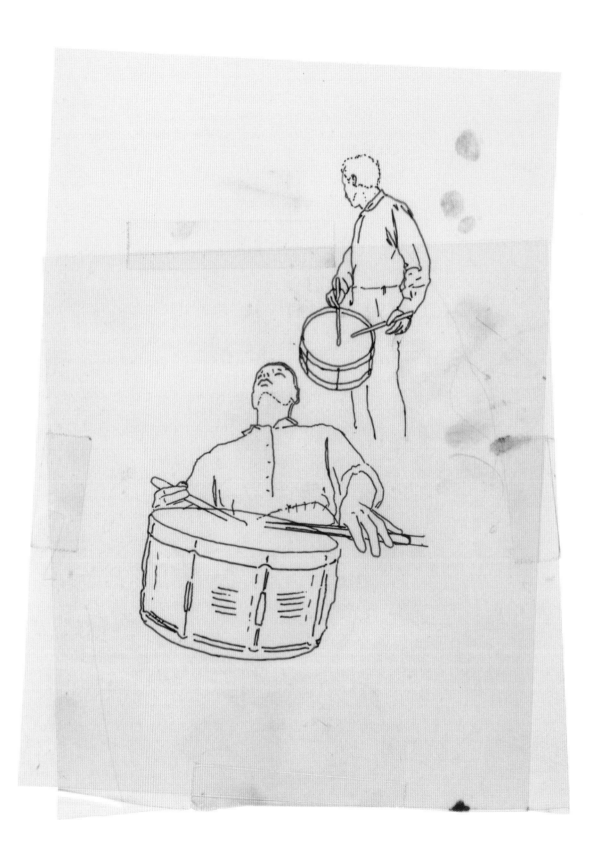

# A Mirror of Consciousness

SHEENA WAGSTAFF

ABOUT ORIGINS. Juan Muñoz has often appeared to be an isolated figure, his sculptural language and ambition set at a distinctive tangent to the prevailing international trends of sculpture in the 1980s and 1990s, when there was still resistance to the idea of figurative sculpture. His career was vividly productive, culminating in his grand opus, *Double Bind* 2000, which wove together every aspect of his artistic project from his first *Spiral Staircase* in 1984, bringing his short career full-circle when he died suddenly, just after its completion, aged forty-eight.

Born in 1953, Muñoz grew up under the repressive authoritarian regime of the dictator General Franco; there was little activity in contemporary art in Spain at the time, apart from that of Eduardo Chillida, Antoni Tapiés and Jorge Oteiza. While acknowledging a rich historical Spanish legacy of convention-breaking artists from Velázquez and Goya to Dalí, Picasso and Miró, Muñoz also looked far beyond Spain to investigate the work of his international contemporaries. His was not a lone quest in the reinvigoration of figurative sculpture within the modernist canon, although he was amongst the first generation of American and European artists in the late 1980s, such as Robert Gober, Mike Kelley, Thomas Schütte, Katharina Fritsch, Paul McCarthy, Stephan Balkenhol, Charles Ray and Kiki Smith, to engage in varying degrees with the sculpted figure, or fragments of it, alongside the possibility of creating a kind of narrative in their work.

At the same time, he drew on a rich vein of sources in literature, architecture, mythology, philosophy, music, film, poetry, theatre and the history of magic and illusion. His notebooks include references to Anna Akhmatova, Robert Bresson, Joseph Conrad, Marguerite Duras, Ralph Ellison, Michael Fried, Alberto Giacometti, John dos Passos, T.S. Eliot, Günter Grass, Philip Guston, James Joyce, Edward Lear, Henry Miller, Barnett Newman, Piet Mondrian, Robert Morris, Octavio Paz, Philip Roth, Alvaro Siza, Robert Smithson, Robert Louis Stevenson and Paul Valéry. His incisive erudition is reflected in the myriad forms of his artistic activity: sculptures in different media, plays for radio and stage, drawings, writings and essays, each of which relate to one another. As a sculptor whose probing intellectual curiosity, mercurial wit and discerning broad-mindedness defined him as a modern humanist, Muñoz's notable legacy for the twenty-first century will demonstrate that his engagement with the seemingly idiomatic, especially in his late work, was prescient of a new aspect of post-national universality. He brought an unapologetic poetry to the Post-minimal art of his time, meshing the self-conscious intellectual enquiry of Conceptual art with the open-ended experimentation and material tactility of Arte Povera, informed by different strategies of literary, cultural and anthropological narrative.

To trace the trajectory of the development of his art is to enter a labyrinth, a Borgesian garden of forking paths, along whose way we encounter the dingy, threadbare lyricism of large drawings in white chalk on black gabardine fabric of darkened, sparsely furnished rooms, like 1940s film-noir storyboards, where a stool placed dangerously near the top of the stairs becomes potent with quiet menace; a wax drum 'that has left its reason behind';[1] or a cast of motley characters, alone or clustered in groups, always absorbed in themselves or one another, inhabiting psychologically charged settings and enhanced by props that create spatial conundrums such as optically destabilising floors, doorways, shadows and mirrors. Not only are the latter the components of the nineteenth-century magician's traditional box of tricks, but they are also part of the pictorial lexicon of the great progenitors and proponents of modernism from Velázquez to Francis Bacon in their invention of the Great Illusion: the creation of space in painting and its potential for allusive metaphor. It was only through the work of artists such as Robert Smithson and Richard Serra that Muñoz felt that sculpture had discovered a parallel achievement of activating space. 'The

difference between these artists and myself is illustrated by Frank Stella's famous remark, 'What you see is what you see.' For me, what you see is not what it seems to be.'[2]

In an interview given the year before he died, Muñoz explained, 'For me, a good sleight-of-hand trick requires ... the spectators to move in a certain direction, so that the trick will be effective and so that the spectator can see the wonder of it ... And I'm explaining the trick. The explanation has as much wonder as the trick itself.'[3] His delight in devising enigmas, concocting illusions and spinning stories with which to engage the spectator in psychological gamesmanship is at once arcane and unprecedented in contemporary sculpture. He had a profound philosophical interest in seeing the extent to which sculpture can test the nature of reality, by exploring the power of absence as well as presence, of silence and its opposite, sound – to create the conditions for a moment in which irreconcilable polarities can be brought together to resonate in each work, like a mirrored reflection of each other.

ABOUT EQUIVOCATION. Even before he found his metier as a sculptor in the early 1980s, Muñoz had already developed a distinctive voice in published essays that owed much to the literary form and symbolist prose of Jorge Luis Borges. Like Borges, Muñoz combined an interest in his native land with a far broader cultural perspective that explored philosophical questions about the nature of time or historical reality, dramatic form, and the art of translation. Like Borges, too, Muñoz revelled in mixing fact with fiction, often writing stories or critical essays that falsely ascribe as factual chronicles that are either partially true or fabulously imaginary, with the view that his 'translation' – as an 'alternative version' of an original form – could be equally valid.

Muñoz's sculpture, too, has always had an equivocal existence: from its invocation of 'in-between' spaces in his first balconies, stairways and doorways, to the evocation of a 'placeless place' in more elaborate works, to which Muñoz introduced different types of sculptural figures, choreographing a psychologically charged dynamic between them and the environment in which they are placed, as well as with the spectator. The earliest miniature renderings of architectural elements such as *Spiral Staircase* 1984 (p.5) and *Hotel Declercq* 1986 (p.15), attached high on gallery columns or walls, whose small scale causes a sense of Lilliputian displacement, find their roots in Post-minimalist sculpture of the 1970s. They are not dissimilar in scale and form to Joel Shapiro's tiny cast-iron houses on wall or floor, or small objects denoting places of transition – a bridge, boat and coffin – all of which represent Shapiro's psychological spin on the Minimalist project in the mid-1970s.[4] Not only does their diminutive scale and positioning cause a sense of spatial disruption, but they also presume a fugitive figurative presence.

Shapiro and Chillida were among the artists, including Richard Serra and Charles Simonds (the latter representing the polar extremes of sculptural scale), selected by Muñoz for an exhibition that he curated in 1982, which explored the tripartite relationship between architecture, sculpture and the viewer.[5] In his catalogue essay, Muñoz stated: 'Over the course of the history of modern art, whenever we find a possible rapprochement between architecture and sculpture, there spontaneously arises a great difficulty in uniting both visions of space ... Nevertheless ... among all the arts ... architecture and sculpture begin and end in their concern with space. Inhabited space, uninhabited, or to-be-inhabited space; even space as a metaphor.'[6] More interested in the 'feel' of space than in its potential to be described by architectural form, however transparent or contingent, Muñoz subsequently embarked on the speculative creation of a 'being' to manifest the absence, making small figures that derived from nineteenth-century vaudeville performances by ventriloquists and illusionists.

Fig 1 Installation view of *Juan Muñoz: Últimos trabajos*, Galería Fernando Vijande, Madrid, 1984

ABOUT GAMES. Muñoz's early figures included wooden acrobats with articulated limbs, little ballerinas with bells or scissors for hands, whose lower bodies and legs are encased in bulbous hemispherical moulds, and ventriloquist's dummies or mannequins, all of which imply the necessity of a 'master' to move and animate them. The mannequin in *The Waste-land* 1987 (p.22) sits waiting, as if anthropomorphically aware of its own dilemma. The work is named after T.S. Eliot's well-known poem, a five-part palimpsest of different voices and literary styles. In turn, Eliot's great work was indebted to what he described as 'a work of anthropology, which has influenced our generation profoundly':[7] James George Frazer's *The Golden Bough: A Study in Magic and Religion* (1890),[8] which takes a modernist anthropo-logical approach to understanding belief as a cultural phenomenon, extending a discussion on religion to the symbolism of magic. This will not have escaped Muñoz – his personal copy of Eliot's poems is heavily annotated, while his notebooks contain many quotations from Eliot. Within the second part of *The Waste Land*, 'Game of Chess',[9] is the imprecation:

> Speak to me. Why do you never speak. Speak,
> What are you thinking of? What thinking? What?
> I never know what you are thinking. Think.

Five years after *The Wasteland*, Muñoz created *Stuttering Piece* 1993, two small figurines seated on cardboard stools, who are given mechanical voices, but whose 'conversation' is disrupted by the speech impediment of one. A stammer results from a psychological spasm between conception and expression, given further emphasis here through being endlessly repeated on a recorded loop, the words becoming almost musical in their repetition:

> What did you say?
> I didn't say anything.
> You never say anything. No. But you keep coming back to it.

These snippets of dialogue also find parallels in the plays of Samuel Beckett and Luigi Pirandello, both of whom Muñoz admired. Indeed, a fragment from a Pirandello play was chosen by Muñoz the previous year, 1992, with which to preface a series of fifteen texts for an exhibition catalogue.[10] The second of these texts not only begins with the above dialogue by Muñoz, but is also, significantly, placed opposite the image of *The Wasteland*, creating a taut literary and visual coincidence between Eliot's poem and Muñoz's work.[11]

Amongst the other texts, which were not attributed to specific sources, but 'transcribed from recordings taken from radio, television, films, Lulu, the street and the odd bar',[12] the ninth is a collaged transcription of dialogues from David Mamet's *House of Games* (1987) (fig.2). One of Muñoz' favourite films,[13] it added a new kind of narrative intricacy and pri-macy of character to 1980s movie screens[14] – a filmic equivalent to Muñoz's simultaneous foray into making figurative sculpture with narrative connotations. It tells the story of the labyrinthine machinations of a conman, Mike, who reveals early in the film that a con works not because the victim, or 'mark', puts her confidence in the trickster, but because the 'confidence-man' appears to give his confidence to the mark. Throughout the film, small con tricks are apparently unmasked and explained, while the other main character, Margaret, strives to discern the difference between the real thing and the carefully crafted facsimile. But even these are revealed as small double-bluffs that culminate in a huge and complex scam, a web of ingeniously elaborate double-double-bluffs. Mamet often opts to tell the tale through image rather than the spoken word: indeed, the film contains periods of complete silence, with the story conveyed through glances or gestures.

The mental gamesmanship of *House of Games* clearly appealed to Muñoz. Mamet's recognition of the narrative power of silence, playing with it as both reality and metaphor, is

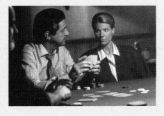

Fig 2 David Mamet (director),
*House of Games* 1987

also shared by Muñoz, whose oeuvre has long been described as one dominated by silence but where sound plays a fundamental role, not just through its palpable absence but also through its potential via the psychological empathy of the spectator to attempt to 'hear' or understand the non-verbal dialogues of his characters. This returns us to the dummy in *The Wasteland*, which embodies the potential for vocal animation from the absent ventriloquist, as it sits forlornly isolated on its shelf.

ABOUT MANNEQUINS. The curious and ancient practice of making voices appear to issue from elsewhere belongs to the history of magic and illusion.[15] Even today, the myth of ventriloquism is perpetuated through the belief that the projection of the voice to another place is by virtue of an extraordinary power. Our fascination with this vocal illusion partly derives from the fact that the power of sound contradicts the evidence of sight, even as it circumscribes a simultaneous enlargement of theatrical space. If the ventriloquist's dummy in *The Wasteland* were to speak, his voice could be seen as an extension of his body into his environment, demarcated by the span of the geometrically patterned floor that extends from where he sits to fill the entire gallery. It is little understood that learning to speak depends on being able to *hear* oneself speak.[16] (Before the nineteenth-century creation of sign-language, many profoundly deaf people were rendered mute simply through being deprived of the opportunity to hear language spoken.) In *The Wasteland*, our anthropomorphic (and cultural) understanding of the dummy renders it not just mute but deaf.

This might be the reason why, during the following year, Muñoz dispensed with the implication of an absent ventriloquist and developed a humanoid version of the dummy, investing it with a literal means of speech via a motorised mouth. However, it mouths a monologue that is utterly silent to our ears. Moreover, the dummy is itself identified as the ventriloquist, the piece being entitled *Ventriloquist looking at a Double Interior* 1988–2000 (p.30) – exposing and further complicating the illusion of projected speech, where historically the ventriloquist himself has the double character to play. 'I made a perfect copy of [a] ventriloquist's doll, because a ventriloquist is always a storyteller. But a ventriloquist's doll without the ventriloquist also becomes a story teller. He sits there, waiting for you in order to talk. He still doesn't speak, but his identity endows him with some capacity to tell a story.'[17] By transferring the verb of hearing to that of seeing, in addition to frustrating the viewer's desire to decode the monologue, Muñoz directs our attention to the mannequin's line of sight. It gazes at a pair of drawings, which appear to be opposite views of the same room, each like a reverse mirror image of the other. The entire work embodies a double-edged conundrum that reverberates between the literal site of the piece and the invisible dotted lines of its aural and visual 'projections'.

Munoz continued to create works with animatronic mouths such as *Winterreise* (A Winter's Journey) 1994 (p.59), explaining that 'On the one hand there is the stillness of a figurative sculpture that for me remains an inexplicable enigma. On the other hand, the representation of movement and gesture within stillness is a challenge that is endlessly fascinating … I think between the stillness and the movement I try to find a place for my sculptures.'[18] *Winterreise* refers to Franz Schubert's song cycle for a single male voice from 1827, which in turn was based on a cycle of twenty-four poems by Wilhelm Müller. It tells the story of a young man, spurned by his sweetheart, walking away from her house for ever. Fighting thoughts of suicide, he walks for miles carrying his heavy backpack, leaving footprints in the snow in his search for a place where he can rest. Munoz's version of *Winterreise* offers a metaphoric package containing many layers of allusion carried by a slight figure of a boy who silently mouths words in rhythmic sequence as he traverses a broad

Fig 3 Joachim Patiner, *St Christopher*
c.1520–4, Real Monasterio de El Escorial,
Madrid

geometric floorscape whilst bearing a smaller person on his shoulders. Unpacking the package can reveal the heavy baggage of misery, or evoke the characteristic hunched stance of St Christopher bearing the weighty burden of the small Christ child, or referring to the children's street game of caballito ('little horse') in which children are hoisted on one another's shoulders to have tournaments with each other. The allusive impact of the work is heightened through the spectator encountering the figures on the same ground: as Muñoz recalled in 2000, 'I make optical floors because they help me to magnify the inner tension of the figure. They create a psychological space for the figure that permeates the spectator's perception.'[19]

ABOUT THE DRUM'S VOICE. In Muñoz's first solo exhibition in 1984, disembodied ears made of wood were incorporated into several works. These organs of hearing find a metaphoric equivalent during the following decade in a number of pieces that include drums, the first of which, *Wax Drum* 1988 (p.29), was made in the same year as *Ventriloquist looking at a Double Interior*. The visceral violence of a pair of scissors plunged into the tympanum skin of the drum evokes a vicious stabbing of the tympanic membrane of the inner ear, creating a deep wound that when enacted destroys both the possibility of sound and hearing.

Ten years later, Muñoz selected one image from a series of photographs of himself, in which he was dressed as a drummer boy in white plimsolls and braces,  and wrote 'Self Portrait' by hand onto the print (p.126). It is curiously reminiscent of another 'self-portrait' – the original cover of Luis Buñuel's autobiography, *My Last Sigh*,[20] published in 1983, which portrays Buñuel as a drummer amidst other drummers in the Spanish village of Calanda in Aragon, where he was born. As documented by Buñuel, Calanda's Easter celebrations feature around 2,000 drummers, who jam in a thirty-six-hour drumming ritual until the skins of their drums are soaked with blood from their hands: a very surreal form of penance.[21] While neither Muñoz's nor Buñuel's self portraits suggest such a gory conclusion (as Muñoz commented in a 1994 essay on Pirandello, 'Bunuel spoke without hope of absolution' in his art),[22] the savage piercing of Muñoz's *Wax Drum* brings to mind the notoriously violent episode in Buñuel's film *Un Chien Andalou* of a knife slitting an eyeball.

Muñoz's self-portrait also evokes Günter Grass's novel *The Tin Drum*, whose protagonist Oskar, having precociously observed the duplicity of the adult world, decides on his third birthday, when given a tin drum, never to grow higher than three feet. Thus he sees the beginning of the Second World War, Hitler's Holocaust and postwar Europe with the eyes of an adult but from the viewpoint of a dwarf. In this way, Oskar finds an opportunity to escape the horror of normality, and to perceive and value the extraordinary. As an emblem of his transformation, the tin drum remains his most treasured possession. While it would be absurd to create a literal connection between the story of Oskar and Muñoz as drummer-boy, the artist was clearly beguiled by Grass's epigrammatic literary style and admired his ability to condense narrative through skilful condensation of fictional time. In a notebook dated 1983, he painstakingly copied out a paragraph by Grass: 'I write compressed time, I write what is ... overlapped by something else, is or seems to be next to something else, while, unnoticed, something that didn't seem to be there any more, but was hidden and for that reason ridiculously long-lasting, is not exclusively present, fear, for instance. G. Grass'[23]

ABOUT MEMORY. The dwarf character first appeared in Muñoz's work in *The Prompter*, also made in 1988 (p.26). As he later recalled, 'My figures – the dwarfs, ventriloquist's dummies – were, from the beginning, always conceptually oriented. I use architecture to give a "theatrical" frame of reference to the figure.'[24] *The Prompter* presents us with an almost empty stage as a site of imaginative projection, via the implacable presence of a dwarf. Enclosed in

the shell of a prompter's box at the edge of a stage, the dwarf character faces across a stage floor comprising black and white tiles laid out in geometric patterns, which create the optical illusion of shifting planes, reminiscent of floors co-opted by Baroque architects from antiquity. At the other end of the stage, tilted at an angle against the back wall, is a drum whose skin surface is emblazoned with a miniature replica of the patterned floor, which Muñoz described as a 'Baroque device, a stage set for the image'.[25] Later he elaborated: 'The optical floors ... construct a mise-en-scene that tells you that you shouldn't trust your eye, that calls into question the act of looking.' Muñoz subsequently likened the work to the recreational diversions of the Mannerist architect, Giulio Romano, or to the work of his sixteenth-century peer, the philosopher and expert on mnemonics, Giordano Bruno, who was acclaimed in 1582 as the author of *Ars Memoriae*. This proposed a mnemonic process by which to memorise things in pre-reading days via a 'theatre of memory' – as a smaller version of the larger world.[26] Muñoz added: 'When I made *The Prompter* I wanted to make a house of memory, the mind you never see but is always there. It is ... like a stage set with no representation, no play, only one man trying to remember, trying not to forget.'[27]

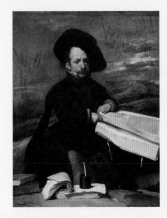

Fig 4 Diego Rodríguez de Silva y Velázquez,
*El Bufón don Diego de Acedo, 'el Primo'* 1635, Museo Nacional del Prado, Madrid

In his 1989 catalogue text for this work, Muñoz paraphrased Borges, 'who imagined forgetting as a form superior to memory', probably in reference to Borges's short story *Funes, the Memorius* (Funes, the Memory) (1942) in which, as a result of a head injury, a young man named Funes remembers absolutely everything he sees with equal clarity and importance. In describing Funes's agony as a result of the utter intensity of his receptivity to everything around him, the story underlines how we make sense of the world through the necessary filter of forgetting. Being the one unseen person who is responsible for remembering every line of the play, the prompter in his enclosure of memory takes on the role of Funes, with the anomaly that, in Muñoz's work, there are no lines to remember or to forget.

ABOUT A DWARF. In describing the genesis of *The Prompter*, in a text illustrated by Velázquez's portrait of *El Bufón don Diego de Acedo* 1636–8 (fig.4), Muñoz wrote: 'We began to speak about the ventriloquist's doll, of the image of the robot, and of simulation. At one point I referred to the importance that dwarfs had played in the protocol of the Baroque court.'[28] Around the same time, he explained that 'The dwarf was the only person that could criticise the court. Because of his physical distortion, he was allowed to distort or exaggerate reality. The dwarf was born in my work from a walk in a garden in Munich ... I went to this very Baroque park ... and picked up a leaflet about the Rococo architect (François de Cuvilliés 1695–1768) who designed it and discovered that he had been very small in size, practically a dwarf. And then I knew what I was going to make: the image of a dwarf inside the prompter box.'[29] Like the Shakespearean 'fool' or savant, a zany commentator whose character is peripheral to the main action but who offers crucial insight on the play, the court dwarf is in a position to reflect and unmask the truths of the social drama unfolding around him, not unlike Oskar in *The Tin Drum*, who questions the very definition of normalcy.

People who are visually different from their fellow human beings have been taken to represent Otherness since human history began. The bodily disproportion of short stature continues to be one of the narratives by which we make sense of ourselves and our world. Public consciousness of people with physical anomalies has changed, however, in the twentieth century due to anthropological and medical research and gene theory, the growth of ideologies concerned with minority rights, as well as the relatively new and provocatively named Freak Theory, all of which have defined the 'anomalous' body as simply a different body.[30] Muñoz continued to cast the figures of two such people, George and Sara, whom he identified in later works such as *Sara with Billiard Table* 1996 (pp.64–5).

**ABOUT ILLUSION**. Amongst the many dwarfs in the Baroque court painted by Velázquez, is a young maid of honour attending the Infanta Margarita in his painting *Las Meninas* (The Maids of Honour) 1656 (fig.5). There is a vast amount of literature devoted to the way in which Velázquez broke in this work the rules that had governed pictorial representation since the Renaissance. As Leo Steinberg commented 'the literature of *Las Meninas* is an epitome of recent thinking about illusionism and the status of art ... a cherished crux for modern investigators, for geometricians, metaphysicians, artist-photographers, semioticians, political and social historians, and even rare lovers of painting.'[31] Despite its title, the painting is a penetrating self-portrait of the artist at work before an invisible canvas portrait. That he is painting King Philip IV and Queen Mariana is implied by their reflections in a mirror at the back of the room. The conundrum that lies at the very core of this profoundly compelling work, however, centres on the puzzle of their 'real' whereabouts within the unique spatial logic of the painting, alongside the mystery of what, if anything, is portrayed on the canvas upon which Velázquez is working. In this way, *Las Meninas* poses an utterly original question about how the visible world is presented, re-presented and perceived, in a complex, unending and constantly shifting dialogue between painting and viewer.

This magnificent palimpsest of pictorial illusion was, of course, known intimately to Muñoz: 'I think that a great painting is also a great fabrication. What you're looking at is an illusion ... This is our great tradition: the creation of space in painting.'[32] He was also aware that a detailed analysis of *Las Meninas* was used by Michel Foucault as a starting point in his groundbreaking 1966 essay 'The Order of Things: An Archaeology of the Human Sciences', which considers pictorial representation in relation to specific structures of knowledge. Foucault points out that Velázquez's work is one of the most powerful examples of classical illusionist painting, transforming the conventional idea of painting as an art of representation into an unprecedented 'representation of the representation', which makes the viewer more aware of the interpretative aspect of painting.[33] After so many attempts at explanation, however, the essential riddle embedded in the work remains unexplained or, to use pictorial terms, invisible. As one perceptive writer puts it, 'This is precisely what Foucault faces in his essay. He is actually looking for a space in which the Same and the Other can comfortably meet. That space is, as he puts it, the "non-place of language".'[34]

It is in this non-place that Muñoz locates his work: in the Borgesian zone of slippage between fact and fiction, translating it into the third dimension as a 'placeless place'. By choosing to populate his works with figures whose physical existence is extra-ordinary such as puppets, acrobats, animatronic figures, ventriloquist's dummies, dwarfs, dancers, as well as characters identifiable from the Middle and Far East such as Turkey and China, all of which have long been associated with the history of ancient magic and the arts of illusion, Muñoz deliberately plays upon the historical and stereotypical Western idea of the exotic. His project actively pursues an ahistorical definition of the 'other'. This is because his concern was how to resolve the challenge of representation: how to allow the figure to model a parallel reality and presence that opens up in us a new sense of consciousness and selfhood. As Thomas McEvilley put it, 'The search for the Other is a search for the newness of one's changing self.'[35]

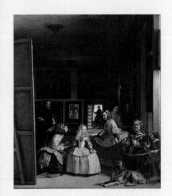

Fig 5 Diego Rodríguez de Silva y Velázquez, *La familia de Felipe IV*, or *Las Meninas* 1656, Museo Nacional del Prado, Madrid

**ABOUT THE ANONYMOUS IMAGE**. At the start of the 1990s, Muñoz began work on a series of 'conversation pieces', which for some have become his signature works. These figures are anonymous, with generic depersonalised features, clustered in attitudes of engagement. Like satyrs, their upper bodies are human, while their lower bodies are engulfed and weighted

by heavy spherical bases. Smaller than average human height, the figures are indistinguishable from one another apart from the position of their arms or their placement.

An early example of a work in this genre is the bronze *Listening Figure* 1991 (p.49), one of five figures displayed in a group, but set apart against the wall, where its anthropological gesture of straining to hear is given additional poignancy through its impossibility. Its relationship to the group has been likened to Seurat's painting *Bathers at Asnières* by writers quoting Muñoz's stated admiration for the way in which each figure in the painting is placed within its own space of silence.[36] The exception is the boy in the river, hands cupped in mid-shout – the drawing for which Seurat titled *The Echo*. The dramatic potential for sound, not just to infuse the scene evocatively but through its subsequent return as an echo, gives the painting a unique sense of a-temporality in relation to its space. Perhaps this is what Muñoz was attempting to achieve through the potential for hearing in *Listening Figure*.

*Listening Figure* calls to mind one of Muñoz's earliest works, *Oreja* 1984, a tiny painted-clay ear, hung on the gallery wall. It is also reminiscent of the maxim 'Be careful what you say; the walls have ears' – which may have derived from a story about Dionysius of Syracuse (430–367 BC), who had an ear-shaped cave cut to hear what was being said from another room. *Conversation Piece* 1996 (pp.66–7) comprises five figures, whose bulging material forms and surface have a crusty resin and sackcloth tactility. Their interaction with one another implies a mysterious exchange, involving, perhaps, a whispered secret, isolation, restraint and desire. But our speculation is in vain because Muñoz's figures are always self-absorbed, indifferent to the presence of the spectator: as we are drawn to their enigma, so we are simultaneously repelled. As Muñoz explained, 'You just have one material world to explain another material world, and the gap between is the territory of meaning.'[37] Both *Listening Figure* and the *Conversation Piece* figures have webbed eyes, like prominent visceral cataracts or vertical muscles, which recall Eliot's 'my guts the strings of my eyes'.[38] It is perhaps not just their self-absorption, but also this implication that they are literally blind to the world that adjusts our perception of their dynamic to another: the exploration of a meeting guided only by touch and sound.

By the mid-1990s, some of Muñoz's figures had become more human in form, their legs released from their weighty encumbrances (although still without feet). Cast from an Art Nouveau ceramic bust, all have identical physiognomies with Asian features and expressions suggesting laughter (fig.6). *Many Times* 1999 (pp.84–5), is a vast composition of a hundred identical figures, a drama-filled tableau of small intermingled clusters of actors, their smiling faces suggesting emotional engagement, the space between them as important to the psychological tension of the piece as their interaction. Most importantly, we observe that they act as mirrors to each other in the closed exchange of mutual unending reflection, repelling anthropomorphic empathy and heightening the sense of isolation in the viewer, who can walk amongst them as if invisible to their gaze.

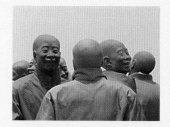

Fig 6 Juan Muñoz, *Many Times* 1999 (detail)

An archetypal device in the history of art to connote otherness (and one of Borges's best-loved motifs), the mirror often features in Muñoz's work, including *Five Seated Figures* 1996 (p.69), *Staring at the Sea* 1997–2000 (p.77) and *One Figure* 2000 (fig.7), one of Muñoz's last works. Like the discontinuity caused by the mirror in *Las Meninas*, where the spatial and perspective logic of the painting locates the king and queen in the identical external space where the spectator stands, the image with which we are confronted in *Many Times* is not our image but the image of Otherness in a Lacanian sense. It was Muñoz's contention that 'My characters sometimes behave as a mirror that cannot reflect. They are there to tell you something about your looking, but they cannot, because they don't let you see yourself.'[39] Muñoz's works create an encounter, similar to a confrontation with a mirror that constantly

alternates between self-recognition and a reflection of the Other. Like a conjuring trick, they offer a space in which Same and Other can meet in that non-spoken territory of meaning. It is the elusive, allusive and alluring re-presentation of representation, rendered by Muñoz in sculptural form, that can be seen as a compelling metaphor for a mirror of our consciousness.[40]

EPILOGUE. In the last interview that Muñoz gave before he died, he said: 'That is at the core of some of the best art of our time: the awareness of how things are done colliding with the way things appear. The making is fundamental to the illusion it creates. It is very surprising how we want to see something that does not exist.'[41] What Muñoz relies upon is our *knowing* suspension of disbelief – to enter voluntarily and momentarily into the illusion of his work without forfeiting self-reflexivity – with the possibility that engaging with its irreconcilable differences might bring us to a different realm of consciousness about ourselves and our place in the world. He regarded the architect Francesco Borromini as 'a master of deception',[42] adding that 'Many good modern artists are as skilful as the great old masters of the Baroque ... You have to make this person trust for a second that what he wishes to believe is true. And maybe you can spin that into another reality and make him wonder.'[43]

Shortly after he had made *Spiral Staircase* at the beginning of his career, Muñoz wrote that the helicoidal form of a spiral staircase, so expertly designed by Borromini, 'seems to rise at the same time as it drops and twists its geometric zero'.[44] *Spiral Staircase* embodied the potential of both descending and ascending movement in simultaneous motion, a phenomenon that Muñoz was to continue to explore in his small ballerinas, compressed into half-shell moulds to limit their mobility to spinning on the spot. Of these works he said: 'it was ... about endlessly moving, but always finding herself in the same space ... The work is both the solution and the search for it.'[45] He was still exploring this notion, in all its rich temporal, spatial and formal complexity, in his final grand opus, *Double Bind*. A stanza from Eliot's *East Coker*,[46] copied several times by Muñoz in his notebooks, describes not only the double-bind of the ballerina's predicament, but, presciently, a triumphant conclusion to the circular trajectory of his artistic life, as well as his living legacy:

Here and there does not matter
We must be still and still moving
Into another intensity ...
In my end is my beginning

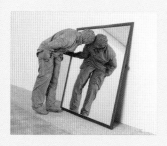

Fig 7 Juan Muñoz, *One Figure* 2000

# To Double Business Bound

MICHAEL WOOD

*'You have to come, to look, to despair and smile'*[1]
JUAN MUÑOZ

There are artists who remake or celebrate or extend the world, and there are those who more subtly, stealthily even, alter our perception of it, so that it will never look quite the same again. The members of this latter group may be very different from each other – I am thinking, for example, of Mondrian, of Borges, of Hitchcock – but the effect is very similar. The symmetries, the conspiracies, the apparent blandness of daily life come to seem haunted by a strange understanding – as if a great, secretive master had signed the banal facade in front of us, or the sad news story, or the empty street.

Juan Muñoz is such a master, and what he alters for us, what cannot survive a careful viewing of his drawings or sculptures or installations, is the notion of a single, unambiguous space or object. 'Everything could be other than it is,' Ludwig Wittgenstein wrote in the *Tractatus*. What Muñoz's work says to us, in a whole range of attractive and tantalising voices, is, 'Everything *is* other than it is.' If we look now at a photograph of Muñoz recording one of his works for radio, *A Man in a Room, Gambling* 1997, for example, with music by Gavin Bryars, it is hard to resist the thought that a man sitting at a table in a large room with a polished floor does not look different enough from a sculpted figure doing much the same thing in the same sort of place, the character seated at a table in Muñoz's eerie installation *Shadow and Mouth* 1996, perhaps (pp.74–5). It's not that Muñoz himself has become a sculpture; it's that the sculpture has begun to infect our idea of what a person is.

A balcony, a banister, a wall, a carpet, a floor, a room, a courtyard, a gallery, a bridge, a city roofscape, a car park, the vast Turbine Hall of Tate Modern: it's not just that each of these elements or places has a story to tell, it's that every story has a further story, and one that it will always fail to complete. That failed story is the one we can't forget. Sometimes Muñoz's scenes are empty – but full of what isn't there. Sometimes they are peopled, with a solitary figure, a pair of figures, a group of figures, a whole army of figures. 'Characters' is what he calls them, although they are usually bland and almost featureless, generically Chinese or generically proletarian, the reverse of the individualism the word 'character' often suggests. But they are characters in the precise sense that the creatures in Luigi Pirandello's famous play are characters, the reference Muñoz himself invokes when he says, 'My characters are … in search of an author.' When the interviewer pursues the point, though, Muñoz slips away. 'You talk a lot about Pirandello', Paul Schimmel says. Muñoz replies, 'He had this wonderful thin, long, narrow face. But I don't go to the theatre.'[2] The face is the play, so to speak, and it's striking that in his 1984 prose text *The Face of Pirandello*, Muñoz starts with the playwright and ends with the filmmaker Luis Buñuel and the idea of ordinariness, 'the moments in which nothing occurs'.[3] Except that there are no moments in which nothing occurs.

Actually, Muñoz's characters have an author, as do the characters in Pirandello. What they don't have is a play. They have wandered into this theatre (this room, this studio, this gallery, this museum) and found themselves frozen into gestural silence, their story having died on them. Of 'the drum as sculpture', meaning the several drums that recur in his work, Muñoz says it 'is an object which has left its reason behind'.[4] For just as Muñoz's empty-seeming works are implicitly crowded, so his peopled works have emptiness in them and around them, like an insidious draught or incipient malady. He himself is very clear about this: 'Perhaps the most successful things I have made have always been about something other than what you're actually looking at.'[5] Asked if he wants to show 'the emptiness' of a certain kind of despair, he says:

'You don't want to show the emptiness. You show the wish for it to be full ... I don't look back on the balconies as empty; they are about anything but themselves. They are images that are already there, already used ...'[6]

In other words, there are figures in the mind when there are none in the room. And when there are figures in the room, we need to remember its former and future emptiness, which Muñoz literally realised in the last section of his show at the Irish Museum of Modern Art in 1994, a patterned floor with no people. 'It was very important for me to have a non-figurative conclusion,' he said. 'To have one gigantic illusion so that there was nothing to look at but the illusion itself.'[7]

Yet there is always something to look at, even if it's only the floor and four walls. The balconies Muñoz evokes were an essential part of his early individual exhibitions, and they come in two forms: fragile, ephemeral-looking drawings, and elegant material objects made of wrought iron. Muñoz insists that his drawings are not 'illustrations' of his sculptures, and it's worth taking him at his word. In both drawings and sculptures the balconies are abstracted: they have (in most cases) no window or house behind them. It's not just that no one stands at them or looks down from them. No one could. They have been withdrawn from the world of human habitation. In the drawings they seem to have been graphically stolen and relocated, spirited away by sleight of hand. They are graceful and ghostly, faint humorous echoes of a Spain that had become tired of being so typically Spanish. As iron objects mounted on a blank wall they have quite a different effect. They are real but lonely, desperately useless, and the humour modulates into a kind of anxiety. We transpose our worries, in a version of the pathetic fallacy. We ask, not where have the people and houses gone, but how could a balcony bear to be so pointless, how could architecture live with such a loss of meaning? This feeling is particularly poignant in the case of the four *Hotel Declercq* pieces, where a single balcony is in each case situated just below the vertically placed letters H O T E L, also in iron (p.15). The solid name on the bare wall seems the material relic of a strange, helpless fantasy: a hotel without rooms or guests, and a town without streets. The solidity, we might say, testifies to absence itself.

'I'm surprised how some of the very early ideas implied in the balconies seem to have reappeared in this work,' Muñoz said in 2001 – he died later that year. 'This work' was his vast and haunting installation *Double Bind* at the Tate Modern (figs.11–13). 'It is very strange to perceive so many years later that I'm paying so much attention to the act of walking through the street and looking up.'[8] This continuing attention suggests we might think of absence and presence themselves as a kind of double bind, each constantly countermanding the other's instructions. We could then regard Muñoz's movement from a kind of minimalism to an apparently plentiful figuration not as a straightforward progression but as a complication of an inner dialogue, richly and repeatedly staged for himself and for us. The later figures, finally, are not fully figurative, but something like abstractions with affect. Lynne Cooke writes very well about the 'unaccountable hilarity' of Muñoz's 'Chinese' figures.[9] We can see they are laughing but we can't make a human story out of their laughter, any more than we can make a working hotel out of a few pieces of iron on a museum wall. 'There is something about their appearance,' Muñoz says of these figures, 'that makes them different, and this difference in effect excludes the spectator from the room they are occupying.' And again, 'They tell you that they wish they could do more than they do.'[10] They laugh, they wish: of course, they are human. Of course they're not human, first because they're sculptures and second because even as sculptures they're ciphers, mere allusions to humanity, not plausible imitations of the condition. Humanity itself is caught up is this play of presence and absence.

Fig 8 Juan Muñoz,
*Untitled (Triple Balcony)* 1984,
Private Collection

And if Muñoz's figures fall short of full figuration, then the notion of story-telling, so often associated with his work, needs a little revision. Muñoz himself describes his Tate installation as 'this ambiguous story', and his collection of notes, drawings and photographs called *Gatherings* is a sort of broken visual novel, elements of narrative in search of a plot, like characters in search of an author. Muñoz earlier said he was 'worried' by the accusation that he was tending towards literature, but then accepted the challenge and said he was indeed a storyteller. 'And though this answer first seemed a great leap, I am now gradually becoming used to the notion.'[11] On a different occasion he said, 'And when I first saw in writing that I had described myself as a storyteller, I realised that I might have crossed some bridge.'[12] This last sentence, incidentally, offers a fine small instance of the interplay of absence and presence. Muñoz doesn't say he is a storyteller or even that he had said he was: he says he read that he had said he was. He is his own other, and he has to believe what this version of the other says.

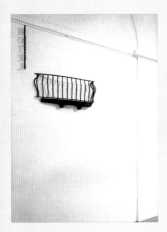

Fig.9 Juan Muñoz,
*Hotel Declercq I* 1986, Galería Pepe Cobo

But of course he doesn't actually tell stories, even when he writes prose. He creates fictions, but that isn't quite the same thing. His account of the fortunes of the statue of the Aztec goddess Coatlique, now in the Anthropological Museum in Mexico City, dug up and reburied several times from the eighteenth century on and more often invisible than not, takes the form of an account of a lecture by the Mexican poet Octavio Paz. Paz did write on this subject, but the lecture Muñoz evokes is his amiable invention. Yet the point here is not narrative: it is a question. What is the relation between the power – the horror, even – of this often hidden statue, and the statue of a general, say, which no one looks at and which 'possesses but one value: the one of not having allowed time to hide it from our eyes'?[13]

Similarly, the balconies contain stories, we might say, but do not tell them. And the installations with ballerinas, Chinese figures, workers, do not narrate: they present us with narrative conundrums, set us searching for the stories we can't do without and can't get into any coherent shape. The most balanced and explicit explorations of this state of affairs occur in the two pieces called *The Wasteland* 1987 (fig.10) and *The Prompter* 1988 (p.26), where the unreachable narrative is crossed with intimations of poetry and theatre too.

*The Wasteland* is a large floor of linoleum tiles, a multiple repetition of one of those optical designs that flip their orientation as you look at them, so that the bottom of a geometric shape, in this case a solid L, abruptly becomes the top of another. Nothing happens on the floor and nothing happens in your perception, but your mind rearranges a visual world. This was one of the Wittgenstein's later examples of what understanding is like. The floor is quite empty. At the far wall, sitting on a steel ledge, is the small bronze figure of a ventriloquist's dummy, looking not unlike a shrunken version of T.S. Eliot himself. What sort of wasteland is this, and what is the dummy doing on the shelf? He seems quite comfortable, and doesn't appear to be missing his master or the realm of speech. But he can't move, and we can't cross the geometrical floor to get to him. Do we want to get to him? What would we do if we reached him? Are we the speaker he is waiting for, the master who has abandoned him there? Why does his calm so disturb us? Have we ever thought that a simple floor, like a complex poem, could evoke the regimented horror of modern life, that sense of the living, marching dead, that Eliot evokes through the brilliant collocation of City businessmen and Dante's limbo:

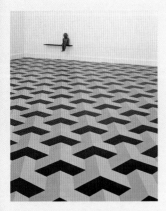

Fig 10 Juan Muñoz, *The Wasteland* 1987, Collection of Elayne and Marvin Mordes, Palm Beach Florida

'A crowd flowed over London Bridge, so many,
I had not thought death had undone so many.'

One could ask quite different questions, grasp at other stories. The point, here as elsewhere, is a double one. We can't begin to respond to this installation without conjuring up some kind of story. The story starts in us as soon as we start looking. Muñoz is a storyteller, as

he says. And the story we conjure up will always end in a puzzle, an urgent helplessness of mind and heart. As a character says in Kafka, 'The text is unalterable and opinions are often only an expression of despair over that fact.' The installation, once unpacked and set up, is unalterable. The figure sits and smiles. The floor stretches out. We reach for another story. Muñoz himself, in conversation, expresses the logical double-bind both casually and clearly. 'I build these works to explain to myself things that I cannot understand otherwise. The work should somehow remain enigmatic to me.'[14] Once we have even half understood how an enigma can be an explanation, we are a long way into Muñoz's world; and our own ordinary world, as I have suggested, is already not what it was.

Fig 11 Juan Muñoz, from *Gatherings*, *Double Bind at Tate Modern* 2001

We have quite a lot of background for *The Prompter*: a prose piece by Muñoz, a small-scale study-model built of wood, prompting many discussions. The final installation shows another linoleum floor of optical patterns, this time triangles and squares, and raised about two feet from the ground, with its metal supports fully visible: a stage making no effort not to seem a stage. There is nothing on the stage except a tilted drum at the back, close to the right-hand corner. The tight surface of the drum repeats the geometrical pattern of the floor. At the front of the stage is a prompter's box, a wooden cowl that looks like an old-fashioned radio from the back. Standing on the floor, facing the stage, his head in the box, only his legs and half his back visible, is a greyish-white papier-maché dwarf. 'That must have been what I said,' Muñoz declares in the prose piece, remembering a perhaps imaginary conversation. 'A house where there is only a hole ... and in it, living in it, a standing dwarf, immobile ... I mentioned ... that in the square of the Xemaa-el-Fna some storytellers say they can recite the Koran by heart ... No, it wasn't like that, now I remember ... There is no audience nor work, there is only a spectator placed in the centre of the scene, immobile, suspended, trying not to forget something.'[15]

Two features of the finished installation capture precisely the uncanny, contradictory qualities of this 'memory'. If we approach the stage, bend over and peer round into the prompter's box, we notice at once that the figure, now not noticeably dwarf-like, has no eyes and no text. He can't prompt anyone, not even himself. Unless, of course, he knows the text by heart. But even then there are no actors and no play; only an orderly expanse of stage and unused drum, a drum 'which has left its reason behind', a vestige of an old circus or parade.

Fig 12 Juan Muñoz, from *Gatherings*, *Double Bind at Tate Modern* 2001

Muñoz is very taken with the idea, found in both Borges and Benjamin (and Proust), that forgetting is a form of memory – perhaps the only real form of memory, since the rest is just the wilful, conscious work of our intelligence. 'When I made *The Prompter*,'he says, 'I wanted to make a house of memory, the mind you never see but that is always there. It is a little like the theatre of Giulio Romano or Giordano Bruno ...'[16] If we think of the satirical Daumier lithograph that has been suggested as the source for *The Prompter*, we can see the distance Muñoz has travelled towards this theatre of the mind. Daumier's picture shows Thiers, the President of the Third Republic, comfortably installed in the prompt box, script firmly held in both hands, although at the moment of this vision his mouth is closed. He presumably tells politicians and people what to say whenever they forget their lines, although he himself gets his lines from a book. This is not a house of memory; it's a working ventriloquist's show.

One of the most appealing things about the materials brought together in the assembly Muñoz called *Gatherings* (figs.11–13) – photographs of fans, bridges, roofs, churches, sketches of shafts, boxes, holes and blinds – is that they evoke the installation *Double Bind* without, in most instances, having very much to do with it in any literal or representational sense. They are what Muñoz calls 'the habitual errors along the way'.[17] But he kept them, and was

willing to publish them, because the errors were not only errors; they were also part of the way, and would have to be for an artist so devoted to giving us something to look at while getting us to remember what we never see. *Gatherings* is the visual equivalent of a Borges story; an allusion to a work that is elsewhere – although the enigmatic allusion is itself a delicate work, not just an 'illustration' or a practice run.

And *Gatherings* allows us to see – which was in fact where this essay first began for me – what the ventriloquist's dummy and the prompter and so many of Muñoz's other figures are doing. They are enacting, holding in front of our eyes, not only the absence that lurks in every presence, but the stasis and the silence that are the secret twins of movement and noise. They are creatures from the world of speech – their only habitat, their only reason – but they will never speak. They are not waiting to speak. The dummy knows the master will not return, perhaps knows there never was a master. That is why he is so calm, that is why he is smiling. The prompter will never remember the non-existent play, never jog the memories of the always absent actors. But these abstracted human instruments, these implements of lapsed speech and failed memory, do have a lasting vocation. If apparently empty balconies 'are about anything but themselves', then these theatrical figures, these storytellers lost inside their own untellable stories, are about everything they cannot do: they mutely signal to us about nothing but that. The show that can't continue is also a show that never stops.

Fig 13 Juan Muñoz, from *Gatherings*,
*Double Bind at Tate Modern* 2001

ABSORTION
AND
THEATRICALITY

# Muñoz's Sculptural Theatre:
## 'the gap in-between is the territory of meaning'

ALEX POTTS

Muñoz was one of several artists who, in a series of ambitious works that caught the public eye in the 1990s, effected a curious, theatrically orientated return to figurative sculpture. For these artists, the vividness of the human scenario confronting the viewer was of more concern than any formal issues traditionally associated with sculpture. Modernist or post-modernist anxieties about the status of the sculptural object and about the viability of figuration were largely irrelevant to the sculptural projects in which they were involved. With Muñoz's work, as with the sculptures of several German artists who at this point were similarly experimenting with renderings of the human figure, such as Katharina Fritsch, Thomas Schütte and Stephan Balkenhol, or with the manikins of the American artist Charles Ray, the distinctive presence of the figure and its effectiveness as image was of much more significance than any concerns about the internal formal structuring of its shape. Muñoz took this tendency to the point where his work was not so much sculpture as a conflation of theatrical stage, architectural space – whether room, threshold, or street – and sculptural figure (see p.84–5). At the same time, he insisted that his work was not literally to be identified with theatre, any more than it was to be thought of as straight-forwardly sculptural.[1] The term 'theatricality' as applied to his work, he suggested, should designate 'something that doesn't necessarily deal with theatre itself'.[2] This complex engagement with the theatrical lies at the core of Muñoz's art. The intensity and self-aware-ness with which it is played out in his case is exceptional, even when seen in the context of his contemporaries' similar experimentation with new kinds of sculptural mise-en-scène, and is integral to the affective power and larger cultural significance of his work.

The somewhat unsettling combination of theatre and sculpture in Muñoz's work produces a scenario where action and stasis, and presence and void, vie with one another. Sculpture and installation, however, was not his only arena of activity as an artist. He exhibited a number of drawings, most notably the 'raincoat' drawings (pp.30–43), and on several occasions accompanied his sculptures with carefully crafted texts, as well as more informal commentary elicited from him in interviews. He thus invited the viewer to specu-late about the broader significance of the depersonalised yet also suggestively real constel-lations of figures and spaces he created by taking into account his work in various different media. To get at the realities, psychological, cultural and socio-political, his work might be evoking, we need to take a broad view, and consider the interplay between these different arenas of activity. As was the case with a number of twentieth-century artists, his artistic project realised itself across several different registers, verbal and non-verbal. The point, though, is not to interpret the aspirations, ideas and fictionalised realities he conjured up in his writings as a key to understanding the effects created by his sculpture. Rather, we need to be mindful of the interplay between the two. Meaning is generated by way of both disparities and affinities between the different registers in which he operated. Muñoz once commented that the significance of art was generated not so much in the artwork itself, as in the gap between the realities of art and the realities of the world outside. 'You have one material world to explain another material world, and the gap in-between is the territory of meaning,' as he put it.[3] We might also look for the meaning generated in the gaps between the empty rooms and thresholds depicted in his drawings, and the populated spaces of his sculp-tural work, or between the aspiration to calm and relative stillness articulated in his writing, and the edginess and absence of composure that prevail in his three-dimensional creations.

## Mise-en-scène

The frequent references to theatre, theatricality and mise-en-scène in Muñoz's discussions of his work are always double-edged. Clearly theatrical effect was a key factor for him, something made quite explicit in an early piece, *The Prompter* 1988 (p.26). Significantly, though, the stage in this work is empty, and the one figure has its back to the viewer, and like the viewer is focusing on what might happen on stage, even as nothing ever does. In another theatrical scenario, *Towards the Corner* 1998 (pp.78–9), members of an audience sit watching and reacting to an invisible performance, either with their backs to us or facing us, depending on where we stand. In neither of these works are the figures acting out a part on stage, though they are in a way 'characters', as Muñoz himself calls them. He suggested that his scenarios might function for the viewer, less as theatrical performances to be looked at than as situations that throw the viewer into the position of being 'the object', 'the one who is on view.'[4] Unlike the spectator watching a theatrical performance, the viewer approaching a work of Muñoz's in a gallery is projected into the same space as the sculpted figures, and is made very aware of his or her positioning in relation to them, including the sense of being excluded, or ignored – an effect not to be had in the theatre, sitting in the dark, set apart from the performance unfolding on stage.

There was one aspect of a theatrical model of how a spectator is situated in relation to a performance, however, that served Muñoz very well. While expressing unease over his work being talked 'about ... in relation to theatre', the idea of theatre for him carried the compelling implication that the spectator felt excluded from the scenario being staged. As he put it: 'You're watching what's taking place, but you cannot answer back ...You cannot collaborate in it.'[5] 'There is something about the appearance' of the figures, he also suggested, 'that makes them different, and this difference in effect excludes the spectator from the room they are occupying.'[6] This difference is brought home to the viewer through the theatrical staging, as well as the figures' artificial, monochrome 'sculptural' colouring, their slightly diminutive scale, and sometimes too the absence of feet or even legs, and the abstract anonymity and otherness of their features – his use of generic Chinese features playing upon a stereotypical Western idea of otherness. The viewer is thus made to feel that the figures exist in a world apart from him or her, in some cases quite literally so, because they are high up on a balcony or ledge (pp.22, 45). Like an earlier generation of Minimalist sculptors who were particularly attentive to the interactions their work set up with a viewer, he was deeply antithetical to the idea of participatory interaction, and for all his fascination with staging social dynamics and their failure with arrays of figures, he steered well clear of relational aesthetics.

A number of Muñoz's contemporaries similarly exploited this play on the affective immediacy of theatrical staging and the clear psychological separation it establishes between viewer and work. While the stance and gestures and proportions of the figures these artists created are realistic, the figures present themselves as insistently 'other' through striking disparities of scale, as in Charles Ray's over-life-size power-dressing female figures,[7] or highly artificial, often monochrome colouring, as in Katharina Fritsch's famous satirical trio of human types, the *Dealer, Monk* and *Doctor* (fig.15), or associations with mannequins and replicants, such Thomas Schütte's metallised aliens that seem to have stepped out of a science fiction film (fig.16). There is a double take, in that the figures look very like living persons and yet also feel categorically different from them. They are posed in such a way that they seem staged for the viewer, while at the same time refusing any possibility of reciprocal interaction. The effect is rather different from that created by traditional classicising figurative sculpture. The theatricality annuls the centredness and suggested composure or self-absorption of the classical figure, and also disrupts the smooth interplay

Fig 14 Katharina Fritsch,
*Tischgesellschaft [Company at Table]* 1998,
Museum für Moderne Kunst, Frankfurt
am Main, on permanent loan from
Dresdner Bank

Fig.15 Katharina Fritsch,
*Händler [Dealer]* 2001, Katharina Fritsch,
Düsseldorf: Courtesy Matthew Marks
Gallery, New York

posited by traditional sculptural aesthetics between the viewer's gazing at a sculpture as an object and identifying or empathising with it as a 'being' or 'presence'.

Muñoz's figures in particular preclude empathetic response. This is not just because of the 'otherness' of their appearance, and their somewhat theatricalised staging. It is also because their static forms represent contingent, passing gestures and stances rather than anchored states of being, in the same way that the spaces or 'rooms' in his works are more like temporary or momentarily glimpsed stage sets than they are places of 'dwelling' in the Heideggerian sense. The images conjured up by his figures are closer in character to the immediately recognisable summarily drawn figures in caricatures and illustrations than they are to the grounded, relatively autonomous beings or shapes of Western sculpture. There are, however, affinities with the gesticulating figures installed on the facades of many late Baroque buildings, or appearing in a flourish on tombs of the period, before a Neo-Classical aesthetic gained ascendancy.

The figurativeness of Muñoz's work was thus far from marking a return to figuration in the traditional sense, or to the possibility of a humanistic identification with the figure on the part of the viewer. Muñoz made a point of asserting that his figures should be seen as being 'like statues, not sculptures',[8] staged so as to make it impossible 'to connect to them on an intimate basis.'[9] The effect, though, was no more modernist or minimalist than it was traditionally figurative. Neither did it have much to do with the body politics of postmodern work, nor with the everydayness or uncanniness of the life casts of such artists as Duane Hanson. It had more of a social character – albeit a distinctively modern one betraying a lack of substantive social bonding – than most modern sculpture. This is particularly evident in the later works where groups of figures are assembled in relatively unstructured collective situations, and interchange between them takes the form of dispersed, intermittent networks of social interaction (see pp.66–7, 84–5).

The disconnection from the problems of traditional sculptural aesthetics, evident in Muñoz's comment that he 'was never interested in the physical form and the formal problems of sculpture as such,'[10] was quite widespread at the time. Katharina Fritsch explained how for her, conjuring up a telling picture in three dimensions was more significant than making something specifically sculptural: 'I am less concerned with sculpture than with the third dimension. Of course I have to abide by all the various laws of sculpture, but actually I would like to forget all these and just make three-dimensional pictures.' For her, then, effective installation was not so much about creating environmental and spatial effects through the siting of a sculpture. What mattered most was the picture being conjured up when the sculpture was staged in a particular setting.

Aesthetically, if not literally, what was being presented to the viewer then was more in the nature of a picture than a sculptural object. In fact she liked to think of the installation of her sculptures in exhibitions as forming not a 'sequence of works' but 'one large picture'.[11] Her 'picture' was akin to Muñoz's theatrical scenario, with Muñoz being more attentive to the specifically theatrical aspects of how a work confronted the viewer. Even so, the pictorial cast of Fritsch's imaginary is echoed in the central role that pictures play in Muñoz's comments about the art that fascinated him, namely his interest in the staging of the figures in Seurat's *Baignade* and what he saw as the uncanny compression of space and time in the empty city squares of De Chirico's paintings.[12]

Minimalism and post-Minimalism was obviously one precedent for this shift from a modernist focus on the sculptural object to the effects created when a work was staged in its setting, so that figure and ground, or figure and mise-en-scène, became equally significant. However, the focus on the image and the psychological impact of a quasi-human

Fig 16 Thomas Schütte
*Grosse Geister nos.4, 5* 1997, *no.14* 1999,
Collection De Pont Museum, Tilburg

presence takes this work out of the ambit of Minimalist-inspired work, as does the absence of unease over figuration that Minimalists inherited from high modernism. What Muñoz found compelling in the work of the Minimalist generation and their immediate successors was not the objects but the environments they created. For him, Judd's 'most important creation was not the rectangular sculptures placed in the middle of a museum'. It was, rather, the 'gigantic environmental display' at Marfa.[13]

Possibly one of the more direct sculptural precedents for Muñoz's approach to figuration was Giacometti's work of the 1940s and 1950s – both the single figures (fig.17) that present-day curators often arrange in quasi-theatrical ensembles, and the informal groupings of small figures on a base (fig.18). Muñoz was clearly fascinated by Giacometti's representations of the human figure, at one point commenting in some detail on his distinctive rendering of the look of the eyes.[14] Giacometti's famous cipher-like standing female figures share the anonymity of Muñoz's male figures, and similarly set up an unsettlingly ambiguous interaction with the viewer. They are immediately striking stage presences – they are not in any way turned inwards or self-contained – but at the same time they set themselves apart from the viewer, projecting a possibility of interaction that they consistently refuse. They mirror the viewer, but their slender shape and non-human scale, either less or greater than life-size, unsettle the mirroring effect and block empathetic identification. While there is something undeniably modernist about their strictly similar format, they are also all different from one another, being endlessly and almost arbitrarily variegated. The figures may at first seem to have the same basic overall shape, but when looked at closely, they never quite possess a definitive, clearly articulated form. The modelling interrupts and clogs their slender upward thrust of armature, and one is blocked from seeing them as fully graspable sculptural shapes.

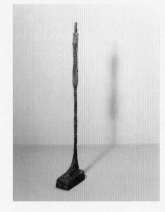

Fig.17 Alberto Giacometti *Standing Woman* 1948–9, Tate. Presented by the artist 1965

What is striking above all about these figures is not some inner formal structure with which they might be loosely endowed, but their effect as presences, and their activation of the space around them.[15] Of course, they are not realistic or illusional in the way Muñoz's figures are, and all suggestion of anecdotal gesturing is effaced. As such they still belong to a very different, modernist, artistic culture. At the same time, they do function as affective presences, whether singly, facing the viewer, or as small-scale ciphers grouped together, sometimes combined with striding male figures in ways that evoke the empty yet voided public spaces of the modern city (fig.18). As such they have prompted volumes of writing about their 'Existential' identity as images of a distinctively contemporary human condition – ciphers of isolated alienation, or of pared-down bare life, or of a damaged humanity in the aftermath of the Holocaust – that disrupt their artistic status as formal exercises in non-naturalistic figuration. Even their apparent centredness or autonomy is unsettled by their staging on sloping bases, and by the constantly shifting sense one has of how close or far away they are. Focusing on their narrow forms as one approaches them creates a curious sense that they are slipping away, receding into the distance, while glimpsed from further away, they can assert a presence that momentarily brings them close. However, if one can argue that in Giacometti's case there is a certain theatricality in the staging of the figure, it is one in which the stage set exists in the mind's eye. Muñoz by contrast configures the gallery space as a stage set, often adding props to make the illusion more complete. He differs in this respect from contemporaries such as Katharina Fritsch and Charles Ray, who, like Giacometti, do not devise such fully materialised scenarios, and rely on a figure's presence and the vivid image with which it confronts the viewer to activate the theatrical illusion.

The theatre as an art form is not designed primarily as a platform for the staging of single characters but as an arena where different characters interact. It is this social aspect

of theatre that is brought into play in Muñoz's work, and makes it different, not just from the single figures, but also from most of the more pictorially conceived figurative ensembles by other artists of the period. Theatrical scenarios of the kind Muñoz created tend to occur more often in small-scale works, such as the groups of figurines Giacometti devised, arrayed together as if impervious to human interaction and isolated in their own worlds, or Thomas Schütte's *Grosser Respekt* 1993–4, a miniaturised scenario of people gathered around a public monument whose looming, gesturing forms fail to engage their attention.[16] Muñoz's groupings of figures in his later work stage clearly recognisable, generic social situations; people hanging around in a courtyard (pp.84–5), or sitting together on a raised bank of seats watching a performance (pp.78–9), or seated expectantly in what seems to be a waiting room (p.69), or engaged in an informal public conversation, haphazardly exchanging comments, milling around and listening out for something (fig.19). While these are social situations, however, they are asocially social, lacking in galvanising moments of collective awareness, the figures situated so they either seem isolated, despite being assembled together, or momentarily caught up in random interactions that fail to add up to anything. Such scenarios clearly bear the imprint of a contemporary social reality, and do so more concretely than the vague evocations of void and social alienation found so often in modern art and literature.

## Thresholds

Muñoz's fascination with the affective power of certain generic spaces and social scenarios did not just play itself out in his sculptural work, but also plays a key role in his drawings and writings. His efforts in these different media inform one another in suggestive ways, though as much through the disparities between them as through their affinities. Muñoz's commitment to working in each of these registers of artistic activity is integral to his larger project, and our understanding of it must similarly negotiate the images and preoccupations that his different practices bring into focus. Muñoz himself made this clear when asked to comment on the relation between his raincoat drawings and his sculptures. He explained that the drawings ought to be regarded as separate entities from the sculptures, otherwise they 'would be like illustrations'. At the same time, they constituted a body of work that formed 'part of a larger discourse', to which the sculptures also belonged. When he commented: 'I do not find it necessary that sculpture should be a free-standing object,'[17] the implication at several different levels was that his sculptures were not simply to be seen as standing on their own.

His raincoat drawings, images of rooms and spaces divested of human presence (pp. 30–43), may at some level seem the antithesis of his sculptural creations. However, the distinction is not so clear-cut. They represent spaces that, while literally empty, also feel temporarily evacuated, either silently awaiting occupation or registering the presence of vanished occupants, furnished as they are with tables, beds and chairs, and configured as the rooms and passageways of some 'inhabited' interior – even if in their insistent sparseness and absence of living clutter, and their black tonality, they are hardly places one would immediately think of as home. They are, as Muñoz put it, both 'extremely normal' and 'discomfiting'. While they are devoid of human presence, they are not in his view to be experienced as entirely empty, but rather give 'the sense that something has happened or is going to happen'. What intrigued Muñoz was the image of a vacated room or space, activated by the expectation that something might be about to happen there, but also deactivated by the awareness that nothing was actually going on. Trying to characterise this effect, which he suggested informed his sculptural work as well as his drawings, he said

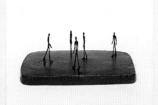

Fig.18 Alberto Giacometti,
*City Square* 1948, Museum of Modern Art,
New York

it was 'about waiting, waiting for something to happen that might never happen; on the other hand afraid it might happen, or even wishing it would never occur ... Like watching a door which one day a person might open.'[18]

Such a complex shifting of responses would not necessarily occur to one, were one only looking at the drawings. In the first instance these would probably first suggest an uneasy emptiness and calm, as if they would remain forever unoccupied, a place no one would enter, where the furniture would always be unused, fitted neatly into the spare rectilinear geometry of the black-walled rooms and passageways. The viewer would need to bring to her or his view of the drawings a predisposition to imagine human presences potentially activating the depicted spaces. After looking at Muñoz's sculptures, however, the compulsion to project a human presence entering into the strangely de-substantiated rooms of the drawings might gather force. Equally, moving from the drawings to the sculptures might bring a sense of haunting emptiness to the scenes populated by the awkwardly animated figures. What does emerge very directly from the drawings, though, is the image of 'that space between', of 'the threshold'[19] that plays a key role in Muñoz's writings. The spaces the drawings represent are never fully enclosed, being either themselves passageways or points of transition from one room to another, or punctuated by doors and windows that lead to some outside space without giving the observer a view of it. Finding oneself on thresholds between the different scenarios conjured up in the various arenas of his practice as artist and writer, as much as between the different kinds of space evoked within any one of these arenas, then, is central to understanding his larger project.

Interplay between his writing and his sculpture was often staged by Muñoz himself. Illustrations of his work in the catalogue of a major retrospective held in 1992 in Valencia were interleaved with a series of Beckett-like dialogues, dialogues of miscommunication and failed understanding that he had assembled,[20] which include interchanges such as this fragment:

'What did you say?'
'I didn't say anything.'
'You never say anything. No. But you keep coming back to it.'[21]

The tenor of such interchanges is echoed most closely not in sculptural scenarios he created – aside from the work *Stuttering Piece* 1993 (p.44), that incorporated this piece of dialogue – but in the fictional scenario he conjured up in a slightly later essay on Pirandello. In this he mused on a kind of room he aspired to create that would be: 'Without hope, full of irrefutable rain falling on an indifferent conversation,' a very normal one in which only the most inconsequential interchanges took place.[22]

The catalogue of the exhibition of his work held in 1991 in Krefeld included the text of his most ambitious piece of writing, 'Segment', here given the German title '*Ein Raum und eine Geste*' [*A Room and a Gesture*].[23] This piece of fictional writing presented itself as a report analysing a ceremonial structure called 'la posa', supposedly discovered by an anthropologist in a remote village in the Peruvian highlands. The posa as characterised by Muñoz was an 'ideal' space of empty calm, where almost nothing happened, and what did happen was intangible, elusive and seemingly inconsequential. It was a temporary structure, a basic frame made of small logs and sticks, that lacked walls and ceiling, situated in a space always a little away from the centre of the village square. No ceremonies were held here, but individual inhabitants would enter it from time to time and temporarily withdraw from the life going on around them. 'Upon entering the posa,' Muñoz explained, 'the Peruvian peasant restores the dignity of being in a place where nothing happens to him and where nothing

occurs'. The building also 'allows the immobile occupant to be in the place of comings and goings, that is the negation of movement and at the same time a generator of pathways.'[24]

Several key metaphors govern his image of this impermanent, yet endlessly reconstituted, and mostly empty but intermittently occupied, space. It is a room, as he put it, 'that accommodates the tensions between the suspension of the human presence and its possible appearance.' At the same time, while marking an enclosure, a room, it is also open, a 'place of transit. Crossroad. Space inscribed in its own exile. Interval.' And finally, it is a space where it might be possible to realise a fragile state of ever-expectant desire, 'a room where the next moment is eternally delayed, indefinitely postponed. A room where a future, forever to come, never takes place,' suggestive of 'another room, another place where something vertiginous might occur.'[25] This quasi-utopian space in which it is momentarily possible to suspend everyday dualities between presence and absence, between open spaces animated by incessant transit and movement and closed-off spaces where everything is still, invites comparison with the rooms and interiors represented in his raincoat drawings. However, in the latter, absence and emptiness and stasis dominate, rather than a utopian atmosphere in which the calm and quiescence would not just be empty and lifeless, but would somehow be imbued with the fullness of existence associated with actions and events.

The scenarios conjured up in Muñoz's sculptural installations are even more at odds with the posa's poised suspension of the dualities and pressures of everyday life because of the insistent presence of the figures and their slightly edgy, often unresolved and somewhat awkward gestures. The spaces found in some of the environments Muñoz created, such as the streets of *A Place Called Abroad* 1996, are too claustrophobic and unsettlingly vacant – the windows are blocked and there is no sky – to evoke the posa's calm and quietly anticipatory sense of absence. Perhaps the suspended animation of the conversing figures of *Many Times* (pp.84–5), particularly in the installation photographed in Muñoz's studio looking out from the threshold to the blinding light outside, has more in common with the fictive scenarios conjured up in his essays on the posa and on Pirandello. However, the tenor is still rather different. In *Many Times*, one is presented with a fairly animated, if free-floating multiplicity of gestures and interactions, frozen rather than gently suspended in time. The effect is of arrested animation rather than a calm poised between animation and stillness. The sculptural scenario is very real to the extent that it refuses a fantasised resolution between Eros and Thanatos, between the restless animating impulses of the life instincts and the inert quiescence sought by the death instincts. More importantly, such a quasi-utopian resolution is made impossible because of the concretely social character of the scenario being staged.

The residually edgy human animation is at odds with the metaphysical aura that haunts the emptiness and alienation of Beckett's dramas, and has more in common with the inconsequential, yet oddly charged, atmosphere of the conversational interchanges in Pirandello's plays. These keep veering from ludicrous, low-key banalities to random heated outbursts, as in this discussion in *Six Characters in Search of an Author* between the 'real' producer and the 'fictional' father who has wandered into the rehearsal looking for an author to stage his character:

PRODUCER: You are more real than me?
FATHER: If your reality can change from one day to the next ...
PRODUCER: Of course it does! That's obvious! It's always changing. Everybody's is.
FATHER (*raising his voice to a shout*): But not ours! Not ours, do you see? That's the difference! It doesn't change, it can't change, it can never be different, ever, because it's fixed, as it is,

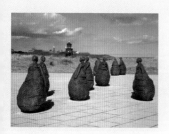

Fig.19 Juan Muñoz, *Conversation Piece*, installation, South Shields, 1999

once and for all. We are stuck with it, sir; and therein lies the horror: stuck with an immutable reality. You should find our presence chilling.

PRODUCER *(suddenly facing him squarely, struck by an idea which has just occurred to him)*: What I'd like to know, though, is: who has ever heard of a character stepping out of his part and holding forth about it like you do? ... Who has ever heard of such a thing? [26]

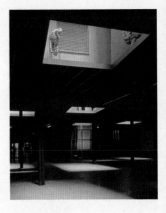

Fig 20 Juan Muñoz,
*Double Bind* 2001, Tate

Muñoz's last major work, the installation *Double Bind* commissioned for The Unilever Series at Tate Modern in 2001, proposed a kind of modern posa in the form of the darkened underground area beneath a raised floor inserted into the Turbine Hall (fig.20). On entering the area, though, one had a sense, not of utopian repose, but of something insistently contemporary, unsettlingly empty, claustrophobically cut off from the bustling spaces of the public areas of the gallery, rather than offering a welcome quiet and respite from these. Muñoz spoke at considerable length about what he saw as the connotations of the space:

'This kind of anonymous space, a sort of extended underground like a car park, is very familiar to us all. It is a space of our time. It is never nighttime and never daytime ... and it could be almost anywhere in the world. These kinds of architectural spaces are very recent. They are a condition of our modernity ... It's the lack of identity that makes them so interesting. But they are still emotionally loaded, even if they are anonymous. The important thing is that they are spaces of transition. Of passage, to be used and then abandoned. No one stays for longer than they need to. No one seems to own them, there is no sense of responsibility for them, no desire to make them more than they are. They just exist down there.'[27]

It is interesting how many of the features of the posa are echoed here, but to rather different effect than in Muñoz's written piece on the subject. In addition to the fact that such an underground space is uneasily oppressive and empty in character rather than open and transparent, like the posa, the possibility of achieving a suggestively empty, calm absorption standing in the darkened lower level of *Double Bind*, and finding the contending pressures of everyday life momentarily suspended, was also precluded by the presence of a largely hidden population glimpsed as one looked up through some of the skylights. Standing on the ledges surrounding several openings in the ceiling were anonymous figures slipping away into hidden interiors, or engaged in seemingly mundane actions and gestures whose purpose one could never quite decipher. A whole alien population, largely invisible, yet, once seen, creating a slightly unsettling if also intriguing presence, inhabited the non-space between the ceiling of the underground area and the floor of the open hall above.

An association might be made with the workers trapped in the underground city in Fritz Lang's film *Metropolis*, or with the Morlocks in H.G. Wells's *Time Machine*, who figured as the mutant descendants of the oppressed working population of Wells's time. But there was a casual everydayness to the dispersed and seemingly uncoordinated activities in which Muñoz's figures were engaged. The world they inhabited, situated on the threshold between the dark underground area and the well-lit open space of the hall above, was very different from the oppressive and frightening spaces conjured up by Lang and Wells – subterranean imprisonment on the one hand, and menacing underground barbarism on the other. Theirs was an otherness that could not be reduced to threat or object of pity or curiosity. Nor were they aliens. This relatively uncategorisable otherness might be associated with the awareness many visitors to the Tate would have of inhabitants of the modern city not visible in the gallery, living on the other side of some ill-defined but insistent class or ethnic divide.

Moving back above, where one looked down on the artificial floor inserted into the Turbine Hall, there was a sense of being released into open space, if somewhat disturbed

by the optical ambiguity of the large black rectangles creating a pattern on the floor below, with some marking the openings of the skylights into the underground area, and others fake, just painted on (fig.21). The anonymous population of grey figures remained completely hidden from view. The only animation in the empty space one surveyed was provided by two lifts, emerging from and disappearing into openings in the floor, caught in a kind of double bind as one went down while the other went up, both completely empty. The contrast between the static setting and the movement of the lifts played out a duality that Muñoz saw as central to his sculptural project, between 'stillness' on the one hand, and the 'representation of movement and gesture' on the other. He described the lifts as 'encapsulating movement, but in a suffocating way.' At the same time, he aspired to 'find a place' for his sculpture 'between stillness and movement.'[28] In *Double Bind*, this space was both a threshold and a state of confinement, where the suggestions of animation the figures imparted did not fuse with the stillness so much as slightly unsettle it.

Muñoz's project, seen as a whole, did open out, through his writing, to utopian impulses that informed the modern artistic imaginary, such as the phantasy of an 'ideal' art whose stillness, and removal from the drives and tensions of everyday living, would not be hollow and escapist, but infused with intimations of movement and life. At the same time, he made it clear that the contradictions and material resistances such utopias sought to transcend would not go away, and he pointedly reinstated them in the scenarios he created with his sculptures. As he put it, 'You don't ultimately try to transcend the physicality of experience. Being in a given room, you receive a given experience.'[29] Because of the social, or asocially social, character of the groups of figures and spaces he devised, this insistence on non-transcendence was far from being an abstract principle, but had a concrete ethical and political dimension. The 'given experience' he was talking about had to do with the actual fabric of social interaction and alienation as experienced in modern urban spaces of habitation, circulation and encounter, spaces Munoz skillfully theatricalised in a way that was both vividly fictionalised and resonantly real.

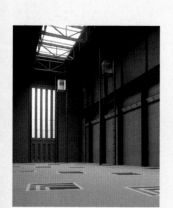

Fig.21 Juan Muñoz,
*Double Bind* 2001, Tate

# Juan Muñoz: Insights and Interpretations

MANUELA MENA

All dialogue with Juan Muñoz came to an end in August 2001. His death marked his entry into the History of Art, which had been so important for him since his formative years in Madrid. His voice has been silenced but his statements addressed to critics, curators and indeed his public are essential to any understanding of his work. One is particularly illuminating: 'The more realistic sculptures are meant to be, the less interior life they have'. He wanted the disturbing relations between his 'creatures' to remain mysterious: the silences, conversations and whispers, the meaning of the words spoken or heard at the wall on which they lean and the interrogation before the mirror. As with the great compositions of Velázquez, the spectator is disconcerted by the mystery and brooding suggestion of his works – such as *Last Conversation Piece* 1994, *A Place Called Abroad* 1996, and *Many Times* 2000 (pp.84–5). Disconcerted, for example, by the hilarity of the characters in *Towards the Corner* 1998 (pp.78–9), in which seven smaller than life-size male figures sit on makeshift tiers as if at a circus, laughing at the events unfolding before their eyes. Here the spectators feel themselves observed and ridiculed by the sculpture that they are seeing. In contrast, in Velázquez's *Las Meninas*, the figures behave as if actuated by what lies before them and therefore outside the space created by the artist, discomfiting and frustrating the spectator, who cannot enter the now remote occluded world of the artwork.

Laughter recurs in *Three Laughing at One* 2001, one of the last works Muñoz created before his death (fig.22). It exemplifies his ideas. The three figures are situated high above the viewer and their lofty thrones mark them out as special and superior. Their laughter is not a sign of joy but arises from their absurd or sinister thoughts; this again elicits a sense of disquiet in the observer. The three characters, timeless in the wilful ambiguity of their clothing, remain in this case in their own world – as so often with Muñoz – neither entering into a relationship with their spectators nor allowing them to participate in their laughter. Their appearance gives no clue to their identity: entertainers, soldiers, beggars, executives? Who knows? Two have dice in their mouths, as though about to perform an amusing trick. But dice also symbolise the game of chance, so their behaviour may relate to something more profound and more disturbing – a comment on the uncertainty of our destiny.

There are no exact parallels in earlier art for the idea presented by Muñoz in *Three Men Laughing at One*. But as early as the seventeenth century, in a key work such as *El Bufón Calabacillas*, Velázquez had already investigated similar ideas and metaphors (fig.23). The bufón or jester, seated on a stone on the ground, laughs with the enigmatic expression of a sphinx. His provocative expression, like the Sphinx of Thebes, interrogates those who pass in front of him – and the price of failing to answer was death. But Velázquez, who distanced himself from the beauty of the classical world, created this modern 'sphinx' for his king.[1] The riddler might be an untrustworthy rascal (*pícaro*) of Velázquez's time; we perceive in Calabacilla's devious smile and gaze a desire to deceive, to pose a cunning, unanswerable riddle. His legs are crossed with a mountebank's flexibility and convey an almost snake-like entangled movement like those of the men in Muñoz's sculpture. They are unstable figures, the meaning of their movements are unclear to the spectator. Velázquez's jester (not in this case a dwarf) hides something not in his mouth but in his hands, one closed over the other. Here is the subject of his question to the passer-by; it is the die with which, like all good *pícaros*, he will cast the fortune of those who stop to answer his question. Muñoz's *Three Laughing at One*, like Velázquez's jester, has its own intense life: that 'interior life' which, Muñoz tells us, is based on a deliberate rejection of the realism deemed typical of Spanish art. The sculpture has roots in similar earlier works such as *Towards the Corner* and, like *One Laughing at the Other*, in the world of circus. But in compositional terms it is very close (however unconsciously) to a historical scene widely diffused in photographic

form, that of the 'Big Three' – Churchill, Roosevelt and Stalin – at Yalta (fig.24). The three powerful rulers are seen laughing among themselves at a decisive moment in History, when the future of millions was directly affected by their meeting. Their laughter is not especially intelligent. In fact, it is as ambivalent and opaque as that of Velázquez and Muñoz's figures. It was also the product of a game having different implications for each of them. Perhaps it unconsciously arose from the contrast between their apparent omnipotence and their profound sense – repressed in their public acts and declarations – of their own weakness. This sudden laughter, both the mask and the mirror of thought, is what makes Muñoz's sculpture and Velázquez's jester rich with their own inner life. The ambiguous expressions and unsettling actions of their protagonists provoke our intense curiosity. The contrast of realism with the 'inner life' of art (cited above) is clear if we compare Muñoz's work with the over-monumental and pompous neo-realist public sculpture made as recently as 2005 by the President of the Russian Academy of Fine Art, Tsereteli, in homage to the three famous actors of the Yalta Conference; their faces, logically enough from Tsereteli's point of view, attempt to look serious, but, in fact, are banal and stupid.

In answer to a question repeatedly asked by interviewers, Muñoz denied that his Spanish roots and, more particularly, Spanish art had been a decisive influence on him. Even in relation to sculptures whose sources in Velázquez are evident, such as his dwarfs, the origins of his ideas were, he always maintained, personal rather than Spanish. Perhaps he was indicating that it is never easy to discover the roots and motivations of an artist and that the kernel of a creator's ideas is never self-evident. Take the dwarfs: how could he deny the inspiration of Velázquez's celebrated works? Yet Muñoz claimed, explicitly, as a metaphor of humanity, that the very dignified figures of his dwarfs, came to him after a walk in the Nymphenburg Gardens in Munich: 'I am not exactly denying that there is a Spanish link [in the dwarfs] but it's not conscious. The dwarf was born in my work from a walk in a garden in Munich ... I picked up a leaflet about the Rococo architect [François de Cuvilliés] who designed it and discovered that he had been very small in size, practically a dwarf. And then I knew what I was going to make: the image of a dwarf inside the prompter box. *The Prompter* is in a way the House of Memory ...'[2] The child Cuvilliés, being a dwarf, entered the court of the Elector of Bavaria as a jester, but his intelligence gained him the support of his master; he studied mathematics and became one of the most highly esteemed architects in Germany.

Muñoz's art has always been close to philosophy, which is interesting in view of the fact that Velázquez's contemporaries saw him in the same light, describing him as an artist 'who surpassed many of his time in philosophy'.[3] But this is not their only common point. Muñoz used an unequivocally modern vocabulary in his international artistic projection and thus distanced himself from the merely local and Spanish. But something nonetheless separates him from other non-Spanish artists of his generation, from those whom he greatly admired, such as the American Minimalists. This element which differentiates him is his identity, to be understood not in terms of nationalism but in terms of the readiness with which he subliminally understood Spanish artists such as Goya and, above all, Velázquez.

Whether their influence is conscious or not, it is interesting to note that these artists are painters rather than sculptors. With few and isolated exceptions related to technique or a particular figure – Donatello's *Habbakuk* or the grouping of the figures in Rodin's *Burghers of Calais* – Muñoz has little in common with the sculptors of the past. He said: 'I was never interested in the physical form and the formal problems of sculpture as such ... I like to retain the illusionistic elements of painting and photography for my sculpture'.[4] These interests are clearly consonant with those of the supreme master of illusionism: Velázquez. Since the

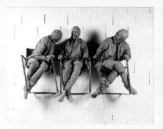

Fig.22 Juan Muñoz,
*Three Laughing at One* 2001,
Private Collection

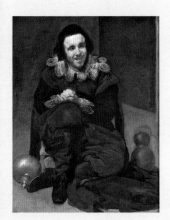

Fig.23 Diego Rodríguez de Silva y Velázquez, *El Bufón Calabacillas* c.1636–9, Museo Nacional del Prado, Madrid

nineteenth century, when Manet 'discovered' him, Velázquez has replaced Raphael at the head of the Western artistic pantheon, perhaps supplanting even Michelangelo. And it is this modern Velázquez, who elicited a reaction almost unique in art when Muñoz transformed his two-dimensional ideas into sculpture. Sculpture has influenced many painters; classical sculpture before the twentieth century and primitive sculpture during it. But Muñoz was inspired in the other direction, translating the two-dimensional world of painting into the three-dimensional expression of sculpture. In his works, groups and installations, he maintained illusionistic elements proper to painting, especially the profound theatrical – scenographic – intuition in which space, perspective, light and colour gradations play such a vital role, as in *The Wasteland* (pp.22–3). In fact, very few sculptors have been interested in painting. In Spain the tradition was probably somewhat different from that of the rest of Europe in the singular expressiveness of polychrome sculpture, which exploited some of the means of painting, such as light and colour, to produce its effects. In modern times, Degas is perhaps the painter who has most naturally translated his ideas of painting into sculpture without sculpture losing out. He did this from his own painterly vocabulary. Picasso, on the other hand, when he reinterpreted Velázquez's *Las Meninas* (fig.25) with the materials of sculpture, confined himself to presenting two-dimensional metal off-cuts in a kind of sculptural collage that was almost too faithful to Velázquez's composition.

Muñoz's taste for the narrative is one of the determining factors in his gradual and (at the time) unexpected move towards presenting the figure. But this is not entirely accurate. His sculptures may have been defined as narrative because his figures act conjointly, relating to one another as if placing an argument before the spectator. But, as in Velázquez, the emblematic narrative of Muñoz does not imply a beginning or an end; there is no resolution of the kind that we find in the strictly narrative compositions of Goya, with their roots in the Enlightenment. Consequently, Muñoz invariably remains enigmatic for the spectator, giving absolute freedom to interpret the intricate and singular world of his images, in which – more than in the work of other artists – one must be guided by the feelings they produce and the intellectual connections they evoke. In Muñoz their story is also metaphorical, suggested by little details and gestures, never self-evident, as in his *Three Laughing at One*. His narration is far from predictable and does not imply the development of a story nor is it, as in the classical theatre, confined to the three unities of action, place and time. Muñoz's sculpture shares with contemporary theatre of the absurd the suspension of conventional reality; his works generate anguish, alarm, and solitude.

Fig 24 Churchill, Roosevelt and Stalin at the Yalta conference 1945, Imperial War Museum, London

Velázquez and Muñoz are both interested in fleeting scenes and transient moments of a kind that cast no light on their own time – on the court or religion – and nevertheless leave the impression that vital questions are debated in them. Velázquez's corpus comprises a mere handful of evanescent instants, such as that in *The Triumph of Bacchus [Los borrachos]*, where the god of wine gazes out at the invisible spectator with a strange expression of complicity while he crowns a court of drunken workers with vine-wreathes. Then there is the surprise – sudden, calculated and infinitely various – of the colleagues of Vulcan at the arrival of Apollo in *The Forge of Vulcan*. On other occasions, Velázquez, like Muñoz, poses a hermetically sealed enigma that implies its own conclusion, as in the theatrical background to *Las Hilanderas*, where on a stage glowing with light unfolds the terrible punishment that Minerva has imposed on the proud Arachne. The paradox for both artists is of the fleeting instant to be captured as if it were endlessly happening and, by virtue of this paradox, the scenes are arrested and crystallised in time. This was another of Muñoz's obsessions. It was no doubt by choice that Velázquez left forever in suspense, as if under some magic spell, the actions being performed in his works, like the little page's foot tickling the dozing

mastiff in *Las Meninas*. Velázquez gives us the impression that at some unspecified moment in the future, at the touch of a wand, someone will release the passage of time and the figures will be restored to motion, as if after many years a clock had been wound up again. Of course, Velázquez is not the only painter to have conveyed the idea of time arrested. Vermeer also contrived this in a century particularly interested in the passage of time and the ephemeral nature of life. But Velázquez captured scenes of no particular importance that are nevertheless heartbreaking in their existential nature and did so with an intensity quite lacking in Vermeer; it is as if the Spanish artist sought to represent his own weariness with life or the uselessness of alien lives – and these are not the attitudes we expect of his time. Velázquez might have said with Muñoz: 'My work has less to do with nostalgia, more with what is unbearable about life'.[5] In Vermeer, the order of the well-off bourgeois society in which he lived is transposed into scenes in which waiting, reunion and the silent reading of a letter have a profound metaphysical sense, which is ultimately optimistic. This is not true of Velázquez. It is as if he knew that the delicious child-princess Margarita in *Las Meninas*, suspended in time like a Sleeping Beauty at the precise moment when her maids-of-honour offer her the little earthenware pot of water, would die aged eighteen, worn out by successive miscarriages in her enforced role, as Empress of Austria, to produce a male heir. Muñoz admired De Chirico's ability to bring time to a halt in his work, but the 'suspension of the moment of the gaze' as Muñoz defined it, had found earlier and more profound expression in Velázquez, as the sculptor no doubt realised. This can also be seen in Muñoz's 'raincoat' drawings (pp.30–43), which contain the metaphysical space we find both in Velázquez and De Chirico.

The starting point for Muñoz's interest in narrative is evident in *The Prompter* 1988 (p.26) and *The Wasteland* 1989. In *The Prompter* he introduces a prompter's box into the hypnotic perspective of the set, with its infinite geometrical tiles: in the box is the first of his dwarfs. We know that it was his encounter with the story of the dwarf-architect of Munich which made Muñoz include this figure in his work. The intention was not to ridicule dwarfs, as in certain Goya scenes, such as his *Strolling Players [Cómicos ambulantes]* or certain *Caprichos* in which he caricatured dwarfs to produce some of his most vicious satire. Muñoz, like Velázquez, uses real dwarfs without caricature, but rather to ridicule us and our sense of perfection: 'When I made a dwarf, I was not so interested in the physical presence of the dwarf. It was more a reference to the question of strangeness than a problem of size ... It's also the sense of being uncomfortable. When I meet a dwarf I feel uncomfortable. It is not my fault. But I feel strange.'[6] Through his use of dwarfs and the shock that their size produces in the spectator – the confrontation with a human being at once so like and unlike – Muñoz makes his work all the more striking and attractive; such is the case with his *Dwarf with a Box* 1988, who stands on a table to attain 'normal' stature. The contradiction that his spectators perceive implants in them a sense of something having gone wrong (and there is no immediate solution); a sense that it is themselves and not the dwarfs who are imperfect and remote from the ideal. In sculptures such as *Dwarf with Three Columns* 1988, *Female Dwarf Looking at Herself in a Mirror* 1996, *Dwarf with a Box* 1988, Muñoz invested his dwarfs with great dignity, much as Velázquez did. This is obtained by their rigorously frontal position (even though we can see them in three dimensions), their serene, almost passive attitudes and, in great measure, by their silence. Installed in the grandiose perspective of impeccably white rooms, contrasted with the size of the columns or simply placed in the hollow of a door, the dwarfs, despite their deformity and diminutive stature, become exemplary and dignified human beings for us to admire.

The metaphorical and comical character once possessed by Velázquez's dwarfs has

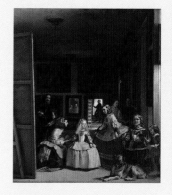

Fig.25 Diego Rodríguez de Silva y Velázquez, *La Familia de Felipe IV, or Las Meninas* 1656, Museo Nacional del Prado, Madrid

been lost with the passage of time and there remains only the enigmatic power of their images: silent, calm, and melancholic. The strength of these isolated figures, strongly lit and absolutely frontal, imparts to them a three-dimensional character common to many of his figures. It is as if they were real men in real space. Muñoz's dwarfs are similarly silent and calm, seeming completely sure of themselves. Their solitude, isolation and expression – reflecting conscious thought – perturbs the spectator and produces a strange sensation of melancholy and uncertainty about our own essence as human beings in today's world: 'My characters sometimes behave as a mirror that cannot reflect. They are there to tell you something about your looking, but they cannot, because they don't let you see yourself'.[7] This is exactly the function of dwarfs in Muñoz's work, that of mirrors that do not reflect the external, physical image of the spectator but one which is nevertheless felt, in some anguish, to be personal. This is, perhaps, like the horrified surprise of Goya's characters when they see their reflection in a mirror that reflects their inner character: the young dandy has become a monkey, the courtesan a serpent. But in *Las Meninas*, on the contrary, the spectators see with astonishment that their images reflected in the mirror at the back of the painting are transformed by virtue of the painter's illusionistic skill, into that of the king and queen.

Fig 26 Francisco de Goya,
*Disparate de los Ensacados* c.1816–28,
Museo Nacional del Prado, Madrid

Of course the world of whispering, concealment and ambiguous personal relationships that we sense in Velázquez was also profoundly studied by Goya, who introduced new psychological factors and emotions such as malevolence, violence and a mordant and terrifying humour in his descriptions of humanity. One of the last sculptures by Muñoz, *Man Hanging from a Foot* 2001, or even *Hanging Figures* 1997 (p.86), moves from Velázquez's calm towards the more unsettling nature of certain Goya paintings and drawings which present similar scenes, and in which the hanging and tortured men have the same terrifying connotations. Such images were transformed by Goya into figures tortured by the ruling power that emerged from the War of Independence. Goya's late etchings, *Los Disparates*, have never been compared to the sculptures of Juan Muñoz but the violence and anguished relationships featured in them are very similar to those present in the sculptor's work. For example, the *Disparate de los ensacados* (Men in Sacks) (fig.26) shows a collection of figures dressed in sacks that hide their bodies up to their necks (see *Conversation Piece* 1996, pp.66–7). Their feet cannot be seen; they move by jumping and falling and cannot relate to one another. In these works by Goya, for example in *Disparate furioso* (Furious Folly) the underlying matter is a horrifying though sometimes subterranean aggressiveness, which can be seen as a key to Muñoz's analysis of the human condition. Here are scenes resembling the most extreme productions of modern theatre and apparently devoid of any relation between the imaginary persons on the 'stage' and the spectator. Only on very few occasions does one of his protagonists look towards the spectator as though curious to know what they make of what they see. For the most part, they are isolated in their own actions. And thus these scenes in Goya, Velázquez and Muñoz become a mirror which reflects the world of those who contemplate them.

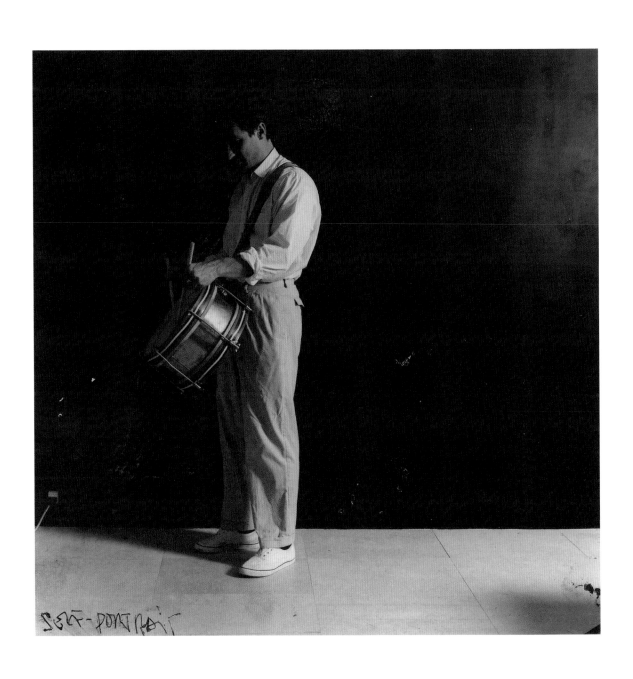

# Isabella Stewart Gardner Museum Lecture
# 14 September 1995[1]

JUAN MUÑOZ

1. I would like to begin with a story. Or perhaps with a fictitious encounter between the man that I am now in this late summer afternoon and the man that I'm not yet. But will be when I read aloud those very same words. I have stopped and I have looked at the top of the page. I have scratched a line over it. I rewrite: I will begin with a story, an encounter between a man who is sitting now at this table, writing, waiting, listening to Schumann on the radio. And the man reading these lines aloud to you. I know that both of them will have an encounter, not fortuitous, but certainly brief. In two weeks' time, in the same room where I will be delivering this lecture, I want now, seated on my desk, to imagine that room, the room where I would pronounce these very same words. Where I will hear my own voice reading aloud the lines that I am now writing.

   Certainly I will make mistakes. But departing from this subtle fact I begin to write… to speak.

   Allow me to imagine this room, a rectangular room, spacious, extended towards the back with various narrow windows, a row of chairs arranged with military perfection. Just in front of me there, where I stand now, is a white, wooden table. With a microphone on top, always uncomfortable. Maybe the walls are white and the ceiling is delicately covered with tiny filigree. And that very table where I will read these lines perhaps will have rounded edges like my table. Nevertheless, sitting here I know that I don't succeed in imagining the arabesque on the ceiling, the colour of these walls. Whether the door is on the right or at the back, if it is open or closed. As yet, this room still does not exist in my mind.

2. I have stopped writing. Today is today. I looked out of the window towards the branches of the poplars. I look at the table where I now write, where I also can hear my voice but different, dwelling inside itself, still muffled. Just in front of me, simply framed, there is an early print of the Guarana river drawn by Yago Levinas around 1550. There where the Guarana finds the ocean, there are tiny sailboats that stroll indifferently next to a sea dragon. The riverbanks are inhabited by exotic plants, and the meticulously drawn trees are covered by schematic clouds that indicate the direction of the winds. Whenever I get bored or lose myself in thought, I look at the river and trace it from its beginning, to its mouth emptying into the ocean.

3. I remember having read in one of his books that Robert Louis Stevenson (who was capable of imagining *Treasure Island* by looking at a child's geography book) said that in the room where the writer works, there should always be one table covered with maps, architectural plans and travel books. A second table, where he writes, and a third one that should always remain empty. If the ultimate intention of all metaphor is to establish an analogy, draw a resemblance, or reproduce in a mirror of words, a similarity that permits one to forget that the image is merely an image, then it would be possible to assert that each one of Stevenson's tables has an analogy outside of itself.

   Let me explain. The second table he mentioned, the work table, is also this one here. In this room, where I'm writing. Where I narrate myself and contradict myself. Where I tend to the mechanisms of creation like a witness. The third table, the empty table, would then be in that hall where I will speak to you in two weeks' time. An empty room that today still does not exist. A table that today still does not exist. Where I will speak about a drawing by Gentile Bellini. Both tables, both rooms, exist in an identical and at the same time distant space.

   The last of the three tables is the first to which Stevenson makes mention. That one covered with topographic charts, maps, and travel books. A table in a certain way is a metaphor of itself. In chess terms, it would be like a castle in position. A table that is a stage

constructed solely for disappearing. As if it were a magic trick, a disappearance act. He who sits there is no longer there. In this game of analogies, then, this table covered with maps is the theme of this lecture. The text I'm reading. The drawing by Bellini.

Allow me now to confuse you. I'll reverse the order of the three tables, like in that game that is still played in the streets of Rome or in my own city. The game where a man behind a cardboard box quickly moves three small cups, one of which conceals a tiny ball. A guessing game called *trile*. When the man stops moving the cups around, the spectator, absorbed in the movement of the cups, is supposed to guess under which of the cups the ball is hidden. So I'm changing the order of the tables very quickly in order to confuse you. By doing so, I will outline a different order of possible similes.

The empty table in Stevenson's metaphor will also be this table, where I am now, where I'm sitting, writing and crossing out words that I will never speak. An empty table where in front of me there is a future text that is not yet written. Each word that I write, each second that follows the previous second comes from my still empty future. The second table – the worktable where the writer, as Stevenson suggested, sits down to write – now could also be a metaphor for the room and the table where I speak. The room whose forms and contours I cannot yet imagine in my narrative.

I will now make one final move, but only one of the cups. Pay close attention. The table covered with plants and topographical drawings is now also, when I look at it and try to decipher its lines, the drawing by Bellini. I believe that I have confused you and so I have won.

Fig.27 Gentile Bellini, *Seated Scribe* 1479–81, Isabella Stewart Gardner Museum, Boston

4. Allow me to start all over again. Allow me to imagine, once again, this room. A large door at the far end. A wide double lift door, fashioned of dark wood with gold-edged panels. I can see rows of high-backed chairs. And four or maybe six large lamps. Nevertheless, each time I imagine this room, every time I try to visualise it, I see it empty.

Now I'm in my own room, the very same room where I live, where I'm writing now all over again. In front of me there is a delicate, elegant print of the Guarana River. To the left of it, slightly higher on the wall, a photograph by the German artist Thomas Struth: a monumental portrait of the art historian Giles Robertson seated in what looks like his living room. Leaning over a dining room table, he holds an open book in his hands. Again and again I keep on looking at his eyes. His gaze is distant. Somehow lost. He looks at something above the book, outside the frame of the photo. Or maybe it's only a gaze that has paused in front of a suspended future.

To my right, on the floor, a pile of books. I shift them around until I find, underneath them all, a book by Robertson. His biography of Giovanni Bellini, the younger brother of Gentile. On page 81 this entry appears:

*Today, the twenty-third of February, Gentile Bellini was buried in São Paolo. Gentile, as official painter of the state, was sent at the Sultan's request, to Constantinople.*

5. Perhaps, in order to explain myself, I should go back a bit in time. Facing me is the print of the Guarana River. I stare at it, imagining that its waters are running backward to its tributaries. I try to remember – if only I could trust memory – the precise moment when I stopped in front of the small, exact, beautiful drawing by Gentile Bellini. I would like to talk about this moment.

But where to begin? Somewhere, I read that the only valid metaphors are commonplaces: houses or rivers, for example. I've already spoken about the river. I've even, in my own way, played with time. I walked through the rooms of the Isabella Stewart Gardner Museum, as if it were a library, instead of an art museum. It was as if I were looking at row after row of

books and leafing through their pages. The Argentine writer Jorge Luis Borges said that a book is an object among other objects. One volume lost among the volumes that populate the indifferent universe. If this is true, then every image is one among the infinite throng of images. And this drawing is only one among the multitude of images that crowd this indifferent universe. A drawing, immobile on its shelf until it finds its reader. A certain gaze, a beholder destined, for an instant, to regard the symbols that the drawing preserves.

What is it that takes place during that instant? Maybe Borges would have called it beauty. A much abused word that has gone out of fashion but nevertheless expresses the mystery that is not within things, but in our encounters with them.

6. Before sitting down at this table to write, I read some essays on Gentile Bellini. Robertson's volume on Giovanni mentions Gentile only very briefly, a dozen or so times. I have looked at Vasari's biography, at Hans Tietze's *The Drawings of the Venetian Painters*. Almost all of it seems useful for historians but somehow irrelevant to this confusing attempt to explain the moment I looked for the first time at this delicate drawing. However one story alone seems to linger in my memory.

Two volumes of drawings by Giovanni's father, Jacobo, were left to Gentile in his father's will. Many years later, Gentile, in his own will, bequeathed to his brother one of the two volumes. What is interesting is the way in which he laid out the conditions by which his brother Giovanni might inherit the bequest. According to the terms of the will, in order to receive his father's book of drawings, Giovanni had to complete a painting that his brother did not want to finish. The other volume had already been presented as a gift to the Sultan Mohammed II when Gentile had travelled to Istanbul. In this way Gentile made both his brother and the Sultan two of the first collectors of drawings in recorded history.

Somehow when I look at his drawing now, I cannot separate the image of the young Turkish man from the importance that he gave to his father's drawing books. And I wonder if the blue cording on the Turk's gown is so minutely depicted, why is it that there is nothing, not a line, on the board where he is drawing. I can imagine that Gentile didn't draw anything on the board because the Arab is presented at the very moment, just before he began drawing. Although the young Turkish man is not drawing anything because he was only a model, but then a model for what? For a man absorbed in a white page.

7. In some way, I have already begun to travel among words. My table is cluttered with pages written with crossed-out words that I will never hear myself pronounce. I get up to grab from the shelf volume II of the *Encyclopedia Britannica*. The volume starts with B for Bayeau and ends with C for Ceanothus, commonly called New Jersey tea. During the American Revolutionary War, its leaves were used as a tea substitute. Page 1. Bayeau, Francisco. Born 1734. Died 1795. Brother-in-law of Francisco De Goya. Considered by his contemporaries the finest Spanish painter of the period. Strange the detours of fate! I'll quote directly from the *Britannica*:

> *Bellini, Gentile. Born 1429, Venice. Buried February 23, 1507. Painter. In 1749 the Doge of Venice sent Gentile to Constantinople as a painter to Sultan Mohammed II. In his pen and gouache drawing Portrait of a Turkish Man, at the Isabella Stewart Gardner Museum, Gentile uses a flat patterned style similar to that of the Turkish miniatures that influenced such later work as his Portrait of Doge Giovanni Mocenigo.*

The *Encyclopedia* points out a certain truth: 'Huge canvases painted with fastidious attention to the smallest detail and crowded with rigid figures.' In total around 60 lines. About his father, Jacobo, even less. His brother-in-law, Andrea Mantegna, is in another volume. And I do not want to get up from this table to look for such a minute bit of information. Gentile's younger brother, Giovanni, a page and a half. But then Giovanni was

different. Robertson's biography ends with the words 'ottimo pittore', a very good painter. The best painter. In the short distance between the two brothers, a radical transformation occurs. That of an art still indebted to Giotto – to the dawn of the Renaissance.

But I did not come here to discuss the historical relevance of another artist. I am here, at this very moment, as I write these lines, as I'm talking to you, to explain that circumstance of a moment of beauty.

I choose to speak about the Gentile Bellini drawing as an image of a man who lives in a place called 'abroad'. I choose that image of a man seated at a table covered with topographical drawings of mountains and rivers, with the floor plans of cities that he has never visited.

8. Some time ago I read in a bad novel 'When there is no place to hide, hide in plain sight.' Now I think that I should have started this lecture with those very same words. 'When you have no place to hide, hide in plain sight.' But then, what is 'plain sight'? Where is that place where everybody is but where no-one can see you? Not only by looking at this drawing, but by writing about it, I have learned that there is no such place. The illumination that those words – or this drawing – offers has to be understood in another realm: not a realm of space but of time. The place where it *is* possible to hide is the *present*. Bellini's character is dwelling inside his own bubble. He remains indifferent to our present. The quality of emotional resonance is such that, when we gaze at his present, we forget ours. This Turkish man is not there to be seen. He is there because he is already hidden from us. Not in our space, but in his own time, in his own present.

I know that as I read this text, I have the feeling that as I undo one conceptual knot on the table, I create with the same threads, an identical one on the floor. But I must go on.

9. I also would like to end. I want to talk about a drawing of a young Turkish man who appears to be about to start drawing. But how can I do it? I could say that Gentile seems to portray an absent-minded man, absorbed in his own limbo. Immobile. Silent. Staring at something that he is supposed to be doing. Drawing, maybe writing. Then I think that it doesn't matter what he's doing. It is an image of a man completely detached, distant. I could say that there is something elusive about him or that his concern seems to appear and then disappear from sight, as my own attention shifts from the board where he's drawing or writing, to his hands, and to the beautiful embroidered blue gown. I could talk about absorption and the absence of the beholder. About being outside while being inside. About the wandering eye or the allegorical and Diderot: the unity of action and time. Absorption again but not necessarily meaning attention. Or about sight turned into insight. Or what Michael Fried calls the supreme fiction: the spectator who is not there.

But then all those words and concepts, all those words that I write now in silence, and that I will read to you aloud will not help me to understand or even to recreate that instant when I first walked into a room at the Gardner Museum and contemplated a delicate, small drawing of a young Turkish man by Gentile Bellini and thought, just for an instant, that it was perfect.

# Will It Be A Likeness?

JOHN BERGER AND JUAN MUÑOZ

[All voices to be spoken by the same man.]

Good Evening. Last week I talked about the dog and we listened to some dogs barking. [Barks.] I suggested that this noise after the aeons of dogs' association with man had something to do with spoken language. Something, but what exactly?

A number of listeners have written me letters – for which I thank you – all of them about the way in which dogs communicate. Some of you sent photos to illustrate your experience.

I gave you my opinion last week [Barks.] that the dog is the only animal with a historical sense of time, but that he can never be a historical agent. He suffers history but he can never make it. And then we looked together at the famous painting by Goya on the subject. And we decided it was better to look at paintings on the radio than on the television. On the TV screen nothing is ever still and this movement stops painting being painting. Whereas on the radio we see nothing but we can listen to silence. And every painting has its own silence.

[Silence.]

A listener from the Black Forest wrote to ask whether, after the dog, we might consider the butterfly, and in particular the Anthocaris Cardamines, commonly known as the Fiancée. For this listener – although our principal subject this evening is something altogether different – we have recorded here in the studio the Fiancée in flight. And if you shut the windows and settle in your chair we will now play for you and you will hear the wings of the Anthocaris Cardamines beating in flight.

[Silence with atmospheric noises.]

Every butterfly too has its own special silence. For sometimes a sound is more easily grasped as a silence, just as a presence, a visible presence, is sometimes most eloquently conveyed by a disappearance.

[Station noises.]

Who does not know what it is like to go with a friend to a railway station and then to watch the train take them away? [Announcement of departures spoken in Chinese.] As you walk along the platform back into the city, the person who has just gone is often more there, more totally there, than when you embraced them before they climbed into the train. When we embrace to say good-bye, maybe we do it for this reason – to take into our arms what we want to keep when they've gone.

[Telephone rings.]

A listener has just telephoned in to ask me what century in God's name do I think I'm living in?

[Woman's voice over telephone, muffled.] Sounds like the nineteenth!

No, Madame, the one I live in is the sixteenth or the ninth. How many, Madame, do you think were not dark? One in seven?

Today everything everywhere on the planet is for sale.

I'm selling. Here's a back, a man's working back, not yet broken, did I hear an offer?

What would I do with it?

Sell it somewhere where they need backs for work.

[Dog barks.]

Every evening Goya takes his dog for a walk along the Ramblas.

A heart?

How old?

Sixteen and healthy, from Mexico.

OK. Bought.

Then man and dog stroll home and Goya draws the curtains and settles down to look at CNN.

A kidney.

Taken!

One male member and a uterus together.

Together how?

They stayed together. They were chased out of their village, they had no land and they were obliged to sell everything to survive.

I'll take the uterus.

And the male member?

Throw it away, plenty more where he came from.

Difficult – they're inseparable.

NAFTA! Separate them!

I'm not sure...

NAFTA! I tell you!

Nafta?

North American Free Trade Agreement.

No, Madame, I live in this century which I can't say is ours and now, if I may, I shall return to the mystery of what makes a presence.

When all the members have been separated and all the parts sold, what is left?

Something more to sell. A whole is more than the sum of its parts.

Yes, so we sell the personality.

A personality is a media-product and easy to sell.

A presence is the same thing as personality, no?

Presence is not for sale.

If that's true, it's the only thing on this earth that isn't.

A presence has to be given, not bought.

Three hundred girls from Thailand.

I'll take them. Ask Melbourne if he's still interested.

Fig.28 Juan Muñoz, *Will It Be A Likeness?* 1996, Private Collection

A presence is always unexpected. However familiar. You don't see it coming, it moves in sideways. In this a presence resembles a ghost.

[Dog barks.]

He's let the dog out and the master has gone to sleep.

Once I was in a train traveling to Amsterdam, through Germany, going north following the Rhine. It was a Sunday and I was alone in the compartment and had been traveling for several hours. With me I had a cassette player and so I decided to listen to some music. Beethoven's one-from-last piano sonata. A man stops in the corridor and peers into the compartment. He makes a sign with his hands to enquire if he can open the door. I slide the door open. Come in, I say. He puts a finger to his lips, sits down and slides the door shut. We listen. When the sonata ends, there's only the noise of the train ... He's a man of about my age but better dressed and with an attaché case. From it he takes out a sheet of paper, writes some words on it and hands the paper to me. "Thank you," I read, "for allowing me to listen with you." I smile, nod, and know that I should not speak. We sit there silently in the presence of the last movement of the sonata. This is how a presence makes itself felt.

[Beethoven.]

An hour later, when a vendor came down the corridor selling coffee and sandwiches, my traveling companion pointed to what he wanted and I understood how he was dumb, how he could not speak.

[Telephone rings. Muffled voice.] Who was the pianist?

Piotr Andersylwski.

That's not true. Why do you lie?

Because Piotr is a friend of mine. He plays marvelously but he has no means, he came from Poland, he's poor and he's already twenty-six and soon – such is the competition on the concert circuit today – soon it will be too late, forever too late, for him to be recognised for the great pianist he is. So I lied to help him.

On my way here to the radio station this evening I passed a photography shop. In their windows they have a notice which says: IDENTITY PHOTOS WITH A TRUE LIKENESS – READY IN TEN MINUTES!

To talk of a likeness is another way of talking of a presence. With photos the question of likeness is incidental. It's merely a question of choosing the likeness you prefer. With a painted or drawn portrait likeness is fundamental; it's not there, there's an absence, a gaping absence.

[Noise of a dog whining and scratching at door.]

The dog is now asking to be let in. The master gets up, opens the door and, instead of returning to bed, goes to his easel on which there is an unfinished painting.

You can't hunt for a likeness. It can escape even a Raphael... Strangely, you can tell whether a likeness is there or not when you've never set eyes on the model or seen any other image of the model. For example, in Raphael's portrait of a woman known as La Muta, the dumb one, there is an astounding likeness. You can hear it.

[Silence.]

Whilst in Raphael's double portrait of himself and a friend, painted in 1517, there's no likeness present at all. This time it's a silence without any life in it. Enough to compare this silence with the Fiancée beating her wings, for us to feel the absence.

[Silence.]

You can't set out to trap it. It comes on its own or it doesn't, a likeness. It moves in sideways like a presence. Maybe a likeness is a presence.

Are you saying a likeness can't be bought or sold?

No, it can't.

Bad news. Maybe you are lying again?

This time there's no need to lie.

Blah blah blah blah blah blah blah... Pure mystification! If you can't in principle buy it or sell it, it doesn't exist. This is what we now know for certain. What you're talking about is your personal phantasm – to which of course you have every right. Without phantasms there would be no consumers, and we'd be back with the apes.

[Animal noise.]

Apes and other animals can feel a presence. When a dog recognises a garment of his master by its smell – perhaps he perceives something similar to a likeness.

So we end up with dogs! I thought we were thinking about invention, creation, human wealth.

One female thyroid gland!

A single thyroid is not sellable. If you're offered one, it's suspect.

There's a painting from Pompeii I'd like to show you all.

Of a dog, I suppose.

No, a woman. She's holding a wooden tablet, like a book, in her left hand and in her right, a pen or stylo, the end of which she holds against her lip. She's thinking about words not yet written. The portrait was painted in the year 79 – the year in which the town was buried

– and preserved – in lava.

Not a great painting, and if I'm sending it to you by radio – it's simply because it's a likeness. She's here in the studio in front of me, with her fringe just out of curlers and her earrings of golden rings which, as soon as she puts them on, are never still.

A likeness is a gift, something left behind and hidden and later discovered when the house is empty … Whilst hidden, it avoids time.

What do you mean "avoids time"?

Confuses time, if you prefer.

You wouldn't get away with this nonsense on television. TV demands speed and clarity. You can't ramble across the screen as you're rambling right now on the radio.

So I send you the Pompeiian woman of two millennia ago, with the tip of her stylo lightly touching her lower lip and her hands which are not rough with work and never will be. At the most she's twenty years old, and you have the impression of having seen her very recently! [Woman's laughter.] Is that not so?

You are a nostalgic old man!

Or a young romantic?

Anyway they're both finished, they belong to the past. Today we live in a world of exchanges, calculations at the speed of light, credits, debts and winnings.

And the dead don't exist?

Let the dead bury the dead – that was well said and has always been true.

Here's a story about an elusive likeness. I still have a portrait I painted when I was twenty. It's of a woman asleep in a chair and on the table in front of her, in the foreground, there is a bowl of flowers. I was in love with the woman and we lived together in two rooms on the ground floor of a house in London. I think somebody could tell from the painting that I loved her, but there's no likeness there. Her primrose green dress – she made it herself on the table in the room where I painted – has a distinct presence, and her fair hair, in whose colour I always saw green, is striking, But there's no likeness. And until six months ago, if I looked at the painting, I couldn't refind a likeness in my memory either. If I shut my eyes, I saw her. But I couldn't see her sitting in the chair in her green dress.

Six months ago I happened to be in London and I found myself two minutes' walk away from the modest house where we rented the two rooms. The house had been done up and repainted but it hadn't been rebuilt. So I knocked on the door. A man opened it and I explained that fifty years ago I had lived there and would it be possible for me to see the two rooms on the ground floor?

He invited me in. He and his wife occupied the whole house. There were carpets and lamps and paintings and china plates on the walls and a hi-fi and silver trays. Useless to look for the gas meter which we fed with coins when we were cold and needed to light the gas-fire or heat some water. Useless to look for the bathtub which when we weren't taking a bath served as a support for a tabletop on which we chopped onions and beat eggs. Everything had been replaced and nothing was the same except for the plaster mouldings on the ceiling and the proportions of the large window by whose light she made her clothes and I painted.

I asked if I could draw back the curtains. And I stood there staring at the window panes – it was raining and already evening so I could see nothing outside.

There I found her likeness as she sat in the chair asleep in the green dress.

Likenesses hide in rooms, you find them sometimes when they're being emptied.

There are many people who are secluded: They live in a kind of Switzerland of perception so that they can't see a likeness when it's staring them in the face.

A journalist is visiting a modern prison which is the pride of the local authorities. They call it a model prison. The journalist is chatting with a long-term prisoner. Finally, still taking notes, he asks, 'And what did you do before?'

'Before what?'

'Before you were here.'

The prisoner stares at him.

'Crime,' he says, 'crime ...'

[Dog barks.]

It is a new day, and Goya is taking the dog for a walk. They are both in exile. In the town of Bordeaux which, when there is a west wind, smells of the Atlantic.

As the Nikkei Stock Average breaks through the 2000-point mark, European money managers brim with confidence that the market to watch next year will be Japan.

An eye with a perfect retina, going, going, gone.

In these parts it is a miracle the people are still alive, says Moisés, a young man who has joined the Zapatista insurrection in Chiapas, south-east Mexico. 'Families of seven to twelve people have been surviving on a hectare or half a hectare of infertile soil ... We have nothing, absolutely nothing, no decent roof over our heads, no land, no work, no health, no food, no education ...' The year is 1994.

Now I'm going to send you by radio a strange likeness – that of a man whose face we do not know. Whenever he's in company, he wears a black ski mask. 'Here we are,' he says, 'the forever-dead, dying once again, but now in order to live.' His assumed name is Marcos. Subcommandante Insurgente Marcos.

A terrorist! It was agreed that this was a radio talk about economics, and you contrive to introduce a terrorist.

An expert in violence!

He's manipulating you at this moment.

[Telephone rings.]

Don't answer it!

I'm not defending him, I'm just transmitting his likeness. A likeness created by his own words: 'I have the urge to write to you and tell you something about being "the professionals of violence" as we have so often been called. Yes, we are professionals. But our profession is hope ... out of our spent and broken bodies must rise up a new world ... Will we see it? Does it matter? I believe that it doesn't matter as much as knowing with undeniable certainty that it will be born, and that we have put our all – our lives, bodies and souls – into this long and painful but historic birth. Amor y dolor – love and pain: two words that not only rhyme, but join up and march together.'

Empty leftist rhetoric!

Here is the rest of his likeness.

'There is something else about this passionate moving of words, something that does not appear in any post-script or any communiqué. It is the anxiety, the uncertainty, the galloping questions that assault us every time one of the couriers leaves with one, or several, communiqués. Questions and more questions fill up our nights, accompany us on our rounds to check the guards, sit beside us on some broken tree trunk looking at the food on the plate ... "Were these words the best ones to say what we wanted to say?" "Were they the right words at this time?" "Were they understandable?"'

A likeness is a gift and remains unmistakable – even when hidden behind a mask.

A likeness can be effaced. Today Che Guevara sells T-shirts, that's all that is left of his likeness.

Are you sure?

Fig.29 Juan Muñoz, *Red prop from 'Will It Be A Likeness?'* 1996, Private Collection, shown in Casa Encendida, 2005

[Silence.]

Sure?

[Silence.]

Why don't you say something? Silence, you know, is something you can't censor, and there are circumstances in which silence becomes subversive, that's why you have to fill it with noise all the while.

There's something dark about the silence around music, marvelously dark.

Goya is walking his dog by the ocean.

The other day I was listening to Glenn Gould playing Mozart's Fantasy in C. Moll. I'm not going to put it on for you, for if I did, I'd have nothing more to say, and they'd pay me less for this programme and I need the money to pay a dentist's bill. Nevertheless I want to remind you of how Gould plays. He plays like one of the already-dead come back to the world to play its music. That's how he played when he was alive.

Three nimble hands.

Why three?

One of the women had an accident at work.

Bought.

[Dog barks.]

In your world there are no likenesses – which is why you want to buy them and can't.

Whose dog is it?

I'll tell you the story of the best likeness ever made. John is the only one who tells the story. The other Evangelists don't refer to it – though they refer to Martha and Mary. The two sisters had a brother, Lazarus, who fell sick and died in the village of Bethany. When Jesus, who was a friend of the family, arrived in the village, Lazarus had been dead and buried for four days.

'Where have you laid him?' he asked.

'Come and see, Lord,' they replied.

Jesus wept.

Then the Jews said: 'See how he loved him!'

But some of them said: 'Could not he, who opened the eyes of the blind man, have kept this man from dying?'

Jesus, once more deeply moved, came to the tomb. It was a cave with a stone laid across the entrance. 'Take away the stone,' he said.

So they took away the stone.

Jesus called in a loud voice. 'Lazarus, Come out!' The dead man came out, his hands and feet wrapped with strips of linen and a cloth round his face.

Jesus said to them, 'Take off the grave clothes and let him go.'

This is the story of the perfect likeness. And it provoked Caiaphas, the high priest, to lay the plot for the taking of Jesus's own life.

Goya is going back with his dog to work in his studio.

Next week I propose to talk about laughter, and as a way of introducing the subject, I'll sign off now by playing you a tape made by my friend Geoff Dyer:

[Jazz on tape.]

Yeah, hello John. That was music from Don Cherry who died yesterday which was all very sad ... and I put that on because he's obviously somebody who, in his life and his playing, knew no frontiers and obviously that's the same for you and also that's why I'm going to read a short bit from your new book:

'Jean Ferrero is seated at a café table under the ocher arcades in the Via Po. In front of

him is a cappuccino and a glass of ice-cold water. Nothing else in the city sparkles like these glasses of water. He leans back in his chair; he has crossed the mountains. Probably his grandfather once came to Torino to argue a case with a notary. Today the arcades are the colour of old files whose labels have been changed many times. Hearing a laugh, he raises his head. It takes him some time to find the one laughing. It's a woman's laugh. Not in the arcade, not at the bar, not by the newspaper kiosk. The laughter sounds as if it comes from a field in the country. Then he spots her. She is standing at a second-storey window on the other side of the street, shaking a tablecloth or a bedcover. A tram passes but he still hears her laughter, and she is still laughing when the tram has gone, a woman no longer young, with heavy arms and short hair. It is impossible to know what she's laughing at. When she stops laughing, she'll have to sit down to catch her breath.'

[Silence.]

Turn the volume of the silence up and you'll hear snowflakes falling on deep snow …

The last likeness …

REPRINTED FROM *SILENCE PLEASE!: STORIES AFTER THE WORKS OF JUAN MUÑOZ* 1996

A''
SEA LEVEL

# Juan Muñoz

RICHARD SERRA

Juan's posture, his character, his temperament were determined and shaped by his aesthetics. Our comprehension of his work brings us into complicity with his creative process. He not only asks, he demands that we become his audience. He provokes in us a heightened awareness of violence, isolation and despair. His work repudiates the strategies of most post-modern installations which usually take the form of a media spectacle supported by marketing techniques and commercial display. As opposed to most installations, Juan's work is a substitute for the unnamable emotions of estrangement, anguish and despair. These works are not the sentiments that sell, they are not the bread and butter of the global market. His work does not leave us with easy moral comfort. The meaning of Juan's art is to be found in the essence of a lingering sorrow, not in the character of décor.

In a general sense, aesthetics is dependant on ethics. Juan's work points to the moral valuations of our lives. Reality isn't the issue. It is perception that promotes reality, that gives it its meaning and each artist evaluates reality through a different prism. In isolated works Juan provided a momentary catharsis, and in more than a few instances, an absurd poetic comic relief. Space may be infinite but our understanding of it is through its reduction. It is in this reduction that Juan gives space its coherence; in an empty balcony, a room, a hallway, a cabinet, a floor, an elevator, in the muted space of a ventriloquist, dummy or dwarf.

Juan understood that his work would be judged against his precursors. He had an insatiable drive to cut his own path converting history and its authority and conventions into his own use. He insisted on himself, challenging all of the existing taboos; the no-no of theatricality, the forbiddance of tricks, the unacceptable transparency of illusion. He gave it back to us in spades from the deck of cards which he carried in his pocket after he turned in his knife.

He had no need to invent the already invented. He turned away from prior tropes. He had a need to know the lesson of history for itself and he went over the whole ground and turned it into what he knew, what he lived. He was searching for an analysis of the human condition that wasn't presently available in the figuration of our time. In short, to show man at his wit's end: silent, a dumb show of depression obsessing our private lives.

In the final analysis a strong artist can only read himself. And Juan was an original. His exploration attempted a new synthesis, the sleight of hand of doing and suffering. He was propelled by anxiety. The theme of grief and anguish always produces a self-portrait. He seemed to recognise that grief, caught in a moment of time was his subject and he condensed that time into something graspable, something that can be retained in thought. The thought that is implicit in his work, the thought that art attempts to protract time to the longest extent possible. The attempt to make time stand still, to create a pause within a pause and in his installations, if time is not totally stopped, at least it gets focused into an almost physical sensation and thereby into memory. You don't forget Juan's figures and to remember them is to restore to them their intimacy in a moment of time. Think of the bounded, muted ballerina.

EXTRACT FROM THE EULOGY FOR JUAN MUÑOZ GIVEN AT HIS MEMORIAL SERVICE, NEW YORK, OCTOBER 2001

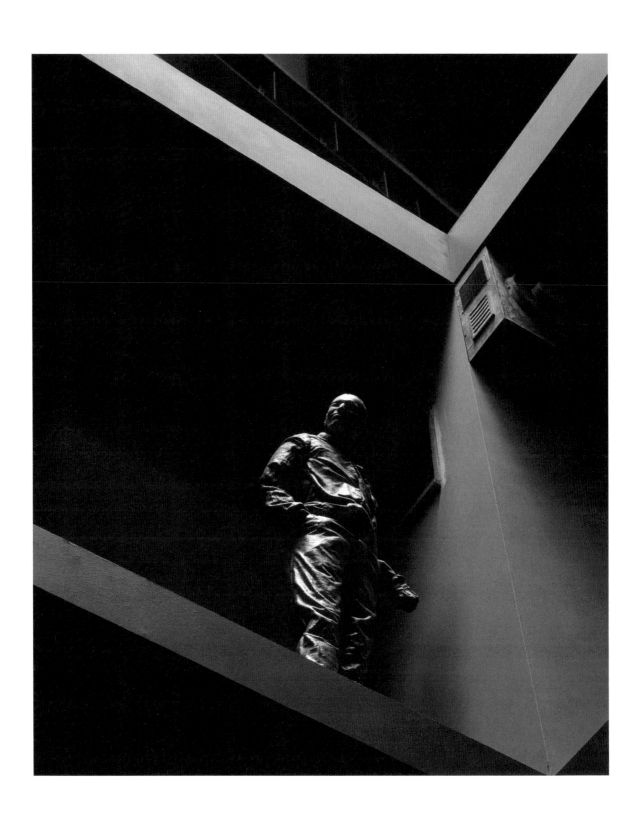

140    *Double Bind* 2001 (detail)

# A Conversation, May 2001

JUAN MUÑOZ AND JAMES LINGWOOD

**JAMES LINGWOOD: How much of this project was latent in your mind before you were invited to work in the Turbine Hall?**
JUAN MUÑOZ: I don't think it is possible to have anything waiting in your imagination for a space and a volume of this kind. The space is there, it's a given. Then I have my language and my experience, that's it. These are the starting points. I don't think anybody can really shape a work like this prior to being asked. You have to come, to look, to despair and smile.

**JL: Had you seen the space before Tate Modern opened?**
JM: I saw it before it was open to the public. I saw it empty, which is maybe important.

**JL: What were the first ideas that you envisaged? Were they close to what you're finally going to make here?**
JM: I don't think I had an immediate vision in front of the space. I did spend many days walking up and down but I could not envisage anything. I did what I believe many artists probably do, and walked through endless amounts of books, and through the streets, taking in all of the little incidents and accidents and encounters of everyday life. You hope that images will resonate in your mind and that they will help to lead you on, to find some shape and form to begin with.

**JL: Which images began to resonate?**
JM: My first idea, or image if you like, was to build two successive bridges. I don't know why – it just came in a very intuitive way: two bridges tilted into the horizon, disappearing into the distance. There was a photograph of two bridges in Ljubljana that I found very interesting on a spatial level. That was the very first idea: standing on a bridge – or a plateau – and looking at something that was leading nowhere; a bridge from nowhere to nowhere. My second idea was to suspend a great number of figures in the space. These are some of what I would call the habitual errors along the way.

**JL: Maybe there's a key consideration here already – the tension between creating an image and building a sculpture. The two bridges could have worked beautifully as an image but you want people to move around the space, and to experience the work in a way that's not just about surveying a kind of landscape.**
JM: No, that should only be one dimension of the work. Somehow, I think it became important for me not to repeat myself. I might have achieved a powerful effect by approximating the project I made in Copenhagen last year with 120 figures installed on a huge balcony, or by doing something similar to the circle of Chinese figures at the Velázquez Palace in Madrid: not allowing people to walk in but to see it only from above. But it's important not to stand still.

**JL: Did the idea of figures suspended in a space mean that you felt you had to address the verticality? Because you've transformed large horizontal expanses before – such as in Madrid or in the courtyard in Dublin. In Dublin you looked across the space, and perhaps down onto it, but you didn't need to address the problem of looking up.**
JM: The verticality of the Turbine Hall is extreme. I am sure that in the final installation it will give me problems that I cannot imagine now.

**JL: Maybe you only have two possibilities – to keep very close to the ground – as many sculptors have done since the 1960s, or somehow to engage with the verticality. The horizontal expanse isn't so intimidating.**

JM: It is true that the horizontality was never the biggest challenge. You can talk about verticality in formal terms but also in symbolic terms. The verticality of the hanging figures that I started to think about in the beginning was certainly a way of dealing with the gigantic distortion that happens when you look up. Probably the image of the elevator that came later on is a resolution of how to engage with the verticality.

**JL: But without providing a fixed image. The fact that there's a slow motion through the space is significant – particularly because the rest of the landscape is still.**
JM: Actually, one of the many momentary images I had as an idea for intersecting the space was of a suspended carpet – with people above it, and people below it. But then the cut would just have been a horizontal one, not a vertical one. The associations weren't right, but anyway it pushed me towards the idea of having two separate spatial experiences, above and below. So the carpet evolved into a floor. This gives two quite different kinds of space – and the dialectic between the two is important.

**JL: A space you could survey but not walk through, and a space that you could walk through but not survey, and the elevators linking the overground to the underworld?**
JM: I remember talking to you some months ago about installing several elevators, and then sensing the inappropriate excess, so I reduced the number of elevators to three, and then to two. The idea of the duet began to shape the thinking.

**JL   When you work with figurative motifs – and the elevators imply figures, even if there are no figures within these ones – you again have a spectrum of possibilities: the solitary figure, the duet, the small group or conversation, or the crowd. Would more than two elevators have created too much of a performance, a concerto of automated movement?**
JM: Trying now to reconstruct how the piece came about, it's difficult because I don't clearly remember how the final form was determined – and there are still many, many decisions to be made. We certainly talked about several elevators being too many, and then three seemed a good idea, with one of them broken and two of them travelling; and then two seemed right, and this brought a kind of musical discourse to the discussion, the idea of a duet, and this started to frame the subject. Because there was no subject before the horizontality, and the verticality – the formal problems began to lead towards the subject. I'm trying to remember the nights and the wine and the conversations. Many decisions are shaped by an accidental encounter, by hearing or seeing something unexpected. The moment when my wife Cristina [the artist Cristina Iglesias] said that coming down the ramp at Tate Modern made her feel as if she were going into a parking lot was important. It's surprising how slowly the piece started shaping itself, from the horizontality of the bridges, to the need to deal with the verticality through the hanging figures, which was later substituted by the absence of the figures, to the displacement of these ideas with others that seemed more complete and more economical.

**JL: This is a familiar process in your work – from having various scenarios or ideas that gradually get pared down, the image of a human presence is displaced by the idea of absence, or emptiness. The balconies in some of your very first sculptures were filled with representations, then they became empty. Do you consciously build things up so that you can then take them away again?**
JM: It's not a systematic, conscious method, no. But in this particular case, in the studio, I spend more time destroying than constructing.

**JL: What kind of metaphorical function do the elevators have?**

JM: They aren't metaphors for anything. They are elevators going up and down.

**JL: But automated movement has been important in some of your earlier works. I'm thinking of the figures in a shoe-box going round and round a room on tracks. They're just stuck in their box, going round.**

JM: I have often given myself fairly limited areas to work with – the problem of the statuary for example – and asked myself how to make something significant today within these limits. On the one hand there is the stillness of a figurative sculpture that for me remains an inexplicable enigma. On the other hand, the representation of movement and gesture within stillness is a challenge that is endlessly fascinating. And the idea of a sculpture that moves, from the Jewish notion of the golem onwards, can create a moment of wonder. The elevators encapsulate movement, but in a suffocating way. I think between the stillness and the movement I try to find a place for my sculptures.

**JL: The elevators just endlessly go up and down in the same way that the figures in the shoe-box go round and round.**

JM: It happens that the world as I know it obliges me to go back again and again to a circular condition. But it does not mean that I do not want to break the circularity.

**JL: What does this circularity mean? It's a strong motif in modernist art – think of Duchamp's rotoreliefs for example. They change but never change.**

JM: I understand this emotion so well, this Duchampian moment of make-believe, this spinning wheel that makes you feel for a split second as if you are looking into a vacuum. The moment you switch it off, it disappears. The relationship of the flatness of the relief, and the awareness of the trick is critical. That is at the core of some of the best art of our time: the awareness of how things are done colliding with the way things appear. The making is fundamental to the illusion it creates. It is very surprising how we want to see something that does not exist.

**JL: How do you address this in the Turbine Hall?**

JM: It's still very intuitive, because you are talking to me about a sculpture that is yet to be made, but I'm beginning to look at the Turbine Hall as part of a city rather than part of a museum. It's a fragment of the urban experience. I'm interested in creating an urban work with several strata: a street full of doors for someone walking down the corridor hoping no door will open before the one he wants to open.

**JL: The two levels give you this duality: the one you can look at and the one you feel your way through; between image and experience, or between scenography and sculpture.**

JM: I'm not interested in scenography. It is a sculpture that includes other sculptures, and several viewpoints. This kind of anonymous space, a sort of extended underground like a car park, is very familiar to us all. It is a space of our time. It is never night-time and never day-time. It's identical at 11.00 in the morning and 3.00 at night and it could be almost anywhere in the world. These kinds of architectural spaces are very recent. They are a condition of our modernity. They are as quintessential as television and probably they became a common experience in our culture at around the same time.

**JL: They're truly functional spaces.**

JM: Yes, nothing has been added to them. For me, perhaps it's this lack of identity that makes them so interesting. But they are still emotionally loaded, even if they are anonymous. The important thing is that they are spaces of transition, of passage, to be used and then abandoned. No-one stays for longer than they need to. No-one seems to own them, there is no sense of responsibility for them, no desire to make them more than they are. They just exist down there.

**JL: You're playing with different perceptual and experiential modes. You have one very classical viewing position – a view from a bridge, standing at the threshold and looking out over a scene in front of you. And then you've juxtaposed this with a different kind of experience – the experience unfolds in a different way, it unfolds in time. And then there's a third space – the interstitial space.**

JM: This is probably the most difficult part of the space to articulate. Of all the times I have worked before, on big projects such as the Palacio de Velázquez in Madrid or at the DIA Foundation in New York, this is the space about which I know the least. This in-between space will hopefully counterbalance the other two.

**JL: You were saying that you hope the viewer will experience this work as they might experience being in a city rather than being in a museum.**

JM: Working on this project I have become more aware even than I wish to be about the role of the spectator and his or her circulation. I know that 10,000 people are going to be there some days, and I'm trying to build a work to which they can pay attention as if they were the only one there. I'm trying to individualise the act of looking and perceiving.

**JL: Does looking up help individualise the act? Would you imagine your piece in the same way if there were ten spectators a day?**

JM: I don't think I'm building the piece for a crowd of people, I'm making the piece for one, a given person at a given time. It makes no difference to me if that person is one of 10,000 or one of ten. Probably I'm making the piece for myself and trying to make a work that I could look at as if I were not the one who made it, but as somebody else. I don't like crowded museums and being aware of other people while I'm looking at something.

**JL: The dynamics of looking is something you've been working on for some twenty years now – from the very first sculptures with figures in balconies, to the more complex configurations in larger spaces.**

JM: I'm surprised how some of the very early ideas implied in the balconies seem to have reappeared in this work.

**JL: Why do you think that is?**

JM: I do not like to repeat myself, but sometimes I cannot help but use mechanisms of perception that I invented for myself and were necessary for me very early on. I haven't used the act of looking up so strongly since the very beginning. It is very strange to perceive so many years later that I'm paying so much attention to the act of walking through the street and looking up.

**JL: The implication of looking up somehow is that someone is looking down at you.**

JM: It's probably implicit. I hope that the elevators will create an extreme image, a compression of meaning, in the sense that it will accentuate all of these possibilities.

**JL: I remember early on in your career, maybe just after you made the balconies, that you spent quite a lot of time in Rome. The act of looking is dramatised in a very strong way there, especially in some of the great Baroque churches.**

JM: It takes a non-believer to construct a devotional space. That's something you learn in Rome. The great constructors of these interiors didn't necessarily believe in the conclusion at the altar.

**JL: They were being asked to respond to the possibility of belief disappearing?**

JM: I think that the great artists of the Baroque were being asked what modern artists are also being asked – to perform, to construct . . .

**JL: To construct what?**

JM: To construct a lie, to build a fictional place. To make the world larger than it is. In the Baroque period they had a multiplicity of media too. The church was a great cinema. You had the smells, the music, the clothing.

**JL: As if they wanted to envelop the visitor, to make sure they believed. But you don't believe it?**

JM: Sure I don't believe it. I'm the one who is painting the black hole!

**JL: You want people to believe it's a black hole, but also to know it's not?**

JM: You don't ultimately try to transcend the physicality of experience. Being in a given room, you receive a given experience. Many good modern artists are as skilful as the great old masters of the Baroque. You learn that very well from Joseph Beuys – how you install something in a room, the apparent disdain or indifference, the pretence that it is accidental. In a Beuys room you think the things have been abandoned by the transport people, but they're very carefully placed. You believe what he wishes you to believe. Smithson, in his *Spiral Jetty*, proved to be equally as brilliant as Borromini could be. We are confronted in modern times with the task of placing and displacing objects in a given environment. it requires an understanding of the physical framework, but also of the moment of the spectator's arrival into the room. You have to make this person trust for a second that what he wishes to believe is true. And maybe you can spin that into another reality and make him wonder.

**JL: The visitor to a Borromini church wanted to believe, and maybe the visitor to a Beuys performance did too. How can you think about belief today, in what is a fundamentally sceptical time?**

JM: The conviction has to originate in the gaze, because now we don't believe in anything but our eyes – and very soon we're going to disbelieve them too.

**JL: What do you want your spectator to believe in ?**

JM: Well. . . to believe. . . it's such a difficult word. It's such a big word, it's almost excluded from ordinary speech. You know what I want? The suspension of disbelief. Even if it's a cliché, it's still relevant: to let go of what you already know, even if just for a moment. For years, as a kid, I had a private tutor called Santiago Amon who was a brilliant scholar as well as a writer on art. One afternoon, as he was showing me a book of Mondrian's paintings, he just said to me 'Drown'. I did not understand then, but he was right. That's all that you can do. Either you drown or you do not. John Berger once said that the chair of Rietveld is not a chair but an act of faith.

**JL: Can you hope for a similar act of faith today?**

JM: It is a very different time. Most of the time if you walk through the big museums you can see that people don't look. Or maybe they look in a different way. They walk through museums as if they were walking in a modern street, like Walter Benjamin's idea of the arcade, strolling past elegant objects that they probably could not afford to buy. They are just surrounded by these images and these moments of luxury . . . And you are the maker of an object and you wonder what is your role is in relation to all this.

**JL: Can we just go back to the Baroque for a moment. The way in which these interiors constructed the position of the spectator seemed to make their place in the hierarchy quite clear – that there was a kind of power from above that almost enveloped the people inside.**

JM: Yes, but there is also an important role played by the view from below. These buildings were made to provoke a centrifugal sense of direction, to create a certain disorientation, even dizziness, as you look from the floor to the ceiling.

**JL: The figures in your studio at the moment, will they inhabit the space in-between the floor and the ceiling?**

JM: My studio, like the living room of a piano player, is not the best room in which to listen to the work. So we will have to see. Right now, all the figures seem to be moving . . . going away.

**JL: There's a feeling of looking for something?**

JM: I remember we were sitting in your kitchen not too long ago and you asked me why I came to London in the first place, back in the 1970s, and I said I came to London to look for my brother. I did find him, and I did find a small flat to rent, and I did find a job, and I did find a language I could deal with, in order to buy food and pay the rent; and I did find a culture that allowed me to respect myself as a contemporary European.

**JL: Why were you looking for your brother?**

JM: I was looking for my brother who was looking for David Cooper, a famous psychiatrist. Cooper was part of a group of analysts, along with R.D. Laing, who were rethinking parts of Gregory Bateson's theory of the 'Double Bind' as a way of dealing with schizophrenia.

**JL: Is the theory of the Double Bind important to this new project?**

JM: No, not really. The title of the piece came very late.

**JL: If you were looking for your brother, were you also looking for yourself? This brings us back to the idea of the duet or the double in a way.**

JM: Well, yes and no. No – it takes you to the idea of a subject. The idea of looking for a subject is extremely relevant. You construct the work and you adjust the construction to a kind of subject. With this work, I have forced every image to be an empty image. The elevators carry nobody. The windows lead nowhere. They imply the night, the closing down of the street, the moment of closure. Everything seems to be closed down. All of the figures have very tightly closed eyes.

**JL: Have you been surprised that your experience in London almost thirty years ago has somehow come into the present work?**

JM: It would be a mistake to think about this piece as a reinterpretation of my memory.

**JL: But it's in there somewhere?**

JM: If I had been asked to make this project in a museum in Berlin, or Los Angeles, I would not have had any personal experience, nor specific memories. I wanted the work to have an interior quality so I revisited the same streets, some of the same places I visited thirty years ago, so perhaps these memories did bring something to the work, help me shape it, because I am being asked thirty years later to perform in a city in which I grew up. On the other hand, I also spent some time in some cities in the Far East last year and that was very important too.

**JL: So you have the idea of a duet, the two lifts that come up and down, and the two levels, and yourself and your brother. There's an exploration of identity here. If you were looking for anyone else except your brother, maybe it would be different.**

JM: He came to London to look for a person. But the person whom he thought could help him was already an alcoholic so there was no hope. Cooper could not help him because he was already incapable of helping himself. The awareness of the impossibility does not make you any happier. You are striving for a solution but you do not find one. There is no poetry, no beauty, no sense attached to this kind of despair. You feel there is no way out, and that shapes your identity too.

**JL: Do you want to show people the emptiness?**

JM: You don't show the emptiness. You show the wish for it to be full. There is nothing rewarding in emptiness, in an empty elevator. I don't look back on the balconies as empty, they are about anything but themselves. They are images that are already there, already used. The balcony, the mirror, the back of the mirror. . .

**JL: The above and the below. The subconscious is so much bigger.**

JM: Yes – for all of us. I'm so happy that you point to the subconscious. It's a word that has been removed from the language of modernism. I'm surprised you even mention it. It seems as if we forget that there are hidden reasons. . .

REPRINTED FROM *DOUBLE BIND AT TATE MODERN* 2001

# Optical Illusion-Producing Rotating Toys

## JUAN MUNOZ

SANTIAGO DE COMPOSTELLA
SEPT. 1997

---

### content

#### I. ROTATING DRUMMER

a – Abstract . . . . . . . . . . . 07
b – Background . . . . . . . . . . 18
c – Summary of the sculpture . . . . 07
d – Drawings . . . . . . . . . . 07
e – Brief description of the drawings . . . . . 18

#### II. HANGING ACROBAT

a – Abstract . . . . . . . . . . 25
b – Background . . . . . . . . . 32
c – Summary of the sculpture . . . . . 34
d – Drawings . . . . . . . . . . 27
e – Brief description of the drawings . . . . . 36

#### III. FALLING DWARF

a – Abstract . . . . . . . . . . 39
b – Background . . . . . . . . . 48
c – Summary of the sculpture . . . . . 49
d – Drawings . . . . . . . . . . 42
e – Brief description of the drawings . . . . . 51

---

Fig. 3

---

Fig. 1

Fig. 2

# On a Registered Patent

ALBERTO IGLESIAS

Both *Building for Music* and *A Registered Patent* are works that deal with music. Somehow in *Building for Music* the ruins of the building are the music. The music doesn't simply illustrate a story, but is a motif or an element that bears witness to that story.

In *A Registered Patent* the text is the legal patent for an object, a box containing a small percussionist who is playing tiny instruments that also reproduce the small scale of the object. At that time I was working with John Malkovich on a film. The three of us met and John was delighted with the idea of working on a piece together. The idea was to produce a radio piece that would be performed live in London on the occasion of the exhibition at the Tate Modern, as an event to mark the closing of the show. But then Juan died and John Malkovich and I decided we would produce the piece anyway. I went to John's home in the south of France, in Provence, taking a recording system and the text with me. We moved to the upper floor, which was the quietest, and John sat down and read it to me in one go, it was as simple as that. We had a laugh and he read it again, section by section, so we would have more options.

All patents are formulated in a very repetitive, almost mannered fashion. They need repetitions in order to delimit all the legal terms; it's a very complex structure. However, Malkovich's rendering is extremely free-flowing, attaching importance to each cadence, each breath. The reading of the piece had a focal point, at which he stopped and lit a cigarette, creating a sort of essential silence. In a concert this would be the *cadenza*, i.e. when the soloist or the violinist is alone, without the orchestra, and adds something else that becomes the climax of the solo, a structure that almost resembles that of a concert. That's the point at which John went quiet and lit up his cigarette. Then he read the last passage. If the work consists of five sections, the cigarette takes place before the fifth. And that is the set arrangement of the piece, which I went on to alter very slightly. I didn't alter the flow of each phrase but I did create spaces for myself between phrases, so that the music could be woven into the text in a very natural way. Sometimes I toyed with the maximum synchrony of his diction and phrasing, and at other times I strayed from that and was much more elusive. We could say that the figure in *A Registered Patent* somehow comes to a stop, either due to the cold or to another external motive (that's what the text says). Before stopping, the percussionist plays a *largo rallentando*, almost imperceptible at first. The piece ends when the figure stops playing and the narrator leaves. Until that moment the text is repetitive, similar rooms succeed one another distinguished only by the music.

I ended up creating a radio piece because Juan had died, but it was originally a piece for radio and theatre. Given that Malkovich was involved in the making it would probably have had a special *mise en scène*.

FROM A CONVERSATION WITH BARTOMEU MARÍ, JANUARY 2005

# A Man in a Room, Gambling[1]

GAVIN BRYARS AND JUAN MUÑOZ

Each day, at precise moments throughout the day and night, the BBC broadcasts its Shipping Forecast on National Radio 4. It happens at 00.33, 05.55, 13.55 and 17.50. In this forecast what the attentive listener (i.e. the professional or amateur sailor) hears is information relevant to his geographical location within certain named regions. But given that these are broadcast without discrimination on national radio they are also heard by many casual listeners and form part of a dimly-perceived auditory experience out of which each radio listener attempts to visualise an intensely dramatic world with its wind speeds ('Severe Gale Force 9[2] imminent'[3]), its weather conditions and visibility ('Visibility Poor'[4]) and so on. The list of the maritime regions read out in sequence forms a kind of litany. It is always recited in the same order going round the British Isles in a clockwise direction from Viking in the extreme North North East through to South East. Iceland (with the addition of Trafalgar at 00.33 only) in the North North West. Those who listen with marginal alertness give some attention to their preferred region. For myself I occasionally give some care to the sequence from Tyne, through Dogger, Fisher, German Bight, Humber and Thames to Dover since that coincides with the area of the North East to South East coast which forms the bulk of my maritime interest and experience.[5] But this is a very limited form of focus and almost always the experience of hearing the Shipping Forecast (with additional reports from 'coastal stations') is a consequence rather of having tuned in early for the National News, which follows immediately afterwards, and therefore of being obliged to sit through the preceding brief programme. Nevertheless this experience gives virtually every listener in the British Isles a hazy impression of, what is at times, a quite dramatic activity taking place in areas whose precise locations are only vaguely sensed and the vague sense of continually unfolding meteorological phenomena. In a very real way these five minutes generate an emotionally powerful imaginary space.

In 1992 Artangel asked me to speak with Juan Muñoz about a possible collaboration. He was in England for an exhibition at the Hayward Gallery and, simultaneously, he was undertaking projects outside the gallery confines, this being Artangel's principle area of interest. One of the projects he realised was his *Untitled (Monument)* on the South Bank of the Thames, which gives the sense of being some kind of memorial but, in reality, (like many 'monuments') is a bogus testament to nothing at all. As such it provides the kind of double-take that was so much the key to many Fluxus pieces from the 1950s onwards (though I suppose a monument can hardly be said to be in 'flux'). This particular piece performed a similar function to Juan's spurious anthropology with his *Posa* in the elegantly presented pamphlet entitled *Segment*.[6]

The project which we developed, however, was for a sound piece and I was initially curious that a sculptor should be interested in working with a musician, especially on a project for radio. We met and found inevitably that we had many things in common – he had studied at Croydon Art College with Bruce Maclean at about the time I was teaching in the Environmental Design department; there were details in his iconography which mirrored my passion for *Twin Peaks* (the recurring dwarf, the patterned floors and so on). Coincidentally in 1992 I found myself devising a project for the Château d'Oiron in France only to find that Juan had a piece in a collective work already installed there, the *Jardin Bestiarium* – his *siffleur* (theatrical prompter) yet another example of the dwarf, and in the same year we both contributed to the Seville exhibition *Los Últimos Días*,[7] designed as a sardonic counterbalance to the millennium celebrations already in the offing. The idea that Juan had in mind for our collaboration was for us to create a series of pieces for radio. Naturally the idea of working with a sculptor in a non-visual medium was interesting and challenging, especially when it emerged that what we would be dealing with was the idea

of describing actions which themselves cause visual illusion and trickery, and placing them in some kind of broadcasting framework.

Our discussion about radio resurrected my long-standing interest in the work of Glenn Gould, whose highly original approach to recording techniques in record production was paralleled by a vision of radio as a creative medium ('Radio as Music').[8] Gould's device of constructing verbal material within, for example, the constraints of baroque counterpoint was particularly stimulating. Equally his subtle awareness of the balance between foreground and background in aural space is extraordinarily acute. At the end of Gould's *The Idea of North*[9] after about 50 minutes of skilfully constructed imaginary dialogue there is a poetic soliloquy in which the narrator (imposed as such by Gould's editing) Wally Maclean, muses on the relationship between the philosophy of William James and 'the idea of north'. This final sequence is accompanied by the last few minutes of Sibelius's *Fifth Symphony*, with the final *staccato* brass chords perfectly placed to underline the closing cadence of the narrator's emphatic verbal statement. It would appear that Gould had lined up the end of Sibelius's music with the last phrases of the voice and he seems to have accepted the consequence therefore of where the musical extract should begin. For the listener, however, the effect is the reverse. The listener gasps at the beauty of this accumulated tension with its apparently nonchalant release. In reality it is a virtuosic artifice, with the music being manipulated, with the lengths of spoken phrases being lengthened and with the final cadence given an enormous boost in its dynamic level.

Radio is a beautiful medium for many reasons. It stimulates the visual imagination; the listener can move between casual and attentive modes of listening; it moves inexorably through time, as well as being used as a way of measuring clock time (timing an egg to the duration of a medium duration new bulletin). It can also function as ambience, and indeed for a great deal of the time this is the preferred mode of attention for the 'listeners' of radio. On the other hand everyday life can equally serve as an unfocused (ambient) activity while the radio itself is playing – the preparation of a meal during a radio play for example. In the visual arts a relatively recent equivalent might be found within Fluxus and especially in the work of George Brecht. The question of whether there is any artwork there or not is often answered by the viewer's double-take, like a response to Brecht's *Silence* notice, for example. This almost immeasurable element between the work's existing or not resembles Duchamp's concept of 'infra-mince' where a series of imponderable spatial measurements is postulated (for example, quantifying the difference in the volume of air displaced by a shirt washed but not ironed, and the same shirt ironed).

For our project, which was called eventually *A Man in a Room, Gambling*, Juan wrote ten texts, each one describing the manipulation of playing cards – dealing from the bottom of the pack, avoiding failure in the Three-Card Trick, how to palm a card and so on. Some of this material was culled from the writings of the extraordinary Canadian S.W. Erdnase and especially from his book *The Expert at the Card Table*[10] which contains some of the most perfectly constructed sleights of hand in card manipulation. We decided that each would last exactly five minutes and would be placed before the last News of the evening on the radio so that the programme would be encountered, in Britain at least, in the same way as our encounters with the Shipping Forecast. For his part, Juan imagined a listener driving along a motorway at night being bemused by this fleeting and perhaps enigmatic curiosity, in fact precisely the way in which most listeners encounter the Shipping Forecast.

In recording the speaking voice, of course, Juan read each of the texts at his own pace and each one lasted a different length of time, varying in length from three minutes to four minutes thirty seconds. Each text therefore had to be manipulated both to make it fit

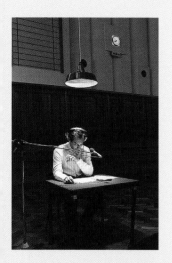

Fig.30 *A Man in a Room, Gambling* 1997, Commissioned and produced by Artangel

the five minutes format in terms of the overall duration and to establish the conventions whereby after four seconds after the start of the programme Juan would be heard to say 'Good Evening', and at precisely four minutes and fifty-two seconds he would say 'Thank you and Good Night.' In addition, and perhaps crucially, each of the ten five-minutes texts was accompanied by a string quartet playing at exactly the same tempo for each piece, giving an overall unifying texture to each five-minute piece and to the sequence of ten programmes. The music too uses quasi-Wagnerian leitmotif techniques. Like an apparently strict musical form it breaks the five minute whole into its structural parts – a descriptive preamble, the action of taking the cards, the development of the cards' manipulation and the revelation of what has been achieved. Various codes are established, for example the coincidence of the word 'now' in the phrase 'now take your cards' with a string *pizzicato*. The presence of the music also serves the additional function of intensifying the trickster's duplicity.

When a focused listener is trying to follow the instructions given by the speaker (his obviously 'foreign' Spanish accent reinforcing the xenophobe's feeling of distrust) he may encounter an occasional attractive passing melodic phrase in the music of the string quartet which takes his attention away from the description for a moment and once this happens he is immediately lost. In addition, within certain programmes (especially the fifth, seventh, ninth and tenth[11]) there are additional textual phrases in the form of brief repetitions of individual words by a Japanese speaker – who takes the implied role of an innocent bystander trying to practice the trick as the speaker describes it. Periodically these words are hopelessly wrong as when the Japanese speaker repeats each key word of a sentence, 'Little finger' – 'Little finger', 'Ring finger' – 'Ring finger', but occasionally 'Thumb' – 'Little finger' adding to the sense of spatial and conceptual dislocation. In addition, in the ninth programme, which is presented in an apparently improvisational way, the speaker claims to have lost his prepared text and offers another explanation of the Mexican Three-Card Trick, which has in fact been already described more formally in programme two. In the ninth programme, however, the ambience is changed further with the addition of environmental sounds (the street outside *tapas* bars near Seville Cathedral) as though the trick is in reality being performed in its habitual location viz. the street, as well as being reflected in the bafflement of the superimposed Japanese participant.

On occasions these pieces have been broadcast within the spirit of the collaborators' intentions – several times in Canada (Juan also took great pleasure in occasionally perform-ing them live,[12] which he did with great professionalism and panache – though, as he had never encountered before the need to acknowledge public applause, he was quite nervous about this aspect of performance) . The use of such public broadcast facilities widens the impact of Juan Muñoz's work in fields which have hardly been investigated as legitimate media for visual expression. The impact of such broadcasts is, of course, minimal and constitutes little more than a gentle prod. But then this is the essential nature of work in an ambient framework. In 1920 Satie rushed round the Gallerie Barbazanges[13] urging the interval audience to carry on talking and to ignore his *musique d'ameublement*. Much later Cage stressed the importance of being alive to sounds around us, of accepting so-called incidental sounds and of waking up to the very life we are living. *A Man in a Room, Gambling* attempts to bring together these varying approaches to musical focus and to create some-thing where in its very ambiguity resides its most appreciable strength.

## A Man in a Room, Gambling

### Programme 1

Good evening ... welcome once again to: *A Man in a Room, Gambling*.

As we mentioned yesterday, we are going to explain the second part of some of the most common card tricks that can be performed at a gambling table. Perhaps one of the most well-known is the apparently simple move of bottom-dealing ... we say 'simple' because most people who don't play cards professionally think that little skill is needed to take a card from the bottom half of the pack without being noticed ... it is true that this move does not demand intensive practice, like the double-lift or certain palming operations or the 'Mexican three-carded' ... but it is important to remember that while bottom-dealing at cards, just one unnatural movement will arouse suspicions.

Now, as on every evening ... take your pack of cards ... shuffle it ... take out roughly half the cards ... because dealing from the bottom is not usually done with a full pack ... it is much easier and more effective when the pack is slimmed down ... Professionals normally wait until the last rounds before dealing from the bottom.

Now, shuffle the half-pack but this time, as you are doing it, place one or more cards at the bottom of the pack ... if you feel comfortable use a riffle shuffle, otherwise do a hand shuffle ... then it will be enough for you to flick the cards ...

If you have already fixed the bottom of the pack, let us move on to today's subject: which is dealing cards from the bottom ...

Hold the pack in your left hand ... but don't grip it ... The middle finger and thumb will do all the work ... now push the top card out a little with your thumb, as if you were offering it for your right hand to deal ... at the same time, bend your ring finger backwards until the nail rests on the edge of the bottom card ... don't worry – this will be hidden by the card sticking out at the top ... now ... force the bottom card down slightly up and sideways with your thumb, pushing it out a little ... the top and bottom cards will be left jutting out of the pack in the same way. The upper card will conceal the bottom one perfectly.

Pay close attention because it only takes a second ... move your right hand as if to take the top card ... At the moment when your right hand reaches your left, at that precise moment ... pull your thumb back and draw back the top card, at the same time that the fingers of your right hand are taking the lower card ... did you see? ... did you see?

Tomorrow we will teach you how to deal from the bottom in stud poker or when you are turning over a trump in bridge.

Thank you and good night.

**Programme 3**

Good evening … we present: *A Man in a Room, Gambling.*

This evening we are going to show the easiest and most daring solution to a problem that has been called the card player's 'black hole'. It is the problem of cutting.

The professional gambler knows how to fix his cards before dealing. The false riffle and the palmed top pack are just two of the many subtle tricks of the trade … But every gambler, not just a professional, can fix some cards while he is shuffling … All you have to do, as you collect the cards from the table, is remember the order of an openly-discarded hand – either the discard itself or the last cards played on the table … Fifteen or twenty seconds are then more than enough to arrange three cards as you shuffle … If no one at the table cuts, you just have to deal from the bottom … but people do cut … at every gambling table the pack is cut after first being shuffled.

Now we will explain two ways of coming out of a cut with the cards in the same order that they had when the pack was shuffled … The first method should be used if you were cutting for a companion … who is on your side … the second cut if you are gambling on your own.

Now, as on every evening, take your pack of cards … shuffle … and arrange some of the cards at the top … here is the false cut … hold the pack by the sides near the end between the thumb and middle finger of each hand … holding the lower part with your left hand and the upper part with your right… draw the bottom pack up and forward with your left hand … bring it in towards you and drop it … move your right hand up a little and slide the upper pack back on top … the moves have to be quick and clean.

Now we will explain the second method. Take the pack again … shuffle it … lay it on the table … cut yourself as if you were going to be your own victim … good. Now pay attention to the moves because they are so simple that they need some audacity to be performed. Remember that you have to shift the cards around openly, casually and without haste. The important thing is that your movements should look quite normal.

Pay close attention … take the lower packet with your right hand … and instead of putting it on top of the other, slide it along the table up to your left hand … now, take the second pack … and put it on top in the same way …

Amazing … it's amazing.

Good night and thank you.

**Programme 10**

Good evening ... once again we present: *A Man in a Room, Gambling.*

During recent evenings, we have told you about some artifices and subterfuges that you can perform at a gambling table. All we are talking about is the ability to take whatever cards, deal them out, and turn them into a winning hand ... A few times, in this short exposition on the art and science of expert card handling, we have followed the opinion of the Canadian master, S.W. Erdnase ... that the professional is more in love with chance than with gambling as such. And it is true: what mainly distinguishes the professional is that he is driven by his love of the act of gambling, while others are motivated by greed ... It is almost a rule that the beginner will win his first hand at a poker table, but will rarely have his money intact after the first hour ...

Talking of cards, we have shown in these evenings how to join or separate them ... and how to place them where you want while you are casually shuffling ... We have explained how to deal yourself an extra card and how to get rid of it in a natural and elegant way ... We have taught you how to do a false cut, and some of the ways of arranging cards while you shuffle ... In this programme, we are going to go over one of the routines again, although perhaps a little more briefly than we did last time. More than any other, this is the artifice, which, if done properly, allows the professional gambler to increase his winnings so that he can then fritter them away. We are talking of dealing from the bottom of the pack.

As on every evening, take your pack ... shuffle ... remove roughly half the cards ... because dealing from the bottom is not usually done with a full pack ... it is easier and more effective when it is slimmed down. It is a norm among professionals to wait until after the discard before dealing from the bottom ... good ... good ... Shuffle the half-pack again, but this time, as you are doing it, put one or more cards at the bottom of the pack ...

Let's begin ... hold the pack in your left hand ... don't grip it tightly ... your middle finger and thumb will do all the work ... push the card out a little with your thumb ... out, as if you were offering it for your right hand to deal ... at the same time, bend your ring finger back until the tip is resting on the rim of the bottom card ... don't worry... this will be hidden by the card sticking out at the top ... now, push the bottom card a little up and sideways with your thumb ... push upwards... notice that the top and bottom cards stick out the pack in the same way ... the top one perfectly conceals the bottom ... good ... Let's continue ... and now pay close attention because it all lasts a second ... move your right hand as if to take the top card ... and at the moment when your right hand reaches your left hand; at that precise moment ... draw back your thumb and pull the top card back, while your right fingers take the bottom card. Did you see? ... Did you see? ...

Thank you very much for being with us ... Good night, and lots of luck.

# Chronology

**1953**
Born 17 June in Madrid, the second of seven children, to Vicente and Hermenia Muñoz.

**1966–70**
Sent to boarding school briefly after being expelled from grade school, 1966–7. Attends Colegio Alameda de Osuna in Madrid, where he is taught by Santiago Amón, editor of *Nueva Forma* and art historian and critic for *El País*. Amón also tutors Muñoz and his brother, Vicente, privately at their home.

**1970–5**
Briefly studies architecture at the University of Madrid. Moves to London with Vicente in October 1970. Travels widely in Europe and lives in Stockholm for fourteen months. Briefly considers pursuing filmmaking; in Madrid, makes a short, 16-mm film documenting public sculpture.

**1976–7**
Receives a British Council scholarship and attends Central School of Art and Design, London (now known as Central Saint Martins College of Art and Design); awarded a Special Advanced Studies in Printmaking (lithography) certificate. Experiments with sculptures that involve sound, tape recorders, moving audiotape, body imprints, and weight and balance.

**1979–80**
Receives another British Council scholarship and attends Croydon School of Art, London (now known as Croydon College), where he completes coursework in advanced printmaking. Meets Spanish art student Cristina Iglesias, whom he later marries. In Malaga, erects a makeshift temporary minaret in the Plaza de Toros.

**1981**
Attends Pratt Graphic Centre, New York. Receives a Fulbright Fellowship through the North American Spanish Committee. Serves as artist-in-residence at P.S.1 Contemporary Art Center, Long Island City, New York. Conducts interview with Richard Serra.

**1982**
Lives in Torrelodones, northwest of Madrid. Curates, with Carmen Giménez, the exhibition *Correspondencias: 5 arquitectos, 5 escultores*; for the exhibition's catalogue publishes his first essay, 'Notes on Three'.

**1983**
Curates a second exhibition, *La imagen del animal: Arte prehistórica, arte contemporáneo*. Abandons curatorial work to concentrate on sculpture. Makes his first welded-metal sculptures.

**1984**
Makes his first balcony and staircase sculptures. First solo exhibition, *Juan Muñoz: Últimos trabajos*, is held at Galería Fernando Vijande, Madrid (for a complete exhibition history, see pp.165–9)

**1986**
Exhibits sculpture *North of the Storm* in the Aperto 86 section of the Venice Biennale, along with a

45-rpm recording of the same title he created with his brother-in-law, composer Alberto Iglesias. Makes *The Wasteland* (p.22), his first work to feature a floor element with a human figure.

**1987**
First solo museum exhibition, *Juan Muñoz: Sculptures de 1985 à 1987*, is held at Capc Musée d'Art Contemporain, Bordeaux.

**1988**
Makes *Dwarf with Three Columns* (p.25), his first sculpture to include a dwarf. Makes his first 'raincoat drawing'.

**1989**
Makes his first bronze sculptures, a series of ballerinas. Collaborates with the Belgian architect Paul Robbrecht on *A Room for a Doctor of Pain*, an installation at Galería Marga Paz, Madrid, 14–19 April, that features an actual-sized reconstruction of the waiting and surgical rooms of a Belgian doctor. Daughter, Lucia, is born.

**1990**
First solo museum exhibition in the United Sates is held at The Renaissance Society at The University of Chicago; in lieu of an exhibition catalogue, *Segment*, the artist's longest essay to date, is published.

**1991**
Makes first 'conversation piece' sculpture. Creates illustrations for an edition of Joseph Conrad's *An Outpost of Progress* (pp.54–7), the studies for which are exhibited in 1992 at Frith Street Gallery, London. Moves to London and rents a studio in Trastevere.

**1992**
Lives in Rome. Receives commission for two works from James Lingwood of Artangel, London: *Untitled Monument (London)*, a temporary outdoor monument on the South Bank of the River Thames, and *A Man in a Room, Gambling*, a series of ten five-minute sound works made in collaboration with composer Gavin Bryars and conceived for the late-night listener. *A Man in a Room, Gambling* is broadcast on public radio stations in Great Britain, Canada, Germany, Austria, and Scandinavia. Muñoz receives commission from Gloria Moure for the Olimpíada Cultural Barcelona '92, for which he creates *A Room Where It Always Rains*, a permanently sited outdoor sculpture at the Plaça del Mar, Barcelona. Makes sound tape *Third Ear* (with critic Adrian Searle) for radio broadcast by the BBC. Invited by the BBC to participate in *Building Sites Europe*, a television series devoted to contemporary architecture in Europe; selects José Rafael Moneo's Museo Nacional de Arte Romano in Merida to discuss on the show. Makes the sound tape *Building for Music* with Alberto Iglesias.

**1993**
Completes *Two Figures for Middelheim* for the Openluchtmuseum voor beeldhouwkunst Middelheim, Antwerp. Makes *Stuttering Piece* (p.44), his first figurative sculpture to include sound. The sound tape *Building for Music* is broadcast on the radio during the

1993 exhibition *Sonsbeek 93*, in Arnhem, The Netherlands.

**1994**
Solo exhibition at Irish Museum of Modern Art, Dublin, features *Conversation Piece (Dublin)*, the artist's largest outdoor sculpture (with twenty-two figures), and the sound piece *Doors of My House*; in conjunction with the exhibition, the museum later publishes *Silence please!: Stories after the Works of Juan Muñoz* (1996), with short stories by John Berger, William Forsythe, Dave Hickey, Patrick McCabe, Alexandre Melo, Vik Muniz, Quico Rivas, Luc Sante, Adrian Searle, Lynn Tillmann, and Marina Warner.

**1995**
Serves as artist-in-residence at Isabella Stewart Gardner Museum, Boston. Son, Diego, is born.

**1996**
Two major solo exhibitions open: *Juan Muñoz: Monólogos y diálogos* organised by James Lingwood, at Palacio Velázquez, Museo Nacional Centro de Arte Reina Sofia, Madrid (travels in 1997 to Museum für Gegenwartskunst Zürich), and *A Place Called Abroad* at Dia Center for the Arts, New York (travels in 1998 to SITE Santa Fe, New Mexico, as *Streetwise*). Directs *Will It Be a Likeness?*, written by Muñoz and John Berger and acted by John Berger and others at Theater am Turm, Frankfurt; the performance is broadcast by Hessischer Rundfunk and other German radio stations (winning 'Hörspiel des Jahres 1996' for best radio program in Germany) and by the BBC (transcript published with illustrations by Muñoz in John Berger, '¿Será un retrato?', *Arte y parte*, no.32 [April–May 2001], 36–49).

**1997–9**
Gavin Bryars Ensemble performs *A Man in a Room, Gambling* in public concerts at BBC Studio One, London, September 1997. In the same year, these sound works are released on compact disc. Muñoz collaborates with Berger on *A Correspondence About Space*, a lecture and performance at the Geheimnisse der Raumproduktion, Hamburg, May 1998. *Will It Be a Likeness?* is performed at Thik Theatre im Kornhaus, Baden, Switzerland, November 1999.

**2000**
Awarded the Premio Nacional de Artes Plásticas by the Spanish government. Receives commission in The Unilever Series for work in the Turbine Hall, Tate Modern, London.

**2001**
In June *Double Bind*, Muñoz's commission for The Unilever Series at Tate Modern, London, is unveiled. Audio piece *A Registered Patent*, with music by Alberto Iglesias and the voice of John Malkovich, presented at Documenta.

Dies on 28 August in Ibiza.

# Notes

### Director's Foreword

1. *A Man up a Lamppost (Between British Sculpture and Sculpture Itself*, first published as *Un hombre subido o una farola in Madrid, Palacio de Velazquez, Entre el objecto y la imagen: Escultura britanica contemporanea*, Madrid and London, Ministerio de Cultura, Dirección General de Bellas Artes y Archivos and The British Council, 1986, reprinted in Hirshhorn catalogue p.62
2. 'A Conversation, May 2001' Juan Muñoz and James Lingwood, *Double Bind at Tate Modern*, 2001, p.75

### A Mirror of Consciousness Sheena Wagstaff

1. 'A Conversation', New York, 22 January 1995, p.44.
2. Juan Muñoz in Paul Schimmel, 'An Interview with Juan Muñoz', 18 September 2000, in *Juan Muñoz*, Hirshhorn Museum 2001, p.147.
3. Ibid.
4. See essay by Rosalind Kraus in *Joel Shapiro*, Museum of Contemporary Art, Chicago, September 1976, p.12.
5. Participants in the exhibition were architects Emilio Ambasz, Peter Eisenman, Frank Gehry, Leon Krier and Robert Venturi with artists Eduardo Chillida, Mario Merz, Richard Serra, Joel Shapiro and Charles Simonds.
6. 'Notes on Three', reprinted in Hirshhorn Museum exh. cat., p.57.
7. See T.S. Eliot, 'Notes on the Wasteland', *The Complete Poems and Plays of T.S. Eliot*, London 1969, p.76.
8. Originally published 1890. See abridged edition, edited by Robert Fraser, Oxford 1994.
9. Eliot, p.65.
10. Juan Muñoz, *Conversaciones*, IVAM Centre del Carme, Valencia, 1992.
11. Ibid.
12. Ibid., p.8.
13. Verified by his friend Vicente Todolí, with whom he shared an interest in film.
14. See Kent Jones, 'Film Comment', The Criterion Collection website.
15. For a detailed study of ventriloquism see Steven Connor, *Dumbstruck: A Cultural History of Ventriloquism*, Oxford 2000 – a book owned and notated by Muñoz.
16. See Maurice Merleau-Ponty, *Phenomenology of Perception*, trans. Colin Smith, London, New York 1996, p.84.
17. Quoted by Neal Benezra, *Juan Muñoz 2001*, Hirshhorn Museum exh. cat., from Jan Braet, 'Fluiten in het donker', *Knack*, no.48 (December 1991), p.111; trans.Eric McMillan.
18. Juan Muñoz and James Lingwood, 'A Conversation', May 2001, *Double Bind at Tate Modern*, London, 2001, p.70.
19. Schimmel, *Juan Muñoz 2001*, p.147.
20. First published in French as *Mon Dernier Soupire* (1983).
21. When one band meets another, they start duelling until all drummers fall into an agreed rhythm, at which point they move onto the next battle. As he said more than once, Buñuel felt that the drumming expressed his philosophy that life is rhythm, a power of communication beyond reason that permeates everything that exists, its oscillation always laying bare a space or silence between, a moment between beats, like a threshold between two places.
22. First published as 'El rostro de Pirandello/

The Face of Pirandello' in Gloria Moure, *Urban Configurations*, Barcelona 1994.
23. Juan Muñoz, notebook dated 1983.
24. Schimmel, *Juan Muñoz 2001*, p.146.
25. Quoted in 'A Conversation between Juan Muñoz and Jean-Marc Poinsot' in *Juan Muñoz: Sculptures de 1985 à 1987*, Capc Musée d'Art Contemporain, Bordeaux, p.44.
26. See reference by Muñoz to Romano and Bruno in interview, *Possible Worlds*, Institute of Contemporary Arts, London, and Serpentine Gallery, London 1990, p.59.
27. Ibid.
28. *Theatergarden Bestiarium: The Garden as Theater as Museum*, The Institute for Contemporary Art/P.S.1 Museum, Long Island City, New York 1990, p.50.
29. *Possible Worlds* 1990, p.60.
30. See the groundbreaking cultural study of corporeal difference, which refines the concept of difference itself, ed. Rosemarie Garland Thomson, *Freakery: Cultural Spectacles of the Extraordinary Body*, New York 1996.
31. Leo Steinberg, 'Velázquez's Las Meninas', October 19 (Winter) 1981, pp.45–6.
32. Schimmel, *Juan Muñoz 2001*, p.147.
33. See Avigdor W. Poseq, 'On Creative Interpretation: Igael Tumarkin's Homage to Velazquez's Las Meninas', *Konsthistorisk Tidskrift* 69, no.1, 2000, pp.33–4.
34. See Estrella de Diego, 'Representing Representation' in *Velázquez's Las Meninas*, ed. Suzanne L. Stratton-Pruitt, Cambridge 2003, p.155. In his preface, Foucault attributes the genesis of The Order of Things to an essay by Jorge Luis Borges (Jorge Luis Borges, 'The Analytical Language of John Wilkins' in *Jorge Luis Borges, Selected Non-Fiction*, trans. and ed. Eliot Weinberger, New York 1999): 'This book first arose out of a passage in Borges, out of the laughter that shattered, as I read the passage, all the familiar landmarks of thought ... to disturb and threaten with collapse our age-old definitions between the Same and the Other.' (Michel Foucault, *The Order of Things: An Archaeology of Human Sciences*, London 1970, p.xv) It is Borges's description of his discovery of 'a certain Chinese encyclopedia entitled "Celestial Empire of Benevolent Knowledge"' in which a curious taxonomy of animals begins: '1. those that belong to the Emperor, 2. embalmed ones, 3. those that are trained, 4. suckling pigs', and so on, that encouraged Foucault to attempt to find a common territory, a new taxonomy in which the antagonistic categories, the Same and the Other, could meet. He concluded: 'Where else could they be juxtaposed except in the non-place of language?' (Foucault, p.xvii).
35. Thomas McEvilley, *Art & Otherness: Crisis in Cultural Identity*, Documentext series McPherson & Co 1992), p.104. In Muñoz's library.
36. Benezra, 'Sculpture and Paradox', *Juan Muñoz 2001*, p.43.
37. A Conversation between Juan Muñoz and James Lingwood, 'Monologues and Dialogues', September 1996, Museo Nacional Centro de Arte Reina Sofia, Madrid 1996, p.159.
38. T.S. Eliot, 'Ash Wednesday', *Collected Poems*, 1930 – a poem in Muñoz's library.
39. Schimmel, *Juan Muñoz 2001*, p.150.
40. See Steinberg 1981, pp.54.

41. Muñoz and Lingwood 1996, p.71.
42. Schimmel, *Juan Muñoz 2001*, p.149.
43. Muñoz and Lingwood 1996, p.74.
44. 'Borromini-Kounellis: On the Luminous Opacity of Signs', first published as 'De la luminosa opacidad de los signos: Borromini-Kounellis', *Figura*, no.6 (fall 1985), pp.94–5, republished in *Juan Muñoz 2001*, Hirschhorn exh. cat., p.60.
45. *Possible Worlds* 1990, p.59.
46. T.S. Eliot, 'East Coker', *Four Quartets*, *The Complete Poems*, p.183.

### To Double Business Bound Michael Wood

1. Juan Muñoz and James Lingwood, 'A Conversation, May 2001', *Double Bind at the Tate Modern*, exh.cat, Tate 2001.
2. Paul Schimmel, 'An interview with Juan Muñoz', *Juan Muñoz*, exh.cat., Art Institute of Chicago/Hirshhorn Museum/ Smithsonian Institution 2001, p.150.
3. 'The Face of Pirandello', *Juan Muñoz*, ibid, p.79.
4. Muñoz and Lingwood, 'A Conversation, New York, 22 January 1995', *Parkett*, No.34, 1995, p.27.
5. Ibid, p.26.
6. Muñoz and Lingwood, 'A Conversation, May 2001', p.77.
7. 'A Conversation, January 1995', p.29.
8. 'A Conversation, May 2001'. p.73.
9. Lynne Cooke, 'Juan Muñoz, 'Interpolations', in *Juan Muñoz*, Dia Center for the Arts, New York 1999.
10. Schimmel, *Juan Muñoz 2001*, p.150.
11. Quoted in Neal Benezra, 'Sculpture and Paradox', *Juan Muñoz*, Art Institute of Chicago/Hirshhorn Museum/Smithsonian Institution 2001, p.38.
12. 'A Conversation, July 1990', p.67.
13. 'On a Square', *Juan Muñoz*, Art Institute of Chicago/Hirshhorn Museum/Smithsonian Institution 2001, p.68.
14. 'A Conversation, January 1995', p.26.
15. 'The Prompter', *Juan Muñoz*, Art Institute of Chicago/Hirshhorn Museum/Smithsonian Institution 2001, p.66.
16. 'A Conversation, July 1990', p.64.
17. 'A Conversation, May 2001', p.67.

### Muñoz's Sculptural Theatre Alex Potts

1. Juan Muñoz, *Double Bind at Tate Modern*, London 2001, p.71. 'I'm not interested in scenography.'
2. Neal Benezra and others, *Juan Muñoz* (Washington, D.C.: Hirshhorn Museum and Sculpture Garden, 2001), p.146.
3. Lynne Cooke, *Juan Muñoz*, New York 1999, p.6.
4. Benezra, *Juan Muñoz 2001*, p.150. See also Iwona Blazwick and others, *Possible Worlds. Sculpture from Europe* (London: ICA and Serpentine, 1990), p.58
5. Muñoz, Conversation 1995, p.43
6. Muñoz, Conversation 1995, pp. 43, 45, Benezra, *Juan Muñoz 2001*, p.150.
7. One of the more striking of these is the figure *Fall 91* (1992), an image of which can be found under 'ray fall91' at http://www.broadartfoundation.org/images/artwork/.
8. Muñoz, Conversation 1995, p.44
9. Benezra, *Juan Muñoz 2001*, p.150
10. Ibid., p.148
11. Edward Allington and others, *Katharina Fritsch*, exh.cat., Tate 2002, pp.98, 112.
12. Muñoz, Conversation 1995, p.42, Blazwick,

*Possible Worlds* 1990, p.61; Benezra, *Juan Muñoz* 2001, p.149

13. Benezra, *Juan Muñoz* 2001, p.148.

14. Ibid., p.78.

15. Both Donald Judd and Richard Serra singled out Giacometti's standing figures as exceptions to the largely object-based character of modern sculpture and commented on their unusual capacity to activate the space around them. Alex Potts, *The Sculptural Imagination. Figurative, Modernist, Minimalist*, New Haven and London, 2000, pp.121, 260–1.

16. The work is illustrated at http://www.thomas-schuette.de/website_content.php; and in Julian Heynen and others, *Thomas Schütte*, London, 1998, p.106 (top). Thomas Schütte's over life-size aluminium *Grosse Geister*, when displayed together in a gallery, did have certain affinities with similarly installed works by Muñoz (such as *Many Times* as shown in the Museum of Contemporary Art, Los Angeles in 2002, displayed on a raised area that this time one was invited to enter). The viewer would enter an arena in which inarticulate, random seeming, fairly crude interactions were staged from which she or he was excluded (Plate 7). Schütte's installations of small scale gesturing aluminium figures of this kind he exhibited in 1995, in the same year as the *Grosse Geister*, create a more 'socialised', less grotesquely alien, effect (illustrated in *Thomas Schütte* 1998, pp.102–5).

17. Blazwick, *Possible Worlds* 1990, p.58.

18. Muñoz, *Conversation* 1995, pp.44–5.

19. Ibid., p.61.

20. *Juan Muñoz*, Valencia: Instituto Valenciano de Arte Moderna (IVAM) Centre del Carme, 1992.

21. Quoted in Benezra, *Juan Muñoz* 2001, p.50.

22. Ibid., p.79.

23. *Juan Muñoz*, exh.cat. Krefeld: Museum Haus Lange 1991.

24. Benezra, *Juan Muñoz* 2001, pp.70, 71. The catalogue is reproduces in full this and a number of other key texts by Muñoz.

25. Ibid., pp.74, 75.

26. Luigi Piranello, *Collected Plays*, Volume 2, London and New York 1988, pp.57–8.

27. Muñoz, *Double Bind* 2001, pp.71–2.

28. Ibid., p.70.

29. Ibid., p.74.

### Juan Muñoz: Insights and Interpretations
### Manuela Mena

1. For an interpretation of this work, see Manuela Mena, '¿El bufón Calabacillas?' in *Velázquez*, Madrid 1999, 297–334.

2. Iwona Blazwick, James Lingwood, Andrea Schliecker, 'Juan Muñoz. A Conversation', July 1990, in James Lingwood, *Juan Muñoz. Monologues and Dialogues*, exh. cat. *Juan Muñoz*, February–May 1997, Zurich, Museum Für Gegenwartskunst, 64 and 95.

3. Antonio Palomino, *El museo pictórico y escala óptica: el Parnaso español pintoresco y laureado* (1715–1724), Madrid 1947.

4. Paul Schimmel, 'An interview with Juan Muñoz', *Juan Muñoz*, exh.cat., Art Institute of Chicago/ Hirshhorn Museum/Smithsonian Institution 2001, pp.145–50.

5. Cristina Carrillo de Albornoz, 'Juan Muñoz más allá de la escultura', *Descubrir el arte*, no.28, 2001, 72–6.

6. James Lingwood, *Juan Muñoz. Monologues and Dialogues* 1997, p.124

7. Schimmel, *Juan Muñoz* 2001.

### Lecture at Isabella Stewart Gardner Museum

1. In an interview the year before he died, Muñoz mentioned that 'For years I used to write, though I have written very little in the last four or five years. I have written only one thing – "A Standard Introduction to Lectures." It's about the difference between the moment of writing and the moment of knowing that you will hear yourself speaking these words that you are writing now.' ('An Interview with Juan Muñoz' by Paul Schimmel in *Juan Muñoz* 2001, p.149)

Munoz's text 'A Standard Introduction to Lectures' (published in Gargarin, *The Index of Artists' Writings*, Municipal Academy of Fine Arts of Waasmunster, 2000) is an edited and shortened version of an earlier (unpublished) text, written by Muñoz as a lecture to accompany his installation, which was inspired by a watercolour entitled *Seated Scribe* 1479–81 by Gentile Bellini at Isabella Stewart Gardner Museum in 1996.

The text reproduced here is the corrected transcript of Muñoz's actual lecture, which, in its delivery to a Boston audience, clearly departed from the text he had originally written.

### A Man in a Room, Gambling Gavin Bryars

1. Published for the first time by *Parkett*, 43, 1995, pp. 52–61. Reprinted here with slight modifications by the author. The three episodes reproduced here give a sense of the sequence and varying content of this work.

2. Severe Gale: winds of Beaufort force 9 (41–47 knots) or gusts reaching 52–60 knots.

3. Imminent: expected within 6 hours of the time of issue.

4. Visibility poor: Visibility between 1,000 metres and 2 nautical miles.

5. My elder brother went to sea when I was a schoolboy, and I would look regularly in Goole Public Library at the journal Lloyds' List, which published precise details of the whereabouts of all merchant shipping on a daily basis.

6. Juan Muñoz, *Segment*, Centre d'Art Contemporain Genève and The Renaissance Society at the University of Chicago, 1990.

7. Los Últimos Días, Pabellón de España, Expo'92, Sevilla, 1992.

8. See Glenn Gould, 'Radio as Music: Conversation with John Jessop' in Page, Tim and Knopf, Alfred A. (ed.) The Glenn Gould Reader, New York 1984, pp.373–88.

9. Glenn Gould, *The Idea of North*, CBC Records, Toronto, 1967.

10. Reprinted as Daniel Ortiz, *The Annotated Erdnase*, Pasadena, California, 1991.

11. The tenth and final programme is the only one in which the principal speaker, Juan, mentions S. W. Erdnase by name. When it happens it is reinforced excessively by the Japanese voice and by an overwhelming reverberation in the sound. The Japanese voice, acting as a quasi-chorus, also interjects 'Goodnight S.W. Erdnase' before Juan's 'Goodnight' at the end of programme seven.

12. He had been very nervous when called from the audience to take a bow after a performance at his exhibition at the Palazzo Velasquez. He performed live for the first time at the BBC Maida Vale Studios in 1997, then subsequently at the Fondation Cartier in Paris, and also for a German TV programme about Gavin Bryars, filmed in 1999.

13. The first example of 'furniture music' was written by Satie in 1920 for the interval of a play by Maxime Jacob and Satie desperately tried to prevent people listening to the music rather than carry on their normal interval drinking.

# Select Bibliography

*Sources are ordered chronologically, and, within years, alphabetically. Interviews with the artist are listed separately, on p.171; the artist's writings are listed on p.170.*

## Solo Exhibition Catalogues And Brochures

**1984**
- Madrid, Galería Fernando Vijande, *Juan Muñoz: Últimos trabajos*, F. Vijande

**1987**
- Bordeaux, Capc Musée d'Art Contemporain, *Juan Muñoz: Sculptures de 1985 à 1987*, Jean-Marc Poinsot

**1990**
- Chicago, The Renaissance Society, University of Chicago, *Juan Muñoz: Segment*: travelled to Geneva, Centre d'Art Contemporain

**1991**
- Eindhoven, The Netherlands, Stedelijk Van Abbemuseum, *Juan Muñoz: Sculpturen, installaties en tekeningen*
- Krefeld, Germany, Museum Haus Lange, *Juan Muñoz: Arbeiten 1988 bis 1990*, Julian Heynen, Krefeld: Krefelder Kunstmuseum

**1992**
- Valencia, Instituto Valenciano de Arte Moderno (IVAM) Centre del Carme, *Juan Muñoz: Conversaciones*, Vicente Todolí

**1994**
- Nîmes, Carré d'Art-Musée d'Art Contemporain, *Juan Muñoz*, Guy Tossatto.

**1995**
- Boston, Isabella Stewart Gardner Museum, *Juan Muñoz: Portrait of a Turkish Man Drawing*, Jill Medvedow
- Santiago de Compostela, Spain, Centro Galego de Arte Contemporánea, *Juan Muñoz*, Gloria Moures

**1996**
- Madrid, Palacio de Velázquez, Museo Nacional Centro de Arte Reina Sofía, *Juan Muñoz: Monólogos y diálogos/Monologues and Dialogues*, James Lingwood: translated and revised for Zurich, Museum für Gegenwartskunst Zürich, as *Juan Muñoz: Monologe und Dialoge/Monologues and Dialogues*, James Lingwood (1997)
- Muñoz, Juan, et al. *Silence please! Stories after the Works of Juan Muñoz*. Dublin and Zurich: Irish Museum of Modern Art and Scalo (published in lieu of an exh. cat. in conjunction with Dublin, Irish Museum of Modern Art, *Juan Muñoz: Sculpture, Drawings and Installation*, 6 July–4 August 1994)
- New York, Dia Center for the Arts, *Juan Muñoz: A Place Called Abroad*, Lynne Cooke
- Turin, Marco Noire Contemporary Art, *Juan Muñoz: Mobiliario, grabados 1996*, Jorge Marsá. Lanzarote: Linea

**1997**
- Washington, D.C., Hirshhorn Museum and Sculpture Garden, Smithsonian Institution. *Directions: Juan Muñoz*, Neal Benezra

**1998**
- Santa Fe, N. Mex, SITE Santa Fe. *Streetwise*, Lynne Cooke

**1999**
- Miengo, Spain, Sala Robayera, *Juan Muñoz: Certain Drawings in Oil and Ink/Algunos dibujos en óleo y tinta 1996–1988*
- New York, Dia Center for the Arts, *Juan Muñoz*, Lynne Cooke

**2000**
- Humlebæk, Denmark, Louisiana Museum for Moderne Kunst, *Juan Muñoz: The Nature of Visual Illusion*, Adrian Searle and Åsa Nacking

**2001**
- London, Tate Modern, *The Unilever Series: Juan Muñoz – Double Bind*
- Washington D.C, Hirshhorn Museum and Sculpture Garden, *Juan Muñoz*. Travelled to: Los Angeles, Museum of Contemporary Art; Chicago; The Art Institute of Chicago; Houston, Contemporary Art Museum

**2005**
- Madrid, La Casa Encendida, *Juan Muñoz. La vos sola – Encultras, dibujos y obras para la radio*

**2006**
- Düsseldorf, Kunstsammlung Nordrhein-Westfalen, *Juan Munoz – Rooms of My Mind*
- New York, Marian Goodman Gallery

**2007**
- France, Grenobla, *Juan Muñoz – Sculptures et dessins*

## Group Exhibition Catalogues and Other Books

**1981**
- Fribourg, Switzerland, *Fri-art 81*, exh. cat

**1982**
- Berlin, *Büro Berlin*, exh. cat

**1983**
- Madrid, Galería Fernando Vijande. *Seis españoles en Madrid*, exh. cat
- Madrid, Palacio de las Alhajas, Caja de Ahorros y Monte de Piedad. *La imagen del animal: Arte prehistórico, arte contemporáneo*, exh. cat. Juan Muñoz, Madrid: Ministerio de Cultura with the collaboration of The British Council

**1985**
- Eindhoven, The Netherlands, Stedelijk Van Abbemuseum. *Christa Dichgans, Lili Dujourie, Marlene Dumas, Lesley Foxcroft, Kees de Goede, Frank van Hemert, Cristina Iglesias, Harald Klingelhöffer, Mark Luyten, Juan Muñoz, Katherine Porter, Julião Sarmento, Barbara Schmidt Heins, Gabriele Schmidt-Heins, Didier Vermeiren.* Exh. cat. Jan Debbaut and Rudy Fuchs

**1986**
- Fontevraud, France, Abbaye Royale de Fontevraud, Fonds Régional d'Art Contemporain (FRAC) des Pays de la Loire, *Ateliers internationaux des pays de la Loire*, November–December, exh. cat.
- Ghent, Museum Van Hedendaagse Kunst, *Chambres d'amis*, Exh. cat. Jan Hoet
- Madrid, Consejería de Cultura de la Junta de Andalucía, *Bienal de Venecia: Aperto 86–Cuatro artistas españoles: XLII Biennale de Venezia*, exh. cat. Kevin Power et al
- Madrid, Palacio de la Moncloa, *Arte joven en el Palacio de la Moncloa*, exh. cat. Carmen Giménez Martín
- Madrid, Sala de Exposiciones de la Fundación Caja de Pensiones, *Pintores y escultores españoles 1981–1986*, exh. cat. Maria Corral and Kevin Power, Barcelona: Fundación Caja de Pensiones
- Paris, Abadía de Fontevraud, *Ateliers Internationaux des Pays de Las Loire*
- Seville, Pabellón Mudéjar, *Diecisiete artistas, diecisiete autonomías*, exh. cat. Marga Paz., Seville: Consejería de Cultura, Junta de Andalucía
- Venice, 42nd Venice Biennale, *XLII esposizione internationale d'arte, la Biennale de Venezia: Arte e scienza*, exh. cat. Lynne Cooke et al, Venice and Milan: Edizioni La Biennale and Electa
- Venice, Edizione La Biennale di Venezia, *Aperto '86, Curato artistas espanoles*
- Zamora, Spain, VII Bienal de Escultura de la Ciudad de Zamora, *Escultura ibérica contemporánea*, exh. cat. Javier González de Durana and Kosmé María de Barañano

**1987**
- Amsterdam, De Appel, *Nightfire*, exh. cat.
- Fontevraud, France, Abbaye Royale de Fontevraud, Fonds Régional d'Art Contemporain (FRAC) des Pays de la Loire. *Juan Muñoz*, exh. cat. José-Luis Brea (published in conjunction with Fontevraud, France, Abbaye Royale de Fontevraud, Fonds Régional d'Art Contemporain (FRAC) des Pays de la Loire, *Lili Dujourie/Juan Muñoz*, summer)
- Paris, ARC-Musée d'Art Moderne de la Ville de Paris, *Espagne 87: Dynamiques et interrogations*, exh. cat.
- San Sebastian, Spain, Fondos del Museo de Bellas Artes de Álava Vitoria-Gasteiz, *Generación de los 80: Escultura–Fondos del Museo de Bellas Artes de Álava*, exh. cat. Vitoria: Museo de Bellas Artes

**1988**
- Amsterdam, Maatschappij Arti et Amicitiae, *Juan Muñoz: Un objeto metálico/A Metallic Object* (published in lieu of an exh. cat. in conjunction with Amsterdam, Maatschappij Arti et Amicitiae, *Jan van de Pavert and Juan Muñoz*, 26 April–21 May)
- Annemass, France, Villa du Parc, Fonds Régional d'Art Contemporain (FRAC) Rhônes-Alpes, *Presentation & propositions*, exh. cat.
- Celant, Germano, *Inespressionismo: L'arte oltre il contemporaneo*, Geneva: translated as *Unexpressionism: Art Beyond the Contemporary*, New York 1989
- Graz, Austria, Stadtmuseum Graz, Grazer Kunstverein, *Steirischer Herbst '88*, exh. cat. Peter Pakesch, Graz: Grazer Kunstverein
- Sicilia, José Mariá, Aurora Garcia, and Axel Bolvig. *Spansk kunst i 1980'erne: De nyeste tendenser: José Mariá Sicilia, Juan Muñoz, Pepe Espaliú, Susanna Solano, Curro González, Ricardo Cotando, Xavier Grau, Txomin Badiola*, Holte: Gl. Holtegaard

**1989**
- Amsterdam, KunstRai 89, *Before and after the Enthusiasm 1972–1992*, exh. cat. José-Luis Brea, The Hague and Amsterdam
- Athens, DESTE Foundation for Contemporary Art,

*Psychological Abstraction*, exh. cat., Jeffrey Deitch
- Brussels, Centre Albert Borschette, *Jeunes sculpteurs espagnols: Au ras du sol, le dos au mur*, exh. cat. Fernando Huici, Brussels
- Karuizawa, Takanawa, Japan, The Museum of Modern Art. *Supein aato toudi/Spain Art Today*, exh. cat. Jaime Brihuega and Miguel Fernández-Cid
- Long Island City, N.Y., P.S.1 Contemporary Art Center, *Theatergarden Bestiarium: the Garden as Theater as Museum*, exh. cat. Chris Dercon et al. Cambridge, Mass: translated as *Bestiarium, jardin-théâtre*, Poitiers, Entrepôt-Galerie du Confort Moderne
- Paris, Musée National d'Art Moderne, Centre Georges Pompidou and La Grande Halle-La Villette, *Magiciens de la terre*, exh. cat. Jean-Hubert Martin et al. Paris
- Santiago de Compostela, Spain, Casa da Parra, *Presencias e procesos: Sobre as ultimas tendencias da arte*, exh. brochure, Maria Luisa Sobrino Manzanares

**1990**
- Cortes, José Miguel G.., ed., *La creacíon artística como cuestionamiento/Artistic Creation at Stake*
- *Discussions Held at the IVAM, 18–19 May 1990*, Valencia: Instituto Valenciano de la Juventud
- Epernay, France, Office Régional Culturel de Champagne-Ardenne, *Sculpture contemporaine espagnole*, exh. cat. X. Anton Castro et al.
- Krefeld, Germany, Museen Haus Lange und Haus Esters, *Weitersehen (1980–1990—)*, exh. cat. Krefeld: Krefelder Kunstmuseen
- London, Institute of Contemporary Arts and Serpentine Gallery, *Possible Worlds: Sculpture from Europe*, exh. cat. Iwona Blazwick, James Lingwood, and Andrea Schlieker
- Madrid, Sala Julio González, Museo Español de Arte Contemporáneo, *X salon de los 16*, exh. cat. Francisco Calvo Serraller et al, Madrid: Grupo 16
- Munich, Galerie Tanit, *Jardins de bagatelle*, exh. cat.
- Newport Beach, Calif., Newport Harbor Art Museum, *OBJECTives: The New Sculpture*, exh. cat. Paul Schimmel, Newport Beach and New York
- North York, Ontario, Art Gallery of York University, *Meeting Place: Robert Gober, Liz Magor, Juan Muñoz*, 4 vols, exh. cat. Gregory Salzman
- Rennes, Centre d'Histoire de l'Art Contemporain, *Le spectaculaire: Rebecca Horn, IFP, Niek Kemps, Claude Lévêque, Raoul Marek, Juan Muñoz, Emmanuel Saulnier, Haim Steinbach, Jan Vercruysse*, exh. cat. Karine Alexandre et al.
- Sydney, Art Gallery of New South Wales, *The Readymade Boomerang: Certain Relations in Twentieth Century Art: The 8th Biennale of Sydney*, exh. cat.
- Toronto, York University, *Meeting Place*

**1991**
- Berlin, Martin-Gropius-Bau, *Metropolis: Internationale Kunstausstellung Berlin 1991*, exh. cat. Christos M. Joachimides and Norman Rosenthal (eds), Stuttgart
- Krefeld, Germany, Krefelder Kulturstiftung, Kaiser Wilhelm Museum, *Skulpturen für Krefeld 2*. 2 vols, exh. cat. Krefeld
- Krefeld, Germany, Museen Haus Lange und Haus Esters. *In anderen Räume*, exh. brochure Julian Heynen, Krefeld
- Malmö, Sweden, Rooseum Center for Contemporary Art, *Trans/Mission: Konst i interkulturell

*limbo/Art in Intercultural Limbo*, exh. cat. Lars Nittve and Hebdige
- Pittsburgh, The Carnegie Museum of Modern Art, *Carnegie International 1991*, 2 vols, exh. cat. Lynne Cooke et al., Pittsburgh and New York
- Santa Monica, Calif., Meyer/Bloom Gallery. *History as Fiction*, exh. cat.

**1992**
- Barcelona, Fundació 'la Caixa', *Tropismes: Colleccio d'art contemporani Fundació "la Caixa"*, exh. cat. Nimfa Bisbé, Dan Cameron, and Rosa Queralt
- Düsseldorf, Kunstverein für die Rheinlande und Westfalen., *Jahresgaben '92: Editionen*, exh. cat.
- Le Havre, France, Musée des Beaux-Arts André Malraux, *Ceci n'est pas une image: Les iconodules, l'image aujourd'hui*, exh. cat. Jérôme Alexandre, Paris: La Différence; Association des conservateurs de Haute-Normandie
- Kassel, Germany, Museum Fridericianum, *Documenta IX*, 3 vols., exh. cat. Baart de Baere et al. Stuttgart and New York
- Ljubljana, Slovenia, Moderna Galerija, *Tišina: Protislovne oblike resnice/Silence: Contradictory Shapes of Truth*, exh. cat. Zdenka Badovinac
- London, Hayward Gallery. *Doubletake: Collective Memory and Current Art*, exh. cat. Lynne Cooke et al., London and New York: translated as Vienna, Kunsthalle Wien, *Doubletake: Kollektives Gedächtnis & heutige Kunst* (1990), exh. cat. Toni Stooss and Eleonora Louis (eds.)
- Madrid, Sala de Plaza de España. *Artistas en Madrid: Años 80*, exh. cat. Miguel Fernández-Cid. Madrid
- Munich, Galerie Bernd Klüser, *Portfolio lettre international*
- Seville, Expo 92, *Fundação de Serralves, um museu português*, exh. cat. Porto: Fundação de Serralves
- Seville, Pabellón de España, Expo 92, *Pasajes: Actualidad del arte español*, exh. cat. José-Luis Brea et al.
- Sydney, 9th Biennale of Sydney, *The Boundary Rider: 9th Biennale of Sydney*, exh. cat. Anthony D. Bond
- Valencia, Instituto Valenciano de Arte Moderno (IVAM), Centre Julio González, *La colección del IVAM: Adquisiciónes 1985–1992*, exh. cat. Tomàs Llorens, Vicente Todolí, and J.F. Yvars

**1993**
- Albuquerque, N. Mex., The Albuquerque Museum, *The Human Factor: Figurative Sculpture Reconsidered*, exh. cat. Christopher C. French and Kathleen Shields
- Antwerp, Koninklijk Museum voor Schone Kunsten, Antwerp 93, *Het sublieme gemis/The Sublime Void: On the Memory of the Imagination*, exh. cat. by Bart Cassiman
- Antwerp, Antwerp 93, and Middelheim, Openluchtmuseum voor Beeldhouwkunst Middelheim, *Nieuwe beelden/New Sculptures*, ext. cat. Bart Cassiman, Menno Meewis and Barbara Vanderlinden
- Arnhem, The Netherlands, *Sonsbeek 93*, exh. cat. Jan Brand, Catelijne de Muynck, and Valerie Smith (eds), Ghent
- Beja, Portugal, Galeria dos Escudeiros, *Juan Muñoz-Julião Sarmento: Metalúrgico alentejana*, exh. cat. Jorge Castanho, Maria Filomena Molder and Herberto Helder, Beja
- Bignan, France, Centre d'Art Contemporain du

Domaine de Kerguéhennec, *Domaine: L'ordre du temps*, exh. cat.
- Copenhagen, Charlottenborg, *JuxtaPosition*, exh. cat. Mikkel Borgh and John Peter Nielson
- Eindhoven, The Netherlands, Stedelijk van Abbemuseum, *Aanwinsten/Acquisitions 1989–1993*, exh. cat. Jan Debbaut
- New York, Marian Goodman Gallery, *Group Show*
- Rome, Palazzo delle Esposizioni, *Tutte le strade portano a Roma*, exh. cat.
- Venice, Peggy Guggenheim Collection, 45th Venice Biennale, *Drawing the Line Against AIDS*, exh. cat. John Cheim et al., New York

**1994**
- Barcelona, Ediciones Polígrafa, *Urban Configurations*
- Barcelona, Galeria Soledad Lorenzo and Galeria Joan Prats-Art-graphic, *Malpais: Grabados y monotipos*, exh. cat.
- Basel, Kunsthalle Basel, *Welt-Moral: Moralvorstellungen in der Kunst heute*, exh. cat. Thomas Kellein
- Bordeaux, Capc Musée d'Art Contemporain, *'Même si c'est la nuit'*, exh. cat.
- Cirlot, Lourdes, *Historia universal de art: Últimas tendencias*, Barcelona
- Madrid, Galería Soledad Lorenzo, *Malpaís: Grabados y monotipos 1994*, exh. cat., Lanzarote
- Moure, Gloria. *Configuraciones urbanas*, Barcelona: translated as *Urban Configurations*, Barcelona
- Las Palmas de Gran Canaria, Canary Islands, Centro Atlántico de Arte Moderno, *Entre la presencia y la representación* exh. cat. Nimfa Bisbe
- Porto, Fundação Serralves *Fragmentos para um museo imaginario*, exh. cat.
- San Sebastian, Spain, Arteleku and Fonds Régional d'Art Contemporain (FRAC) d'Aquitane, $1m=c.299792458^4s$, exh. cat. Philippe Bouthier
- Storrs, Conn., Atrium Gallery, University of Connecticut, *Selections from the LeWitt Collection*, exh. cat. Walter McConnell

**1995**
- Athens, Panhellenios Syndesmos Aithouson Technis. *Art Athina 3 '95: Synantisi sygchronis technis.*
- Barcelona, Museu d'Art Contemporani, *L'escultura. Creacions paral-leles. Metáfores del real*, exh. cat. Teresa Blanch
- Helsinki, Nykytaiteen Museo-Valtion Taidemuseo, *Yksitynen/Julkinen/Private/Public: Ars 95*, exh. cat.
- Luxembourg, Musée National d'Histoire et d'Art *'Collection': Art moderne et contemporain au Van Abbemuseum Eindhoven*, exh. cat.
- Maastricht, The Netherlands, Bonnefantenmuseum, *Sculpture from the Collection of Marlies and Jo Eyck/Sculpturen uit de colectie var Marlies en Jo Eyck*, exh. brochure Aloys van den Berk
- Manchester, England, Rochdale Canal, *Duck not on a Pond, Ganders never Laid a Golden Egg*, exh. brochure
- Palma de Mallorca, Mallorca, Centre de Cultura, *Arquitectures plurals*, exh. cat.
- Rotterdam, Caldic Collection, *A Collection [of] Sculptures*
- Santiago de Compostela, Spain, Casa de la Para, *Incidentes*, exh. cat.
- Tokyo, The Watari Museum of Contemporary Art, *Ripple Across the Water*, exh. cat.
- Zurich, Scalo, *Silence Please*

**1996**
- Athens, DESTE Foundation for Contemporary Art, *Everything That's Interesting is New: the Dakis Joannou Collection*, exh. cat. Jeffrey Deitch et al., Athens and Ostfildern
- Berwick-Upon-Tweed, England, *Berwick Ramparts Project*, exh. cat. Pippa Coles, Berwick-Upon-Tweed
- Copenhagen, *CitySpace 1996: Sculptures and Installations made for Copenhagen 96*, exh. cat.
- Jerusalem, Israel Museum, *Marks: Artists Work throughout Jerusalem*, exh. cat. Suzanne Landau
- Savy, Robert, et al., *Fonds Régional d'Art Contemporain-Limousin: 1989–1995: "Deuxième époque"*, Limoges
- Turin, Museo d'Arte Contemporanea, Castello di Rivoli, *Collezioni di Francia: Le opere dei Fondi Regionali d'Arte Contemporanea*, exh. cat. Giorgio Verzotti, Milano and Turin
- Zurich, Museum für Gegenwartskunst Zürich, Museum für Gegenwartskunst Zürich, exh. cat. Arina Kowner and Rein Wolfs

**1997**
- Los Angeles, Margo Leavin Gallery, *Maxwell's Demon*. exh. cat.
- Lyon, Musée d'Art Contemporain, *4ᵉ Biennale d'art contemporain de Lyon: L'Autre*, exh. cat. Harald Szeemann
- Madrid, Museo Nacional Centro de Art Reina Sofía, *En la piel de toro*, exh. cat. Aurora García and Joaquím Magalhaes
- North Miami, Fla., Museum of Contemporary Art, *Tableaux*. exh. cat. Bonnie Clearwater (ed.)
- Paris, Fondation Cartier pour l'art contemporain, *1: La collection de la Fondation Cartier pour l'art contemporain*, exh. cat.
- Venice. *La Biennale de Venezia: XLVII esposizione internationale d'arte*, exh. cat. Germano Celant ed)
- Zurich, Museum für Gegenwartskunst Zürich, *Hip*, exh. cat. Marleen Wolfs et al.

**1998**
- Antwerp, Museum van Hedendaagse Kunst, *Subjective Presences: A Choice from the Collection of Fundació "la Caixa"*, exh. cat.
- Bernier, Jean, and Marina Eliades, *Jean Bernier Gallery: 1977–1998*, Athens
- Gainesville, Fla., Samuel P. Harn Museum of Art, *Inner Eye: Contemporary Art from the Marc and Livia Straus Collection*, exh. cat.
- Ghent, Stedelijk Museum voor Actuele Kunst, *Watou: 'Voor het verdwijnt en daarna'*, exh. cat.
- Gijón, Spain, Centro Cultural Caja de Asturias, *Il trienal de art gráfico: La estampa contemporánea*, exh. cat.
- Humlebæk, Denmark, Louisiana Museum of Modern Art, *Louisiana at 40–The Collection Today*, exh. cat., special issue of *Louisiana Revy* 38, no.3 (June)
- London, Hayward Gallery, *Voice Over: Sound and Vision in Current Art*. exh. cat. Michael Archer, London
- Madrid, Museo Nacional Centro de Arte Reina Sofia, *Dibujos germinales: 50 artistas españoles*, exh. cat.
- Oostende, Belgium, Museum voor Modern Kunst, *René Magritte en de hedendaagse kunst/René Magritte and the Contemporary Art*, exh. cat.
- Pontevedra, Spain, Museo de Pontevedra, *Fisuras na percepción: 25 Bienal de arte de Pontevedra*, exh. cat. Alberto González-Alegre et al.
- Ribalta, Jorge (ed.), *Servicio público: Conversaciones sobre financiación pública y arte contemporáneo*, Salamanca and Barcelona.
- Stockholm, Moderna Museet, *Wounds: Between Democracy and Redemption in Contemporary Art/Mellan demokrati och forlosning i samtida konst*, exh. cat. David Elliott and Pier Luigi Tazzi

**1999**
- Boon, Kunstmuseum Bonn, *Zeitwenden: Ausblick*, exh. cat. Dieter Ronte and Walter Smerling, Cologne
- Boston, The Institute of Contemporary Art, *Collectors Collect Contemporary 1990–99*, exh. cat. Jessica Morgan
- Istanbul, *The Passion and the Wave: 6th International Istanbul Biennial*, exh. cat. Paolo Colombo et al.
- Krefeld, Germany, Krefelder Kunstmuseum, *C/O Haus Lange-Haus Esters, 1984/1999*, exh. cat.
- Künzelsau, Germany, Museum Wurth. *Spanische Kunst am Ende des Jahrhunderts*, exh. cat. Kosme María de Barañano Letamendía and C. Sylvia Weber. Sigmaringen: Thorbecke
- Leipzig, Germany, Galerie für Zeitgenossische Kunst, *Life Cycles*, exh cat.
- Liverpool, Tate Gallery Liverpool, *Trace: 1st Liverpool Biennial of International Contemporary Art*, exh. cat. Anthony Bond et al., Liverpool
- Middelburg, The Netherlands, Zeeuws Museum, *Het bevorde plein*, exh. cat. Florent Bex, Middelburg
- Nuremberg, Kunsthalle Nürnberg, *Vergiß den Ball und spiel' weiter*, exh. cat.
- Warsaw, Mediterranean Foundation and the National Museum, *North-South: Transcultural Visions*, exh. cat.

**2000**
- Ghent, Stedelijk Museum voor Actuele Kunst, *Over the Edges*, 2 vols., exh. cat. Jan Hoewt and Giacinta Di Pietrantino
- London, Tate Modern, *Between Cinema and a Hard Place*, exh. brochure Frances Morris et al.
- Long Island City, N.Y., P.S.1 Contemporary Art Center, *Around 1984: A Look at Art in the 80's*, exh. cat. Carolyn Christov-Bakargiev
- Las Palmas de Gran Canaria, Canary Islands, Centro Atlántico de Art Moderno, *Máquinas*, exh. cat. Marga Paz
- Sydney, Art Gallery of New South Wales, *Biennale of Sydney 2000: 12th Biennale of Sydney*, exh. cat. Fumio Nanjo et al.

**2001**
- New York, Museum of Modern Art, *Parkett: Collaborations and Editions since 1984*, exh. cat. Deborah Wye and Susan Tallman, Zurich and New York
- New York, Museum of Modern Art, *Collaborations with Parkett: 1984 to Now*, exh. brochure Deborah Wye
- Oakland, Calif., Oliver Art Center, California College of Arts and Crafts Institute, *A Contemporary Cabinet of Curiosities: Selections from the Vicki and Kent Logan Collection*, exh. cat. Ralph Rugoff
- Warner, Marina. 'Here Comes the Bogeyman: Goya, the Late Grotesque, and Juan Muñoz', in *Robert Lehman Lectures on Contemporary Art*, vol. 2, edited by Karen Kelly and Lynne Cooke, New York: Dia Center for the Arts

**2002**
- Düsseldorf, K21 Kunstsammlung

Nordrhein-Westfalen, *Startkapital*, exh. cat.
- Kassel, documenta XI, exh. cat.

**2003**
- Tokyo, The Mori Art Museum, *Happiness: a survival guide for art and life*, exh. cat.
- Valencia, Fundacion Bancaixa, *II. Bienal de Valencia, La ciudad radiante*, exh. cat.

**2004**
- Seville, *BIACS: Bienal Internacional de Arte Contemporaneo de Sevilla*, exh. cat.

**2005**
- Venice, Biennale di Venezia, *The Experience of Art*, 51, exh. cat.

**2007**
- Barcelona, Macba, *A Theatre without Theatre*, exh. cat.

## Articles and Reviews

**1984**
- Serraller, Francisco Calvo, 'La tercera mirada del misterio', *El País* (Madrid), 17 November, Art section

**1985**
- Collado, Gloria, '70, 80, 90 ... La historia interminable: Rumbo a lo desconocido', *Lápiz* 3, no.23 (February), 35–8
- Pinharda, Joao, 'Retrato de una epoca', *Mais* (Lisbon), 15 March
- Porfírio, José Luis, 'Quatro caminhos: Simetries e contrastes', *Expresso* (Lisbon), 16 March

**1986**
- Cameron, Dan, 'Spain is Different', *Arts Magazine* 61, no.1 (September), 14–17
- Koether, Jutta, and Diedrich Diederischsen, 'Jutta and Diedrich Go to Spain: Spanish Art and Culture Viewed from Madrid', *Artscribe*, no.59 (September–October), 56–61
- S. C., 'El arte joven español en la Fundación Cartier', *ABC* (Madrid), 24 December
- Serraller, Francisco Calvo, 'Las imágenes rotas de un agonista', *El País* (Madrid), 19 December, section C
- Tazzi, Pier Luigi, 'Albrecht Dürer Would Have Come Too', *Artforum International* 25 (September), 124–8

**1987**
- Albertazzi, Liliana, 'Espagne aujourd'hui', *Galeries Magazine*, no.17 (February–March), 50, 57, 116–17
- Brea, José-Luis, 'Juan Muñoz: Nada es tan opaco como un espejo', *Sur Exprés*, no.1 (15 April–15 May), 32–3
- Collado, Gloria, 'Tierra desierta', *Guía del ocio*, no.576 (29 December 1986–4 January 1987), 42
- Danvila, Jose Ramon. 'Contra todo tipo de circunstancias', *El Punto de las Artes* (Madrid), 19 December 1986–8 January 1987
- ———. 'Un encuentro con el arte en Marga Paz', *El Punto de las Artes* (Madrid), 9–15 October
- 'El estado del arte', *Sur Exprés* (November–December), 49–55
- Power, Kevin, 'Juan Muñoz', *Artscribe*, no.64 (summer), 93

- Serraller, Francisco Calvo, 'Cuatro artistas españoles jóvenes exponen en Burdeos', El País (Madrid), 30 September
- ———. 'La nouvelle sculpture espagnole', Art Press, no.117 (September), 17–20

**1988**
- Aliaga, Juan Vicente. 'Spanish Art: A History of Disruption', Artscribe International, no.68 (March–April), 64–7
- Brea, José-Luis, 'Juan Muñoz', Flash Art (Spanish edition), no.1 (February), 70.; also published as 'Juan Muñoz: The System of Objects', Flash Art, no.138 (January–February), 88–9
- Christov-Bakargiev, Carolyn, 'Something Nowhere', Flash Art, no.140 (May–June), 80–5
- Phillipson, Michael, 'Juan Muñoz', Artscribe, no.68 (March–April), 88–91
- Power, Kevin, 'Das Wesen des Tanzes', Kunstforum International 94 (April–May), 233–6
- ———. 'Spanien–Kunstlerportraits: Juan Muñoz', Kunstforum International 94 (April–May), 148–9
- Steenbergen, Renée, 'Juan Muñoz', NRC Handelsblad (Rotterdam), 29 April

**1989**
- Brea, José-Luis, 'Juan Muñoz: The Other Speaks', New Art International 4, no.2 (March), 62–4
- Cembalest, Robin, 'Spain: Learning to Absorb the Shock of the New', Artnews 88 (September), 127–31
- Costa, José Manuel, 'Juan Muñoz', ABC (Madrid), 5 May
- ———. 'Juan Muñoz, la metáfora entre los pucheros', Guía de Madrid, no.80 (April)
- ———. 'Juan Muñoz: La temperancia del objeto', El Punto de las Artes (Madrid), 21–7 April, 164–5
- Danvila, Jose Ramon, 'Juan Muñoz, la reflexión sobre le cotidiano', El Punto de las Artes (Madrid), 20–6 October
- Deitch, Jeffrey, 'Psychological Abstraction', Flash Art, no.149 (November–December), 164–5
- Fernández-Cid, Miguel, 'Una consulta en la galería', Diario 16 (Madrid), 14 April, Art section
- Grout, Catherine, 'Cristina Iglesias, Juan Muñoz: Sculptures.', Artstudio, no.14 (autumn), 110–17
- Jimenez, P, 'Juan Muñoz, metáfora de lo cotidiano', ABC (Madrid), 28 November
- Lambrecht, Luk, 'Juan Muñoz', Flash Art, no.148 (October), 143–4
- Melo, Alexandre, 'Some Things That Cannot Be Said Any Other Way', Artforum International 27 (May), 119-21
- Nazaré, Leonor, 'Crise de l'object–Cómicos', Expresso (Lisbon), 4 November
- Serraller, Francisco Calvo, 'La danza inmóvil', El País (Madrid), 21 October, Art section

**1990**
- Aliaga, Juan Vicente, 'Discursos alienados', El País (Madrid), 1 December, Art section
- Arnaudet, Didier, 'Des pratiques de l'objet dans l'art des années 80: Apparences, metaphores et empreintes', Colóquio artes 32, no.85 (June), 54–61
- Bradley, Kim, 'Juan Muñoz at Galería Marga Paz', Art in America 78 (February), 179
- Cantor, Judy, 'Juan Muñoz', Artnews 89 (April), 181
- F.B., 'Muñoz: Un oeil noir vous regarde', Beaux-Arts Magazine, no.85 (December), 127

- García, Aurora, 'Juan Muñoz, Galería Marga Paz', Artforum International, no.10 (Spring), 65–8
- Jimenez, Carlos, 'España, el cierre de una década/The Close of a Decade', Arte en Colombia, no.43 (February), 76–9, 147–9
- Llorca, Pablo, 'La tercera via', Guía de Madrid (June)
- Marlow, Tim, 'London, Lisson Gallery, Juan Muñoz', The Burlington Magazine 132, no.1043 (February), 144
- Melo, Alexandre, 'A propósito de objectos complexos', Ler, no.11 (summer), 57–9
- ———. 'Cartografía de la supervivencia', Diario 16 (Madrid), 2 May
- Olivares, Rosa, 'Beyond Form: An Update on Spanish Sculpture', Arts Magazine 65, no.4 (December), 52–7
- Packer, William, 'Some Transubstantiation Needed', Financial Times (London), 20 November, Arts section
- Roberts, James, 'Juan Muñoz', Artefactum 7, no.32 (February–March), 44

**1991**
- Blase, Christoph, 'Wohnen in Krefeld', Das Kunst-Bulletin, no.3 (March), 10
- Brenson, Michael, 'Juan Muñoz', New York Times, 26 April
- CDG, 'Genf: Juan Muñoz im Centre d'Art Contemporain', Das Kunst-Bulletin, no.1 (January), 42
- Chauvy, Laurence, 'Des ballerines aux jambes coupées', Journal de Genève, 8 January
- Dohnalek, Claudio, 'Inaugurada en Berlin la exposición "Metropolis", simbolo de la unificación', El País (Madrid), 27 April
- Hixson, Kathryn, 'Chicago in Review', Arts Magazine 65 (February), 106–8
- Lambrecht, Luk, 'Juan Muñoz, Centre d'Art Contemporain, Geneva, and Museum Haus Lange, Krefeld', Forum International 8 (May–August), 67
- Levels, Marlies, 'Pose (pauze) posa: Momenten van stilstand in het werk van Juan Muñoz', Archis, no.12 (December), 27–30
- Poiatti, Myriam, 'Juan Muñoz: Quatorze "ballerines"', Tribune de Genève, 5–6 January
- Praplan, Geneviève, 'La paix de l'esprit', La Suisse (Geneva), 22 January
- Savioz, Cathy, 'Muñoz: Ni Lucio, ni Carlos, Juan!' Voir, no.76 (February), 23
- Searle, Adrian, 'Waiting for Nothing', Frieze, no.2 (December), 24–9
- Serraller, Francisco Calvo, 'Juan Muñoz', Beaux-Arts Magazine, no.96 (December), 104–6
- Tager, Alisa, 'The Essence of Absence: The Sculpture of Juan Muñoz', Arts Magazine 65 (summer), 36–9
- Van den Boogerd, Dominic, 'Bevroren barok', Metropolis M, no.6 (December), 28–35

**1992**
- Bourriaud, Nicholas, 'Figuration in an Age of Violence', Flash Art 25, no.162 (January–February), 87–91
- Charbonnier, Jean-Michel, 'Les jeunes talents', Beaux-Arts Magazine, no.106 (November), 22–9
- Cork, Richard, 'Do You See What they See?' Times (London), 28 February, Features section
- Deitcher, David, 'Art on the Installation Plan', Artforum International 30 (January), 79–84
- Fernández-Cid, Miguel, 'La apariencia y el sentido',

Cambio 16 (Madrid), 25 May
- Jinkner-Lloyd, Amy, 'Musing on Museology', Art in America 80 (June), 43–51
- Maldonado, José, 'Cascando: Aun por terminar, aun por ver', Papers d'art (December), 10–11
- Peters, Philip, 'En Route: Jan Hoet's Documenta', Kunst & Museumjournaal 4, no.2, 25–32
- Pol, Marta, 'Jose Maldanado/Juan Muñoz', Papers d'art (September)
- Searle, Adrian, 'Juan Muñoz: Un recuerdo de Londres', Revista de Occidente, no.129 (February), 47–56
- Smolik, Noemi, 'Aspekte der Skulptur: Zwischen fester Form und Grenzlosigkeit', Kunstforum International 199, 201–4
- Tarantino, Michael, 'Juan Muñoz', Artforum International 30 (April), 111–12
- Villén, Ángel L. Pérez, 'La vanitas neobarroca', Lápiz 10, no.87 (May–June), 64–7
- Zaya, Octavio, 'Juan Muñoz: A Theater of Appearances (Between Transit and Inertia)', Balcon, no.10, 15–25

**1993**
- Barriga, Paulo, 'Très airosas saídas', Diário do Alentejo (Beja), 3 December
- Krumpel, Doris, '"Doubletake" in der Wiener Kunsthalle', Der Standard (Vienna), January
- Melo, Alexandre, 'A importância de ser actual', Expresso (Lisbon), 10 December
- Oliveira, Luísa Soares de, 'Arte radical', Público (Lisbon), 29 November
- Pinharanda, João, 'Julião Sarmento e Juan Muñoz', Público (Lisbon), 17 December
- Schwabsky, Barry, 'Reviews: New York', Sculpture 12, no.4 (July–August), 54–5
- Shone, Richard, 'London: Recent Exhibitions', The Burlington magazine 135, no.1078 (January), 45–7
- Stegeman, Elly, 'The Sublime Void', Kunst & Museumjournaal 5, no.2, 53–7
- Titz, Walter, 'Die Gedachtnisse der Welt', Kleine Zeitung (Graz), January

**1994**
- Jocks, Heinz-Norbert, 'Juan Muñoz', Kunstforum International, no.125 (January–February), 344–5
- Piguet, Philippe, 'Nîmes: Juan Muñoz', L'oeil, no.461 (May), 15

**1995**
- 'Beide kehren zur menschlichen Figur zurück', Hamburger Abendblatt, 7 July
- Bensley, Lis, 'Viewers are Actors in Muñoz's Sculpture Dramas', New Mexican (Santa Fe), 13 October
- Bryars, Gavin, 'A Man in a Room, Gambling', Parkett, no.43 (March), 52–5: translated as 'Ein Mann in einem Zimmer beim Kartenspiel', 56–61
- Cooke, Lynne, 'Juan Muñoz and the Specularity of the Divided Self', Parkett, no.43 (March), 20–3: translated as 'Juan Muñoz und die Spiegelungen des Geteilten Selbst', 24–7
- Danek, Sabine, 'Feuer zum Mitnehmen', Szene Hamburg, August
- Durden, Mark, 'Duck not on a Pond, Ganders never Laid a Golden Egg', Art Monthly, no.191 (November), 33–5
- Giuliano, Charles, 'Juan Muñoz: Portrait of a

Turkish Man Drawing', *Art New England* 17, no.1 (December 1995–January 1996), 64
- Hermida, Xosé, 'Juan Muñoz expone su último obra, basada en la "absorción y teatralidad"', *El País* (Madrid), 21 December
- J.S.M. 'Klapperschlange mit Tränenkette', *Stuttgarter Zeitung*, 14 August: also published as 'Wie bestellt und nicht abgeholt', *Landeszeitung für die Lüneburger Heide*, 8–9 July
- Melo, Alexandre, 'The Art of Conversation', *Parkett*, no.43 (March), 36–41: translated as 'Die Kunst der Konversation, 28–35
- Melrod, George, 'Post-Pop Pizzazz', *Art and Antiques* 18, no.10 (November), 39–40
- Schupp, Ulrike, 'Theatralische Reminiszenen: Skulpturen von Juan Muñoz und Henk Visch im Kunstverein', Hamburger *Rundschau*, 20 July
- Sherman, Mary, 'Xu Bing and a Prayer', *Artnews* 94 (December), 55–6
- Sierra, Rafael, 'El regreso del escultor pródigo', *El Mundo* (Madrid), 21 December, Culture section
- Temin, Christine, 'Juan Muñoz Practices the Gentle Art of Dislocation', *Boston Globe*, 24 September, Art section
- Unger, Miles, 'Juan Muñoz', *New Art Examiner* 23 (December), 27–8

**1996**
- Borràs, Maria Lluïsa, 'Una muestra de naderías', *La Vanguardia* (Barcelona), 8 November
- Dannatt, Adrian, 'Juan Muñoz', *Flash Art*, no.191 (November–December), 105–6
- Danvila, Jose Ramon, 'Juan Muñoz: Intensidad interior, espacio y escenografía', *El Punto de las Artes* (Madrid), 7 November
- ———, 'La mirada dinámica', *El Mundo* (Madrid), 8 November
- Erausquin, Victoria, 'Misterio en el Retiro', *Expansión* (Madrid), 9 November
- 'Esculturas de Juan Muñoz en el Palacio de Velázquez', *Egin* (San Sebastian), 23 October
- Fernández-Cid, Miguel, 'Presencias y ecos de Juan Muñoz', *ABC* (Madrid), 25 October
- Flórez, Fernando Castro, 'El espacio inquietante del hombre: En lugar del ventrílocuo', *Cimal Arte Internacional*, no.47, 25–32
- ———, 'La figuración desviada', *Diario* 16 (Madrid), 2 November
- Foix, Vicente Molina, 'Nueva York-Valencia', *El País* (Madrid), 5 November
- Gonzalez García-Pando, Carmen, 'Juan Muñoz: Eculturas públicas con pensamientos privados', *Reseña*, no.278 (December), 44
- Hunt, Ian, 'Making It All Up', *Art Monthly*, no.200 (October), 70–1
- Jarque, Fietta, 'La primera antológia del escultor Juan Muñoz transforma radicalmente el Palacio de Velázquez', *El País* (Madrid), 25 October
- 'Juan Muñoz at the Palacio de Velázquez', *Guidepost* (29 November), 10–11
- 'Juan Muñoz, bellezza y originalidad', *Noticias Médicas*, no.3.635 (November), 46
- Lloyd, Ann Wilson, 'Empty Hands, Silent Mouths', *Art in America* 84, no.3 (March), 50–1
- ———, 'Juan Muñoz', *Sculpture* 15 (January), 78
- Princenthal, Nancy, 'Artist's Book Beat', *On Paper* 1, no.2 (November–December), 40–1
- Reyes, J. A. Álvarez, 'La derecha ha dado un golpe

de Estado en el IVAM', *Diario* 16 (Madrid), 25 October
- Serraller, Francisco Calvo, 'Un montaje magistral', *El País* (Madrid), 25 October
- Sierra, Rafael, 'El Reina Sofía resume la trayectoria del escultor Juan Muñoz', *El Mundo* (Madrid), 25 October
- Smith, Roberta, 'Wandering through a Place that Never Was', *New York Times*, 27 September, section C
- Van Hove, Jan, 'Voorzichtig optimisme op Lineart', *De Standaard* (Brussels), 29 November

**1997**
- Billeter, Fritz, 'Kunst: Warum lachen diese Chinesen?' *Brückenbauer* (Zurich), 12 February
- Cañas, Susana, 'Las misteriosas figuras de Juan Muñoz.', *El tiempo latino* (San Francisco), 14 March
- Canning, Susan M, 'Juan Muñoz', *Sculpture* 16, no.3 (March), 58–9
- Cassiman, Bart, 'Juan Muñoz', *Dietsche Warande & Belfort* 6 (December), 681–2
- Cochran, Rebecca Dimling, 'Juan Muñoz', *Art Papers* 21 (March–April), 81
- Cohn, David, 'Juan Muñoz', *Artnews* 96 (February), 126
- Cruz, Juan, 'Gavin Bryars and Juan Muñoz', *Art Monthly*, no.211 (November), 30–1
- Dixon, Glenn, 'Stage Fright', *Washington City Paper*, 14 March
- Eccles, Tom, 'Juan Muñoz at Dia', *Art in America* 85 (May), 121
- F.J. 'Gavin Bryars clausura con un concierto la exposición de Juan Muñoz en el Retiro;, *El País* (Madrid), 11 January
- Gerster, Ulrich, 'China grinst–Juan Muñoz im Museum für Gegenwartskunst', *Neue Zürcher Zeitung*, 6 February
- Grabher, Ariane, 'Von Leben in einem Schuhkarton', *Vorarlberger Nachrichten* (Wichnergasse), 6 February
- Hanks, Robert, 'Music–Contemporary: A Sound Strategy', *Independent* (London), 22 September, Features section
- Harris, Jane, 'Juan Muñoz', *Art Papers* 21 (March–April), 64
- Howell, George, 'Cheryl Donegan; Juan Muñoz', *Art Papers* 21 (July–August), 35
- ———, 'Juan Muñoz: Figurative Metaphors on the Washington Mall', *Sculpture* 16, no.1 (January), 8–9
- Kuoni, Gisela, 'Von der Faszination der lähmenden Abwesenheit', *Bündes Zeitung*, 19 March
- Llorca, Pablo, 'Juan Muñoz', *Artforum International* 35 (February), 95–6
- McEvilley, Thomas, 'The Millennial Body: the Art of the Figure at the End of Humanity', *Sculpture* 16, no.8 (October), 24–9
- McFadden, Sarah, 'The 'Other' Biennial', *Art in America* 85 (November), 84–91
- Muñoz, Jorge, 'El impacto de Juan Muñoz', *Inversión* (Madrid), 10 January
- Oberholzer, Niklaus, 'Lauter lächelnde Unbekannte um uns', *Neue Luzerner Zeitung*, 10 February
- Richard, Paul, 'Laughing the Faces of Danger', *Washington Post*, 10 March, Style section
- Rosa, Tessa, 'L'infinita solitudine di Juan Muñoz', *Azione* (Naples), 1 May
- SFD, 'Irritierend: Juan Muñoz im Museum für Gegenwartskunst', *Tagblatt der Stadt Zürich*, 11 February

- Searle, Adrian, 'Hush! Listen to the Sound of Sculpture', *Guardian* (London), 18 September, section 2
- Vachtov, Ludmila, ;Die Falle der Mutanten', *Neue Nidwaldner Zeitung* (Luzern), 6 February
- Vignjevic, Tomislav, 'Prireditev v znamenju neizogibnih sprememb', *M'ars* 9, no.2, 54–7
- Vogel, Wolfram, 'Schrecken des Kriegs als Disco', *Südkurier* (Konstanz), 6 February
- Wüst, Karl, 'Sisyphos in der Schuhschachtel', *Bischofszeller Nachrichten*, 8 February
- Zwez, Annelise, 'Geschichten ohne Worte, Lachen ohne Laute', *Anzeiger von Ulster*, 4 February
- ———, 'Kunst-Geschichten ohne Worte', *Schaffhauser Nachrichten*, 11 February

**1998**
- Berger, John, 'El cæ fuego', In *La ciutat de les paraules*. Barcelona: Edicions de l'Eixample
- ———, 'Hotel Declerq', *Eaeyoepotynia* (Athens), 6 April: also published in *Tri-quarterly* (fall), 91–6
- Brea, José-Luis, '"En la piel de toro", Palacio de Velázquez', *Artforum* 36 (January), 107–8
- Cruz, Juan, 'Hearing Voices', *Art Monthly*, no.214 (March), 12–15
- Rinne, Hannu, 'Museossakin kamppailevat ja muoto', *Taide*, no.3, 19
- Romano, Gianni, 'Juan Muñoz: Galeria Continua, San Gimignano', *Untitled: A Review of Contemporary Art*, no.15 (spring), 25
- Tossatto, Guy, 'Juan Muñoz', *L'oeil*, no.492 (January), 56–9

**1999**
- Antmen, Ahu, and Vasif Kortun, 'The Istanbul Fall', *Flash Art* (Italy) 32, no.209 (November–December), 84–5
- Barragán, Paco, 'Ya no tiene sentido la representación nacional', *El Periodico del Arte*, no.25 (August–September)
- Bröder, F.J., 'Ab in die Ecke und schäm dich', *Nordbayerischer Kurier* (Bayreuth), 23–4 October
- Buck, Louisa, 'It's not So Cold up North', *Art Newspaper*, no.95 (September)
- Chambert, Christian, 'The International Curators Had Moved On', *Nu*, pt.2, 88
- Massey, Diane, 'A Sharp Satire on City's Greats', *Daily Post* (New York), 6 October
- Muñoz, Juan, with Attilio Maranzano, 'The Burning of Madrid as Seen from the Terrance of My House' (photo essay). *Janus* 3 (March), 22–7
- Schmidt, Kristin, 'Vergiß den Ball und spiel' weiter–Das Bild des Kindes in der zeitgenössischen Kunst', *Monatsanzieger* (Nuremberg), no.223 (October)
- Searle, Adrian, and Jonathan Jones, 'Venice on the Mersey', *Guardian* (London), 28 September, section 2

**2000**
- Alberge, Dalya, 'Company of Men to Replace Giant Spider', *Times* (London), 3 October
- Bergendahl, Berit, '104 leende kineser', *Götesborgs-Posten*, 18 March
Berger, John, 'A Mouth Speaks Out Alone', In *LAB. Academy of Media Arts Yearbook*, Cologne
- Bergström, Lotta, 'Vad skrattar de åt, kinesrna?' *Hallands Nyheter* (Falkenberg), 22 March
- Bonde, Lisbeth, 'Det aktive værk', *Information*

(Copenhagen), 18 March
- Carlsson, Larsolof, 'Kineser på bred front',
*Helsingborgs Dagblad*, 17 March
- Castro, Fernando, 'El narrador de historias',
*ABC* (Madrid), 1 December
- Charpentier, C-J., 'Hundra spanska kineser',
*Nya Läns-Tidningen/Nya Lidköpings Tidning*, 29 March
- Costa, José Manuel, 'Juan Muñoz realizará una
escultura de seseuta metros para la Tate Gallery',
*ABC* (Madrid), 4 October
- Dakinah, 'Louisiana: Muñoz' optiske illusion',
*Lokal-Avisen Ugebladet* (Vestfyn), 22 March
- 'El escultor Juan Muñoz obtiene el premio Nacional
de Artes Plásticas', *ABC* (Madrid), 1 December
- Ersgård, Stefan, 'Leende kineser gästar Louisiana',
*Arbetet Nyheterna* (Malmö), 18 March
- Feinstein, Roni, 'Report from Sydney:
The Biennale of Reconciliation', *Art in America* 88
(December), 38–45
- Fernández-Cid, Miguel, 'Artista polémico,
obra inquietante', *La Rázon*, 1 December
- H.D., 'Spektakulær udstilling på Louisiana',
*Frederiksborg Amts Avis* (Hillerød), 18 March
- Hansen, Jørgen, 'De fremmede', *Jyllandsposten,
Morgenavis*, 22 March
- ———, '100 kinesere og en spanier', *Jyllandsposten,
Morgenavis*, 17 March
- Hemming, Sarah., 'Sarah Hemming Wonders How
You Replace a Seven-Tonne Spider', *Daily Express*
(London), 30 December, Weekend section
- Holmqvist, Åke, 'Kinesiska leenden som
provocerar', *Norra Skåne* (Hässleholm), 25 March
- Hörle, Suzanne, 'Leende kineser på Louisiana',
*Nya Wermlands-Tidningen* (Karlstad), 23 March
- Hornung, Peter, 'Muñoz verdensteater',
*Politiken* (Copenhagen), 17 March
- J.P., 'The Dis-Orient Express', *Copenhagen Post*,
24–30 March
- Jones, Jonathan, 'Big and Beautiful?'
*Guardian* (London), 4 October
- Jørgensen, Tom, 'Magien mangler', *Ekstra Bladet*
(Copenhagen), 20 March
- Malmqvist, Conny C-A., 'Kineser, kineser–överallt
kineser', *Kvällspoten* (Malmö), 22 March
- Misfeldt, Mai, '100 kinesere på museums-besøg',
*Berlingske Tidende* (Copenhagen), 17 March
- Moe, Helen, 'Under smilets syntetiske maske',
*Kristeligt Dagblad* (Copenhagen), 16 March
- Montigny, Britte, 'kenet bedrar', *Skånska Dagbladet*
(Malmö), 24 March
- Nielsen, Elisa, 'Beskuer eller aktør',
*Aktuelt* (Copenhagen), 20 March
- Prassad, Raeckha, 'Muñoz Moves into
Spider's Space', *Guardian* (London), 4 October
- Rifbjerg, Synne, 'En Kinamands chance',
*Week-end Avisen* (Copenhagen), 18 February
- Rodriguez, Juan Carlos, 'La fama internacional
de Juan Muñoz le da el Premio Nacional de Artes
Plásticas', *La Rázon*, 1 December
- Scavenius, Bente, '100 små kinesere', *Børsen*
(Copenhagen), 20 March
- Serraller, Francisco Calvo, 'El escultor Juan Muñoz
obtiene el Premio Nacional de Artes Plásticas',
*El País* (Madrid), 1 December
- Sierra, Rafael, 'España intente reconciliarse
de nuevo con Juan Muñoz', *El Mundo* (Madrid),
1 December
- Waak, Malin, 'Kineser som konstverk',
*Sydsvenska Dagbladet* (Malmö), 24 March
- Win, 'Juan Muñoz er naeste satsning',
*Helsingør Dagbladet*, 25 February

**2001**
- Adams, Tim, 'Breaking the Mould',
*Life: The Observer Magazine* (3 June), 11–14
- Campbell-Johnston, Rachel, 'The Urbane
Spaceman', *Times* (London), 11 June, Arts section
- Cumming, Laura, 'Don't Mention the War ...'
*Observer Review*, 17 June, Arts section
- Jarque, Vicente, 'La Figura táctil, o las imágenes
de Juan Muñoz', *Arte y parte*, no.32 (April–May), 22–31
- Muñoz, Juan, and Julian López, 'Escena de
desaparición' (photo essay). *Arte y Parte*, no.32
(April–May), n.p.
- Searle, Adrian, 'We Are Not Alone', *Guardian*
(London), 12–13 June, Visual Arts section

# Exhibition History
## 1984–2008

*Exhibitions are listed chronologically within each year; exhibitions for which dates are unknown follow alphabetically at the end of each section.*

## Solo Exhibitions

### 1984
- Madrid, Galería Fernando Vijande, *Juan Muñoz: Últimos trabajos*, 7 November–7 December: exh. cat.

### 1985
- Lisbon, Galería Cómicos, *Retrato de um homem em pé de Pontormo*, 7–30 March

### 1986
- Ghent, Galerie Joost Declerq, *Juan Muñoz*, 28 November 1986–24 January 1987
- Madrid, Galería Marga Paz, *Juan Muñoz*, 11 December 1986–20 January 1987

### 1987
- Marseille, Galerie Roger Pailhas, *Juan Muñoz*, 23 May–22 June
- Bordeaux, Capc Musée d'Art Contemporain, *Juan Muñoz: Sculptures de 1985 à 1987*, 25 September–22 November: exh. cat.
- London, Lisson Gallery, *Juan Muñoz*, 9 November–19 December
- Lisbon, Galeria Cómicos, *Estudos para a descrição de um lugar*, 3 December 1987–9 January 1988

### 1988
- Athens, Galerie Jean Bernier, *Juan Muñoz*, 26 May–24 June
- Dusseldorf, Galerie Konrad Fischer, *Juan Muñoz*, 19 October–3 December
- Paris, Galerie Ghislaine Hussenot, *Juan Muñoz*, 24 November–23 December

### 1989
- Madrid, Galería Marga Paz, *Juan Muñoz*, 14–19 April
- Ghent, Galerie Joost Declerq, *Juan Muñoz*, 13 May–17 June
- London, Lisson Gallery, *Juan Muñoz*, 27 October–25 November
- Madrid, Galería Marga Paz, *Juan Muñoz*, 27 October–25 November

### 1990
- Athens, Galerie Jean Bernier, *Juan Muñoz*, 19 January–19 February
- Bristol, England, Arnolfini Gallery, *Vertical Balcony Too*, 9 June–15 July
- Chicago, The Renaissance Society at The University of Chicago, *Juan Muñoz*, 18 November–30 December: travelled to Geneva, Centre d'Art Contemporain, 1 December–16 February 1991 (in lieu of an exh. cat. Muñoz's essay *Segment* [1990] was published)

### 1991
- Düsseldorf, Galerie Konrad Fischer, *Juan Muñoz*, 16 February–20 March
- Krefeld, Germany, Museum Haus Lange, *Juan Muñoz: Arbeiten 1988 bis 1990*, 17 February–21 April: exh. cat.
- New York, Marian Goodman Gallery, *Juan Muñoz*, 3–27 April
- Eindhoven, The Netherlands, Stedelijk Van Abbemuseum, *Juan Muñoz: Sculpturen, installaties en tekeningen*, 23 November 1991–12 January 1992: exh. cat.

- Paris, Galerie Ghislaine Hussenot, *Juan Muñoz*, 30 November 1991–8 January 1992

### 1992
- Valencia, Instituto Valenciano de Arte Moderno (IVAM) Centre del Carme, *Juan Muñoz: Conversaciones*, 10 April–28 June: exh. cat.
- London, Frith Street Gallery, *Juan Muñoz: Drawings and Prints*, 6 November–19 December

### 1993
- New York, Marian Goodman Gallery, *Juan Muñoz*, 17 February–20 March
- Athens, Galerie Jean Bernier, *Juan Muñoz*, 13 May–9 July
- London, Lisson Gallery, *Juan Muñoz*, 22 October–4 December
- Düsseldorf, Galerie Konrad Fischer, *Juan Muñoz*, 29 October–6 December

### 1994
- Nîmes, Carré d'Art-Musée d'Art Contemporain, *Juan Muñoz*, 25 March–29 May: exh. cat.
- Dublin, Irish Museum of Modern Art, *Juan Muñoz: Sculpture, Drawings and Installation*, 6 July–4 August (in lieu of an exh. cat. the book *Silence please!: Stories after the Works of Juan Muñoz* [1996] was published.)

### 1995
- Boston, Isabella Stewart Gardner Museum, *Juan Muñoz: Portrait of a Turkish Man Drawing*, 15 September–31 December: exh. cat.
- Santa Fe, Laura Carpenter Fine Art, *Juan Muñoz: New Work from New Mexico–Sculpture and Drawings*, 14 October–12 December
- Santiago de Compostela, Spain, Centro Galego de Arte Contemporánea, *Juan Muñoz*, 12 December 1995–25 February 1996: exh. brochure

### 1996
- Athens, Galerie Jean Bernier, *Juan Muñoz*, 21 March–29 April
- Turin, Marco Noire Contemporary Art, *Juan Muñoz: Mobiliario, grabados 1996*, 10 April–7 May: exh. cat.
- New York, Dia Center for the Arts, *A Place Called Abroad*, 26 September 1996–29 June 1997: exh. brochure: travelled to Santa Fe, SITE Santa Fe, as *Streetwise*, 6 June–2 August 1998: exh. brochure; exh. cat. (1999)
- Madrid, Palacio de Velázquez, Museo Nacional Centro de Arte Reina Sofía, *Juan Muñoz: Monólogos y diálogos*, 25 October 1996–15 January 1997: travelled to Zurich, Museum für Gegenwartskunst Zürich, as *Juan Muñoz: Monologe und Dialoge*, 1 February–19 May 1997: exh. cat.

### 1997
- Washington, D.C., Hirshhorn Museum and Sculpture Garden, *Directions: Juan Muñoz*, 6 March–15 June: exh. brochure
- San Gimignano, Italy, Galleria Continua, *Juan Muñoz*, 22 November 1997–31 January 1998
- Paris, Galerie Ghislaine Hussenot, *Juan Muñoz*, 6 December 1997–20 January 1998

### 1998
- Miengo, Spain, Sala Robayera, *Juan Muñoz:*

*Certain Drawings in Oil and Ink/Algunos dibujos en óleo y tinta 1996–1988*, July: exh. cat.

### 1999
- New York, Marian Goodman Gallery, *Juan Muñoz: Crossroads*, 21 September–30 October
- Athens, Bernier/Eliades Gallery, *Juan Muñoz: A Brief Description of My Death*, 25 November–22 January 2000

### 2000
- Humlebæk, Denmark, Louisiana Museum for Moderne Kunst, *Juan Muñoz: The Nature of Visual Illusion*, 18 March–18 June 2000: exh. cat.

### 2001
- Washington, D.C., Hirshhorn Museum and Sculpture Garden, Juan Muñoz, 18 October 2001–13 January 2002: travelled to Los Angeles Museum of Contemporary Art, 4 May–27 July 2002; Chicago, The Art Institute of Chicago, 14 September–8 December 2002; Houston, Contemporary Arts Museum, 1 February–30 March 2003: exh. cat.
- Santander, Palacete del Embarcadero, *Juan Muñoz*, 1 February–1 March 2001
- London, Tate Modern, *The Unilever Series: Juan Muñoz: Double Bind at Tate Modern*, 12 June–10 February 2002

### 2002
- Sevilla, Galería Pepe Cobo, *Juan Muñoz*, 2 February–20 May 2002

### 2002–2003
- New York, Doris Freedman Plaza, *Juan Munoz: Public Art Fund*, 26 September 2002–31 March 2003

### 2004
- New York, Zwirner & Wirth, *Juan Muñoz*, 7 February–27 March 2004: exh. cat.
- Paris, Galerie Marian Goodman, *Juan Muñoz*, 27 March–30 April 2004
- Stockholm, Magasin 3 Stockholm Konsthall, *Juan Muñoz–Three Laughing at One*, 1 April–6 June 2004

### 2005
- Madrid, La Casa Encendida, *Juan Muñoz. La voz sola – Esculturas, dibujos y obras para la radio*, 16 March–4 July 2005: exh. cat.

### 2006
- New York, Marian Goodman Gallery, *Juan Muñoz*, 25 April–10 June 2006: exh. cat.
- Düsseldorf, K21 Kunstsammlung Nordrhein-Westfalen, *Juan Muñoz – Rooms of my mind*, 14 October 2006–4 February 2007: exh. cat.

### 2007
- Grenoble, Musée de Grenoble, *Juan Muñoz. Sculptures et dessins*, 10 March 2007–28 May 2006: exh.cat

## Group Exhibitions

### 1979
- London, Dryden Street Gallery
- London, Half Moon Gallery
- London, Morley Gallery

**1980**
- London, British Council, *Three Days a Week: Wolfgang Koethe, Lila Mookerjee and Juan Muñoz*, March–April
- London, Morley Gallery
- Warsaw, Museum Plaketu

**1981**
- Fribourg, Switzerland, *Fri-art 81*, 21 August–18 October: exh. cat.
- Long Island City, N.Y., P.S.1 Contemporary Art Center, *Room 202*

**1982**
- Berlin, *Büro Berlin*: exh. cat.

**1983**
- Madrid, Casa del Monte, Palacio de las Alhajas, Caja de Ahorros y Monte de Piedad, *La imagen del animal: Arte prehistórico, arte contemporáneo*, December 1983–January 1984: travelled to Barcelona, Fundació 'la Caixa', 22 March–30 April 1984: exh. cat.

**1984**
- Madrid, Centro Cultural de la Villa, *Madrid, Madrid, Madrid: 1974–1984*, July–September

**1985**
- Eindhoven, The Netherlands, Stedelijk Van Abbemuseum, *Christa Dichgans, Lili Dujourie, Marlene Dumas, Lesley Foxcroft, Kees de Goede, Frank van Hemert, Cristina Iglesias, Harald Klingelhöffer, Mark Luyten, Juan Muñoz, Katherine Porter, Julião Sarmento, Barbara Schmidt Heins, Gabriele Schmidt-Heins, Didier Vermeiren*, 24 May–30 June 1985: exh. cat.
- Madrid, Círculo de Bellas Artes, *Muestra de arte joven*

**1986**
- Seville, Pabellón Mudéjar, *Diecisiete artistas, diecisiete autonomías*, 28 February–6 April: travelled to Palma de Mallorca, Mallorca, La Lonja, summer: exh. cat.
- Madrid, Sala de Exposiciones de la Fundación Caja de Pensiones, *Pintores y escultores españoles 1981–1986*, 9 April–11 May: travelled to Paris, Fondation Cartier pour l'art contemporain, fall: exh. cat.
- Zurich, Museum für Gegenwartskunst Zürich, *Die Sammlung*, 5 May–15 September: exh. cat.
- Ghent, Museum Van Hedendaagse Kunst, *Chambres d'amis*, 21 June–21 September: exh. cat.
- Venice, Aperto 86, XLII Venice Biennale, *Bienal de Venecia: Aperto 86–Cuatro artistas españolas*, 29 June–28 September: exh. cat.
- Zamora, Spain, VII Bienal de Escultura de la Ciudad de Zamora, *Escultura ibérica contemporánea*, 20 September–20 October: exh. cat.
- Álava, Spain, Fondos del Museo de Bellas Artes de Álava Vitoria-Gasteiz, *Generación de los 80: Escultura–Fondos del Museo de Bellas Artes de Álava*, September 1986–April 1987: travelled to San Sebastian, Monte San Telmo, December 1987–January 1989: exh. cat.
- Lisbon, Galeria Cómicos, *L'attitude*, 16 October–22 November
- Fontevraud, France, Abbaye Royale de Fontevraud, Fonds Régional d'Art Contemporain (FRAC) des Pays de la Loire, *Ateliers internationaux des pays de la Loire*, November–December: exh. cat.

- Madrid, Palacio de la Moncloa, *Arte joven en el Palacio de la Moncloa*: exh. cat.

**1987**
- Fontevraud, France, Abbaye Royale de Fontevraud, Fonds Régional d'Art Contemporain (FRAC) des Pays de la Loire, *Lili Dujourie/Juan Muñoz*, summer: travelled to Meymac, Abbaye Saint-André, Centre d'Art Contemporain, spring 1988: exh. cat.
- Madrid, Galería Marga Paz, *Juan Muñoz, Julião Sarmento, José María Sicília, Jan Vercruysse*, 2 October
- Paris, ARC-Musée d'Art Moderne de la Ville de Paris, *Espagne 87: Dynamiques et interrogations*, 10 October–22 November: exh. cat.
- Amsterdam, De Appel, *Nightfire*, 20 December 1987–31 January 1988: exh. cat.

**1988**
- Annemass, France, Villa du Parc, Fonds Régional d'Art Contemporain (FRAC) Rhônes-Alpes, *Presentation & propositions*, 22 January–5 March: exh. cat.
- Amsterdam, Maatschappij Arti et Amicitiae, *Jan van de Pavert and Juan Muñoz*, 26 April–21 May (in lieu of an exh. cat., the book *Juan Muñoz: Un objeto metálico/A Metallic Object* [1988] was published)
- Bayonne, France, Musée Bonnat, Fonds Régional d'Art Contemporain (FRAC) d'Aquitaine, *Richard Baquié, Pascal Convert, Juan Muñoz, Susana Solano*, 17 June–17 September
- Graz, Austria, Stadtmuseum Graz, Grazer Kunstverein, *Steirischer Herbst '88*, 25 September–3 November: exh. cat.

**1989**
- Long Island City, N.Y., P.S.1 Contemporary Art Center, *Theatergarden Bestiarium: the Garden as Theater as Museum*, 15 January–12 March: travelled to Seville, Casino de la Exposición-Casino del Teatro Lope de Vega, 26 June–30 July, and Poitiers, France, Entrepôt-Galerie du Confort Moderne, 30 September–29 November: exh. cat.
- Brussels, Centre Albert Borschette, *Jeunes sculpteurs espagnols: Au ras du sol, le dos au mur*, 23 January–30 May: exh. cat.
- Lisbon, Galeria Cómicos, *Spazio umano*, 14–25 March
- New York, Langer and Co., *80's International*, 15 March–14 April
- Karuizawa, Takanawa, Japan, The Museum of Modern Art, *Supein aato toudi/Spain Art Today*, 29 April–12 June: exh. cat.
- Paris, Centre Georges Pompidou and La Grande Halle-La Villette, Musée National d'Art Moderne, *Magiciens de la terre*, 18 May–14 August: exh. cat.
- Amsterdam, KunstRai 89, *Before and after the Enthusiasm 1972–1992*, 24–28 May: exh. cat.
- Athens, The House of Cyprus, DESTE Foundation for Contemporary Art, *Psychological Abstraction*, 18 July–16 September: exh. cat.
- Lisbon, Galeria Cómicos, *Crise de l'objet*, 19 October–25 November
- Santiago de Compostela, Spain, Casa da Parra, *Presencias e procesos: Sobre as ultimas tendencias da arte*, November: exh. brochure
- Madrid, Galería Marga Paz, *Complex Object*

**1990**
- Newport Beach, Calif., Newport Harbor Art Museum, *OBJECTives: The New Sculpture*, 8 April–24 June: exh. cat.
- Sydney, Art Gallery of New South Wales, *The Readymade Boomerang: Certain Relations in Twentieth Century Art: The 8th Biennale of Sydney*, 11 April–3 June: exh. cat.
- Madrid, Sala Julio González, Museo Español de Arte Contemporáneo, *X salon de los 16*, 8 May–17 June: exh. cat.

- Rennes, France, Galerie Art & Essai, Université Rennes 2 and Galerie de Cloître, Ecole Régionale des Beaux Arts, Centre d'Histoire de l'Art Contemporain, *Le spectaculaire: Rebecca Horn, IFP, Niek Kemps, Claude Lévêque, Raoul Marek, Juan Muñoz, Emmanuel Saulnier, Haim Steinbach, Jan Vercruysse*, 10 May–13 July: exh. cat.
- Epernay, France, Office Régional Culturel de Champagne-Ardenne, *Sculpture contemporaine espagnole*: travelled to Charleville-Mézières, Musée Rimbaud; Reims, Palais du Tau, Fonds Régional d'Art Contemporain (FRAC); Reims-Val-de-Vesle, Silo, Centre de Création Contemporaine; and Troyes, Musée d'Art Moderne, Centre d'Art Contemporain Passages, Cadran Solaire; summer: exh. cat.
- Ghent, Galerie Joost Declerq, *R. Devriendt, L. Dujourie, J. Muñoz, J. P. Temmerman, N. Tordoir*, 11 July–1 September
- Munich, Galerie Tanit, *Jardins de bagatelle*, 14 September–31 October: exh. cat.
- North York, Ontario, Art Gallery of York University, *Meeting Place: Robert Gober, Liz Magor, Juan Muñoz*, 26 September–28 October: travelled to Calgary, Alberta, Nickle Arts Museum, 22 February–7 April 1991, and Vancouver, British Columbia, Vancouver Art Gallery, 8 May–7 July 1991: exh. cat.
- New York, Marian Goodman Gallery, *Group Show*, 18–30 October
- London, Institute of Contemporary Arts and Serpentine Gallery, *Possible Worlds: Sculpture from Europe*, 9 November 1990–6 January 1991: exh. cat.
- Krefeld, Germany, Museen Haus Lange und Haus Esters, *Weitersehen (1980–1990–)*, 18 November 1990–27 January 1991: exh. cat.

**1991**
- Berlin, Martin-Gropius-Bau, *Metropolis: Internationale Kunstausstellung Berlin 1991*, 20 April–21 July: exh. cat.
- New York, Marian Goodman Gallery, *A Group Show*, 14 June–31 August
- Santa Monica, Calif., Meyer/Bloom Gallery, *History as Fiction*, 1 August–7 September: exh. cat.
- Malmö, Sweden, Rooseum Center for Contemporary Art, *Trans/Mission: Konst i interkulturell limbo/Art in Intercultural Limbo*, 27 August–27 October: exh. cat.
- Krefeld, Germany, Krefelder Kulturstiftung, Kaiser Wilhelm Museum, *Skulpturen für Krefeld 2*, 15 September–10 November: exh. cat.
- Graz, Austria, Grazer Kunstverein, *Körpe und Körper*, 6 October–14 November
- Pittsburgh, The Carnegie Museum of Modern Art, *Carnegie International 1991*, 19 October 1991–16 February 1992: exh. cat.
- Plymouth, England, Plymouth Arts Centre, *The Poet in Paint*, 26 October–23 November
- Krefeld, Germany, Museen Haus Lange und Haus Esters, *In anderen Räume*, 1 December 1991–9

February 1992
- Madrid, Galería Marga Paz

**1992**
- Lisbon, Galeria Cómicos, *Accrochage 1/92*,
17 January–21 March
- Valencia, Instituto Valenciano de Arte Moderno
(IVAM), Centre Julio González, *La colección del IVAM:
Adquisiciónes 1985–1992*, 7 February–5 April: exh. cat.
- London, Hayward Gallery, *Doubletake:
Collective Memory and Current Art*, 20 February–20
April: travelled to Vienna, Kunsthalle Wien, as
*Doubletake: Kollektives Gedächtnis & heutige Kunst*,
8 January–28 February 1993: exh. cat.
- Seville, Salas del Arenal, Pabellón de España,
Expo 92, *Los últimos días*, 19 April–12 May: exh. cat.
- Seville, Pabellón de España, Expo 92, *Pasajes:
Actualidad del arte español*, 20 April–12 October:
exh. cat.
- Ljubljana, Slovenia, Moderna Galerija, *Tišina:
Protislovne oblike resnice/Silence: Contradictory Shapes of
Truth*, 19 May–21 June: exh. cat.
- Kassel, Germany, Museum Fridericianum,
*Documenta IX*, 12 June–20 September: exh. cat.
- Seville, Expo 92, *Fundação de Serralves, um museu
português*, 26 June–15 July: exh. cat.
- Barcelona, l'Hospitalet de Llobregat, Centre
Cultural Tecla Sala, Fundació 'la Caixa', *Tropismes:
Colleccio d'art contemporani Fundació 'la Caixa'*,
11 July–15 August: exh. cat.
- Le Havre, France, Musée des Beaux-Arts André
Malraux, *Ceci n'est pas une image: Les iconodules, l'image
aujourd'hui*: travelled to Darnétal-Rouen, l'Usine
Fromage-École d'Architecture de Normandie,
and Evreux, Musée-Ancien Evêché; 16 October–
14 December: exh. cat.
- Düsseldorf, Kunstverein für die Rheinlande und
Westfalen, *Jahresgaben '92: Editionen*, 3–23 November:
exh. cat.
- Madrid, Sala de Plaza de España, *Artistas en Madrid:
Años 80*, November 1992–January 1993: exh. cat.
- Sydney, *The Boundary Rider: 9th Biennale of Sydney*,
15 December 1992–14 March 1993: exh. cat.

**1993**
- Rome, Palazzo delle Esposizioni, *Tutte le strade
portano a Roma*, 11 March–26 April: exh. cat.
- Albuquerque, N. Mex., The Albuquerque Museum,
*The Human Factor: Figurative Sculpture Reconsidered*,
14 March–3 July: exh. cat.
- Copenhagen, Charlottenborg, *JuxtaPosition*,
29 April–6 June: exh. cat.
- Bignan, France, Centre d'Art Contemporain du
Domaine de Kerguéhennec, *Domaine: L'ordre du temps*,
1 May–23 May: exh. cat.
- Arnhem, The Netherlands, *Sonsbeek 93*, 5 June–26
September: exh. cat.
- Venice, Peggy Guggenheim Collection, 45th Venice
Biennale, *Drawing the Line Against AIDS*, 8–13 June:
travelled to New York, Guggenheim Museum Soho,
6–9 October: exh. cat.
- New York, Marian Goodman Gallery, *Group Show*,
summer
- Antwerp, Koninklijk Museum voor Schone
Kunsten, Antwerp 93, *Het sublieme gemis/The Sublime
Void: On the Memory of the Imagination*, 25 July–10
October: exh. cat.
- Brussels, Galerie Xavier Hufkens, *Accrochage*,

July–August.
- Eindhoven, The Netherlands, Stedelijk van
Abbemuseum, *Aanwinsten/Acquisitions 1989–1993*,
18 September–31 October: exh. cat.
- Beja, Portugal, Galeria dos Escudeiros, *Juan Muñoz-
Julião Sarmento: Metalúrgico alentejana*, 27 November
1993–31 January 1994: exh. cat.
- Quimper, France, Centre d'Art Contemporain
de Quimper, *Lieux de la vie moderne*, 17 December–30
January 1994

**1994**
- San Sebastian, Spain, Arteleku and Fonds
Régional d'Art Contemporain (FRAC) d'Aquitane,
*1m=c.299792458's*, 13 January–4 February: exh. cat.
- Basel, Kunsthalle Basel, *Welt-Moral:
Moralvorstellungen in der Kunst heute*, 30 April–31 July:
exh. cat.
- Las Palmas de Gran Canaria, Canary Islands, Centro
Atlántico de Arte Moderno, *Entre la presencia y la
representación*, 17 May–16 July: exh. cat.
- Bordeaux, Capc Musée d'Art Contemporain,
*<<Même si c'est la nuit>>*, 17 June–6 November:
exh. cat.
- Madrid, Galería Soledad Lorenzo, *Malpaís: Grabados
y monotipos 1994*, 27 June–27 July: travelled to
Barcelona, Galería Joan Prats-Artgrafic, June–July
1995: exh. cat.
- Porto, Fundação Serralves, *Fragmentos para um
museo imaginario*, 28 July–18 September: exh. cat.
- London, Marc Jancou Gallery, *The Little House on
the Prairie*, 15 September–21 October
- London, Frith Street Gallery, *Marlene Dumas,
Juan Muñoz, Thomas Schütte: Drawings*, 25 November
1994–21 January 1995
- Storrs, Conn., Atrium Gallery, University of
Connecticut, *Selections from the Le Witt Collection*,
2–23 December: exh. cat.
- Hirai, Japan, Museo, Marugame

**1995**
- Barcelona, Galeria Àngels de la Mota,
*El contrato natural*, 11 February–11 March
- Helsinki, Nykytaiteen Museo-Valtion Taidemuseo,
*Yksitynen/Julkinen/Private/Public: Ars 95*, 11 February–
28 May: exh. cat.
- Maastricht, The Netherlands,
Bonnefantenmuseum, *Sculpture from the Collection of
Marlies and Jo Eyck/Sculpturen uit de colectie var Marlies
en Jo Eyck*, 11 March–3 September: exh. brochure
- Palma de Mallorca, Mallorca, Centre de Cultura,
*Arquitectures plurals*, 6 April–25 March: exh. cat.
- Santiago de Compostela, Spain, Casa de la Para,
*Incidentes*, 27 April–18 June: exh. cat.
- Lisbon, Galeria Luís Serpa, *Formas únicas da
continuidade do espaço, parte 1*, 6 May–9 June
- Glasgow, Tramway gallery, *Trust*, 7 May–18 June
- Athens, Athens Exhibition Centre, Art Athena 3 '95,
*Forms from Spain: End of Twentieth Century Spanish Art*,
9–14 May
- Luxembourg, Musée National d'Histoire et d'Art,
*<<Collection>>: Art moderne et contemporain au Van
Abbemuseum Eindhoven*, 13 May–25 June: exh. cat.
- New York, Marian Goodman Gallery, *Group Show*, 17
June–31 August
- Lisbon, Galeria Luís Serpa, *Formas únicas da
continuidade do espaço, parte 2*, 24 June–29 July
- Hamburg, Hamburger Kunstverein, *Juan Muñoz/

Henk Visch*, 7 July–27 August
- Tokyo, The Watari Museum of Contemporary Art,
*Ripple Across the Water*, 2 September–1 October:
exh. cat.
- Manchester, England, Rochdale Canal,
*Duck not on a Pond, Ganders never Laid a Golden Egg*,
23 September–31 October: exh. brochure
- Bignan, France, Centre d'Art Contemporain du
Domaine de Kerguéhennec, *Le domaine du diaphane*,
30 September 1995–28 January 1996
- Villeurbane, France, Le Nouveau Musée-Institut
d'Art Contemporain, *Artistes/Architectes*,
7 October–24 February
- Athens, Galerie Jean Bernier, *Andreas Gursky,
Cristina Iglesias, Juan Muñoz, Eric Poitevin, Yvan
Salomone, Pia Stadtbaumer and Sue Williams*,
30 November 1995–10 January 1996
- Barcelona, Museu d'Art Contemporani, *L'escultura.
Creacions paral·leles. Metáfores del real*, 30 November–
18 February 1996: exh. cat.

**1996**
- Athens, Athens School of Fine Arts, DESTE
Foundation for Contemporary Art, *Everything That's
Interesting is New: the Dakis Joannou Collection*,
20 January–20 April: travelled to Copenhagen,
Museum of Modern Art, spring 1997: exh. cat.
- Turin, Castello di Rivoli, Museo d'Arte
Contemporanea, *Collezioni di Francia: Le opere dei Fondi
Regionali d'Arte Contemporanea*, 15 February–21 April:
exh. cat.
- Zurich, Museum für Gegenwartskunst Zürich,
*Die Sammlung*, 5 May–15 September: exh. cat.
- Copenhagen, *CitySpace 1996: Sculptures and
Installations made for Copenhagen 96*, 15 May–
1 October: exh. cat.
- Jerusalem, Israel Museum, *Marks: Artists Work
throughout Jerusalem*, 5 June–31 August: exh. cat.
- Madrid, Galería Juana de Aizpuru, *Tórridos terrenos:
Colección Sibila de art contemporáneo*, 6–26 June:
travelled to Seville, Sibila, 3–15 September; Valencia,
Charpa, 19 September–19 October; and Barcelona,
Joan Prats, 24 October–30 November
- Berwick-upon-Tweed, England, *Berwick Ramparts
Project*, summer: exh. cat.
- Knokke-Heiste, Belgium, Crown Gallery,
*Francesco Clemente, Juan Muñoz, Wilhelm von Gloeden*,
October–November.
- New York, Marian Goodman Gallery, *A Group Show*,
5 December–5 January 1997
- Amsterdam, Bloom Gallery

**1997**
- Brussels, Galerie Xavier Hufkens, *Accrochage*,
23 April–18 May
- Prague, Jiri Svetska Gallery, *United Enemies:
Mannerism and Synthesis*, 4 May–22 June
- North Miami, Fla., Museum of Contemporary
Art, *Tableaux*, 8 May–27 July: travelled to Houston,
Contemporary Arts Museum, 18 October–30
November: exh. cat.
- Madrid, Palacio de Velázquez, Museo Nacional
Centro de Art Reina Sofia, *En la piel de toro*,
14 May–8 September: exh. cat.
- Venice, *La Biennale de Venezia: XLVII Esposizione
internationale d'arte*, 15 June–9 November: exh. cat.
- Lyon, La Halle Tony Garnier, Musée d'Art
Contemporain, *4ᵉ Biennale d'art contemporain de Lyon*:

*L'Autre*, 9 July–24 September: exh. cat.
- New York, Marian Goodman Gallery, *A Summer Show*, July–August
- Athens, Galerie Jean Bernier, 7 October–11 November
- Los Angeles, Margo Leavin Gallery, *Maxwell's Demon*, 8 November–20 December: exh. cat.
- Zurich, Museum für Gegenwartskunst Zürich, *Hip*, 8 November 1997–11 January 1998: exh. cat.
- Paris, Fondation Cartier pour l'art contemporain, 1: *La collection de la Fondation Cartier pour l'art contemporain*, 21 November 1997–11 January 1998: exh. cat.

**1998**
– London, Hayward Gallery, *Voice Over: Sound and Vision in Current Art*. Traveled to Bristol, Arnolfini Gallery, 31 January–22 March; Newcastle, Hatton Gallery, 4 April–17 May; and Nottingham, Castle Museum and Art Gallery, 12 September–1 November: exh. cat.
– Stockholm, Moderna Museet, *Wounds: Between Democracy and Redemption in Contemporary Art/Mellan demokrati och forlosning i samtida konst*, 14 February–19 April: exh. cat.
- Gainesville, Fla., Samuel P. Harn Museum of Art, *Inner Eye: Contemporary Art from the Marc and Livia Straus Collection*, 22 March 1998–3 January 1999: travelled to Knoxville, Tenn., Knoxville Museum of Art, spring 1999; Atlanta, Georgia Museum of Art, summer 1999; Norfolk, Va., the Chrysler Museum of Art, fall 1999; and Purchase, N.Y., The Neuberger Museum of Art, 30 January–16 April 2000: exh. cat.
- Oostende, Belgium, Museum voor Modern Kunst, *René Magritte en de hedendaagse kunst/René Magritte and the Contemporary Art*, 4 April–28 June: exh. cat.
- Malmö, Sweden, Malmö Konsthall, *Arterias*, 24 April–7 June
- Humlebæk, Denmark, Louisiana Museum of Modern Art, *Louisiana at 40–The Collection Today*, 18 June–30 August: exh. cat.
- Ghent, Stedelijk Museum voor Actuele Kunst, *Watou: 'Voor het verdwijnt en daarna,'* 28 June–6 September: exh. cat.
- Pontevedra, Spain, Museo de Pontevedra, *Fisuras na percepción: 25 Bienal de arte de Pontevedra*, August-September: exh. cat.
- New York, Marian Goodman Gallery, *Breaking Ground*, 25 September–7 November
- Gijón, Spain, Palacio Revillagigedo, Centro Cultural Caja de Asturias, *Il trienal de art gráfico: La estampa contemporánea*, September–Novembe: exh. cat.
- Antwerp, Museum van Hedendaagse Kunst, *Subjective Presences: A Choice from the Collection of Fundació 'la Caixa'*, 9 October–10 January 1999: exh. cat.
- Mdrid, Palacio de Velázquez, Museo Nacional Centro de Arte Reina Sofía, *Dibujos germinales: 50 artistas españoles*, 14 October 1998–11 January 1999: exh. cat.

**1999**
- Künzelsau, Germany, Museum Wurth, *Spanische Kunst am Ende des Jahrhunderts*, 24 January–26 May: exh. cat.
- Le Blanc-Mesnil, France, Forum Culturel du Blanc-Mesnil, Département de la Seine Saint-Denis, *Regards croisés*, 16 February–30 April

- Boston, The Institute of Contemporary Art, *Collectors Collect Contemporary 1990–99*, 31 March–28 May: exh. cat.
- Madrid, Circulo de Bellas Artes, *20 años de escultura española: Hacia un nuevo clasicismo*, 15 April–9 May
- Warsaw, Mediterranean Foundation and the National Museum, *North-South: Transcultural Visions*, 14 May–25 June: exh. cat.
- Humlebæk, Denmark, Louisiana Museum of Modern Art, *Nye Konstallationer/New Constellations*, 21 May–25 July
- London, Frith Street Gallery, *0 to 60 in 10 Years: A Decade in Soho (Part 1)*, 28 May–2 July
- Cagliari, Italy, Centro Comunale di Arte e Cultura Exma, *Grabados*, 18 June–17 July
- Middelburg, The Netherlands, Zeeuws Museum, *Het bevorde plein*, 19 June–3 October: exh. cat.
- Istanbul, *6th International Istanbul Biennial*, 17 September–8 November: exh. cat.
- Liverpool, Tate Gallery Liverpool, *Trace: 1st Liverpool Biennial of International Contemporary Art*, 24 September–7 November: exh. cat.
- Athens, Bernier/Eliades Gallery, *George Lappas, Juan Muñoz, Thomas Schütte …*, 14 October–20 October
- Nuremberg, Kunsthalle Nürnberg, *Vergiß den Ball und spiel' weiter*, 21 October 1999–9 January 2000
- Leipzig, Germany, Galerie für Zeitgenossische Kunst, *Life Cycles*, 24 October–5 December: exh cat.
- Krefeld, Germany, Krefelder Kunstmuseum, *C/O Haus Lange-Haus Esters, 1984/1999*, 21 November 1999–2 February 2000: exh. cat.
- Bonn, Kunstmuseum Bonn, *Zeitwenden: Ausblick*, 4 December 1999–4 June 2000: travelled to Vienna, Museum moderner Kunst Stiftung Ludwig Wien, 20er Haus and k/haus-Künstlerhaus, 5 July–October 2000: exh. cat.

**2000**
- Sydney, Art Gallery of New South Wales, *Biennale of Sydney 2000: 12th Biennale of Sydney*, 26 March–30 July: exh. cat.
- Ghent, Stedelijk Museum voor Actuele Kunst, *Over the Edges*, 1 April–30 June: exh. cat.
- London, Tate Modern, *Between Cinema and a Hard Place*, 12 May–3 December: exh. brochure
- Long Island City, N.Y., P.S.1 Contemporary Art Center, *Around 1984: A Look at Art in the 80's*, 21 May–September: exh. cat.
- Athens, Bernier/Eliades Gallery, 6 June–6 July
- Las Palmas de Gran Canaria, Canary Islands, Centro Atlántico de Arte Moderno, *Máquinas*, 19 September–19 November: travelled to Palma de Mallorca, Mallorca, Fundació 'la Caixa', 19 December–4 February 2001: exh. cat.

**2001**
- Oakland, Calif., Oliver Art Center, California College of Arts and Crafts Institute, *A Contemporary Cabinet of Curiosities: Selections from the Vicki and Kent Logan Collection*, 17 January–3 March: exh. cat.
- New York, Museum of Modern Art, *Collaborations with Parkett: 1984 to Now*, 5 April–12 June 2001: exh. brochure; exh. cat.

**2001**
- Dublin, IMMA, Irish Museum of Modern Art, *The First 10 Years: Selected Works from the Collection*, 10 April–23 September 2001

- Paris, Galerie Marian Goodman, *Group Show*, 21 June–27 July 2001
- Nantes, Musée des Beaux-Arts de Nantes, *Dialogue Ininterrompu*, 7 July–19 November 2001: exh. cat.
- Madrid, La Caja Negra, *Obra Grafica*, 24 July–5 September 2001
- New York, P.S.1 Contemporary Art Center, Long Island City, *Animations*, 14 October 2001–13 January 2002: travelled to Berlin, KW, Institute for Contemporary Art, 8 February–11 May 2003.: exh. cat.
- Baden-Baden, Kunsthalle Baden-Baden, *Big Nothing: Hohere Wesen, der blinde Fleck und das Erhabene in der zeitgeössischen Kunst*, 27 January–18 March 2001
- Sevilla, Galería Pepe Cobo, *Atlantes*, November 2001
- Las Palmas de Gran Canaria, Centro Atlántico de Arte Moderno (CAAM), *Rumbos de la Escultura Española del siglo XX*, 13 December 2001–10 February 2002: exh. cat.

**2002**
- Mallorca, Centro Cultural Andratx, *The song of the Pirate*, 15 March–1 September 2002
- Düsseldorf, K21 Kunstsammlung NordrheinWestfalen, Startkapital (from the Ackermans Collection), 21 April 2002–open end: publication
- Kassel, *Documenta XI*, 8 June–15 September 2002: exh.cat.
- Rotterdam, Museum Boijmans Van Beuningen, *Imagine*, 22 October 2002–2 February 2003
- Barcelona, CaixaForum, *Colección de Arte Contemporáneo Fundación 'la Caixa'*, 14 March–6 May 2002
- Madrid, Circulo de Bellas Artes, *Traslaciones. México-España, Pintura y Escultura, 1977–2002*, 25 July–20 September 2002

**2003**
- Martigni, Fondation Pierre Gianadda, *Les artistes espagnols de Picasso à Barceló*, 31 January–9June, 2003: exh. cat.
- New York, Marian Goodman Gallery, *A Sculpture Show*, 12 February–14 March 2003
- Berlin, Martin-Gropius-Bau, *Warum! Bilder diesseits und jenseits des Menschen*, 28 May–3 August 2003
- Valencia, Fundación Bancaixa II. Bienal de Valencia, *La ciudad radiante*, 1 June–31 August, 2003: exh. cat.
- Thessaloniki, Macedonian Museum of Contemporary Art, *Europe exists*, 16 June–15 September 2003: exh. cat.
- Gent, S.M.A.K –Stedelijk Museum loor Actuelle Kunst, *Gelijk het leven is*, 28 June–14 September 2003
- Coruna, Fundación Luis Seoane, *La construcción del espectador*, 18 July–28 September 2003
- Thun, Kunstmuseum Thun, *Images of Society*, 7 September–16 November 2003: exh cat
- Louisville, KY, Speed Art Museum, *Potential Images of the World*, 16 September 2003–13 June 2004
- Antwerpen, MuHKA, Museum van Hedendaagse Kunst, *The collection V–autumn 2003*, 4 October–16 November 2003
- Genoa, Palazzo Ducale, *Bilbao a Genova – La cultura cambia le città*, 11 October 2003–11 January 2004: exh. cat.
- Tokyo, The Mori Art Museum, *Happiness: a survival guide for Art and Life*, 18 October 2003–18 January 2004: exh. cat.
- Burgos, CAB Centro de Arte Caja Burgos,

*Punto de Encuentro. La Colección (I),*
31 October–31 December 2003

**2004**
- Vitoria-Gasteiz, ARTIUM Centro-Museo Vasco
de Arte Contemporáneo, *Rumbos–La Colección III,*
1 January 2004–13 February 2005
- Palma de Mallorca, Es Baluard Museu d´Art
Modern i Contemporani de Palma, *Es Baluard any
zero,* 31 January–23 September 2004: exh. cat.
- Zurich, Migrosmuseum für Gegenwartskunst,
*L'Air du Temps,* 3 April–31 May 2004: exh. cat.
- Genova, Loggia di Banchi, *Periplo del Mediterraneo.
Nuove expressioni tra Genova,* 07 May 2004–04 July 2004:
exh. cat.
- Santander, Museo de Bellas Artes de Santander,
*Colección de Arte Contemporáneo Fundación 'la Caixa',*6
July–18 September 2004
- Buffalo, NY, Albright-Knox Art Gallery, *Bodily Space:
New Obsessions in Figurative Sculpture,* 20 April–7
September 2004
- Leeds, Henry Moore Institute, *With Hidden Noise:
Sculpture, Video and Ventriloquism,* 8 May–08 August
2004: exh. cat.
- San Francisco, CA, John Berggruen Gallery,
*Sculpture and Form,* 3 June–4 September 2004
- New York, Marian Goodman Gallery, *Reflecting the
Mirror,* 14 June–27 August 2004
- Sevilla, BIACS–I Bienal International de Arte
Contemporáneo de Sevilla, *La Alegria de mis suenos,*
3 October–26 December 2004: exh. cat.
- West Palm Beach, FL, Norton Museum of Art,
*Continental Drift: Installations by Joan Jonas, Ilya
Kabakov, Juan Muñoz, and Yinka Shonibare,* 23 October
2004–9 January 2005: exh. cat.
- Seattle, WA, Henry Art Gallery, *WOW (The Work of the
Work),*6 November–6 February 2005
- Munich, Galerie Bernd Klüser, *Sonderaktion
Graphiken und Bücher,* 19 November–23 December
2004
- Antwerp, MuHKA Museum voor Hedendaagse
Kunst, *Presentation of the Collection X,* 27 November
2004–24 April 2005
- London, Whitechapel Art Gallery, *Faces in the Crowd
– Picturing Modern Life from Manet to Today,* 3 December
2004–6 March 2005: travelled to Turin, Castello di
Rivoli Museo d´Arte Contemporanea, 4 April–10 July
2005: exh. cat
- Alicante, Castillo de Santa Bárbara de Alicante,
*Metamorfosis de la Escultura. Artistas Contemporáneos en
la colección del IVAM,* 10 December 2004–6 March 2005

**2005**
- Madrid, Sala de Exposiciones de la Fundació
'la Caixa', *Obras entorno a la ciudad,* 19 January–
20 February 2005
- Madrid, Galeria Pepe Cobo, *Feminae,*
28 January–1 March 2005
- Vitoria-Gasteiz, ARTIUM Centro-Museo Vasco de
Arte Contemporáneo, *El estado de las cosas – El objeto
en el arte desde 1960 hasta nuestros días,* 3 February–
22 May 2005
- Valladolid, Museo de la Pasión, *Lenguajes y sentidos
– Colección Caja de Burgos,* 31 March–1 May 2005
- Venice, *The Experience of Art,* 51. Biennale di Venezia,
12 June–6 November 2005: exh. cat.
- Klosterneuburg, Sammlung Essl – Kunsthaus,
*Figur/ Skulptur,* 24 June–22 January 2006

- Dusseldorf, K21 Kunstsammlung, *Sammlung 2005
– Neupräsentation der erweiterten Sammlung,* 2 July–18
September 2005
- Los Angeles, CA, MOCA, *The Blake Byrne Collection,*
3 July–10 October 2005
- Istanbul, Istanbul Modern, *Centre of Gravity,*
17 September 2005–15 January 2006: exh. cat.
- Nuoro, MAN – Museo d´Arte di Nuoro, *BYO –
Bring your own,*
23 September 2005–8 January 2006: exh. cat.
- San Gimignano, Galleria Continua, *Senza Confine,*
30 September–22 October 2005
- Salamanca, DA2 – Domus Artium 2002, *Baroque
and Neobaroque / The Hell of the Beautifull,* 3 October
2005–8 January 2006: exh. cat.
- Dublin, IMMA, Irish Museum of Modern Art,
*Drawings and Works on Paper from the IMMA Collection,*
13 December 2005–7 May 2006
- Peekskill, New York, Hudson Valley for
Contemporary Art, *Figure it Out: Contemporary
Figurative,* 22 May 2005–10 April 2006
- Reims, Palais du Tau, *Anges,* 25 Juin–31 December
2005, Mallorca, Castillo de Bendinate en Calvià,
*Escultura y Paisaje,* 4 August–16 October 2005
- Boston, Isabella Stewart Gardner Museum, *Bellini
and the East,* 14 December 2005–26 March 2006:
travelled to London, National Gallery,
12 April–25 June 2006

**2006**
- Madrid, Museo Nacional Centro de Arte Reina
Sofía MNCARS, *La visión impura – Fondos de la colección
permanente,* 14 February–11 September 2006
- Vitoria-Gasteiz, ARTIUM Centro-Museo Vasco de
Arte Contemporáneo, *Catarsis – Rituales de purificación
– La Colección V,* 9 March 2006–28 February 2007
- Wijlre, Hedge House, *Chers amis, samengesteld uit
de collectie Pierik en de collectie Eyck,* 15 March–
15 November 2006
- St. Petersburg, FL, Salvador Dalí Museum, *Salvador
Dalí and a Century of Art from Spain – Picasso to Plensa,*
5 May–30 July 2006
- Eindhoven, Stedelijk Van Abbemuseum,
*What happened to Art: Een keuze uit de collectie
1955–2000,* 20 May–17 September 2006
- Umeå , Suecia, Umedalen Skulptur, *Umedalen
Skulptur 2006,* 10 June–13 August 2006
- London, ICA Institute of Contemporary Arts,
*Surprise, Surprise,* 2 August–10 September 2006
- Santa Monica, CA, Patrick Painter Inc., *Works on
Paper,* 9 September–14 October 2006
- Barcelona, MACBA, Museu d'Art Contemporani
de Barcelona, *Col·lecció 18. Absorció i teatralitat,*
22 September 2006–15 January 2007
- Valencia, IVAM – Institut Valencià dArt
Modern, *Espacio, Tiempo, Espectador. Instalaciones
y nuevos medios en la Colección del IVAM,*
26 September 2006–7 January 2007
- Athens, Bernier/Eliades Gallery, *Farrago,*
5 October–9 November 2006
- Istanbul, Istanbul Modern, *Venice-Istanbul,*
18 October 2006–18 January 2007
- London, Frith Street Gallery, *Resonance:
The final exhibition at 59–60 Frith Street,*
3 November–21 December 2006
- Porto, Museu Serralves – Museu de Arte
Contemporânea, *The 1980´s: A Topology,*
11 November 2006–15 April 2007: exh. cat.

- Marseille, [mac] Musee d´Art Contemporain de
Marseille, *The art of a life, hommage to Roger Pailhas,*
1 December 2006–8 April 2007
- Chicago, Chicago Museum of Contemporary Art,
*Figures in the Field – Figurative Sculpture and Abstract
Painting from Chicago Collections,* 4 February–23 April
2006

**2007**
- Brno, Checa República, The Brno House of Art
– Central Building, *Active Constellation,* 23 January–1
April 2007
- Valencia, IVAM, *Speed II: La velocidad de las máquinas,*
22 February–8 July 2007: exh. cat.
- New York, MoMA – Museum of Modern Art,
*Comic Abstraction – Image-Breaking, Image-Making,*
27 February–11 June 2007: exh. cat.
- Badajoz, Museo Extremeño e Iberoamericano
de Arte Contemporáneo MEIAC, *Secuencias – 1976
– 2006. Arte contemporáneo en las colecciones públicas de
Extremadura,* 28 March–28 June 2007
- Enschede, Rijksmuseum twenthe – Museum
voor oude en moderne kunst, *Collectie depot VBVR:
Peter Strycken,* 31 March–2 September 2007
- Essen, Museum Folkwang Essen, *Rockers
Island – Olbricht Collection,* 5 May–1 July 2007
- Barcelona, MACBA Museu d'Art Contemporani
de Barcelona, *Un teatre sense teatre,* 24 May–11
September 2007: exh. cat.
- Herford, MARTa Herford, *Garde le silence,
le silence te gardera,* 2 June–7 October 2007: exh. cat.
- Dallas, Dallas Museum of Art, *Fast Forward:
Contemporary Collections for the Dallas Museum of Art,*
11 February 2007–20 May 2007: exh. cat.

**Commissions/ Public Projects**

2001 – Thirteen laughing at each other, Cordoaria
Garden, Porto, Portugal (commissioned by Porto
2001 and Crédito y Caución). Since December 2001.

2002 – Conversation Piece, New York, Doris C.
Freedman Plaza, Juan Muñoz: Public Art Fund,
26 September 2002–31 March 2003

# Artist's Writings

*Only the first publication of each work is listed below.*

**1982**
'Notas afines a tres', in Madrid, Ministerio
de Obras Públicas y Urbanismo, *Correspondencias: 5
arquitectos, 5 escultores*, exh. cat. by Carmen Giménez
and Juan Muñoz

**1983**
'Los primeros/Los últimos', in Madrid,
Palacio de las Alhajas, Caja de Ahorros y Monte
de Piedad, *La imagen del animal: Arte prehistórico,
arte contemporáneo*, exh. cat. by Juan Muñoz

**1985**
'Desarrollo de las escultura inglesa actual:
La palabra como escultura. Richard Long.
Ian Hamilton Finlay', *Figura*, no.4 (winter), 18–20

'The Best Sculpture is a Troy [Trojan] Horse/
Tambien metafora', *Domus* 659 (March), 77

'Desarrollo de las escultura inglesa actual II:
Hacia delante. De Richard Deacon a Anthony Caro',
*Figura*, no.5 (spring-summer), 32–3

'De la luminosa opacidad de los signos:
Borromini-Kounellis', *Figura*, no.6 (fall), 94–5

**1986**
'De la precision en las distancias', in Madrid,
Palacio de Velázquez, *Piedras: Richard Long*, exh. cat.
Ministerio de Cultura and The British Council

'Un hombre subido a una farola (Entre la escultura
britànica y las escultura a solas)', in Madrid, Palacio
de Velázquez, *Entra el objecto y la imagen: Escultura
britànica contemporánea*, exh. cat.

'El hijo mayor de Laocoonte/Laocoon's Eldest Son',
In Bern, Kunstmuseum Bern, *Chema Cobo*, exh. cat.
by Jürgen Glaesemer and Juan Muñoz

**1987**
'Illusionismo, percepcion, proyecto', *Sur Exprés*,
no.1 (15 April–15 May), 35

**1988**
Amsterdam, Maatschappij Arti et Amicitiae,
*Juan Muñoz: Un objeto metálico/A Metallic Object*
(published in lieu of an exh. cat. in conjunction
with Amsterdam, Maatschappij Arti et Amiticiae,
*Jan van de Pavert and Juan Muñoz*, 26 April–21 May)

'Die Zeit der Pose', *Durch* 5, 25–7

**1989**
'The Prompter', in Long Island City, N.Y., P.S.1
Contemporary Art Center, *Theatergarden Bestiarium:
The Garden as Theater as Museum*, exh. cat. by Chris
Dercon et al. Cambridge, Mass.

'Un texto de Juan Muñoz/A Text by Juan Muñoz/Un
testo di Juan Muñoz', *Spazio umano/Human Space* 1
(March), 20–4

'Yotsu no imeiji/Tres imágenes o cuatro', in
Karuizawa, Takanawa, Japan, The Museum of
Modern Art, *Supein aato toudi/Spain Art Today*, exh.
cat. by Jaime Brihuega and Miguel Fernández-Cid

**1990**
'Auf einem Platz', in Krefeld, Germany,
Museen Haus Lange and Haus Esters,
*Weitersehen (1980—1990—)*, exh. cat.

*Segment*, Chicago and Geneva, The Renaissance
Society at The University of Chicago and Centre
d'Art Contemporain (published in lieu of an ex.
cat. in conjunction with Chicago, The Renaissance
Society at The University of Chicago, *Juan Muñoz*,
18 November–30 December)

**1991**
'A Drawing-Room Trick', in Pittsburgh, The Carnegie
Museum of Art, *Carnegie International* 1991, vol.1, exh.
cat. by Lynne Cooke et al., Pittsburgh and New York

**1992**
'A *imagem* proibida/La *imagen* prohibida/The
Prohibited *Image*', in Porto, Fundação Serralves,
*Julião Sarmento: 21 de Maio a 28 de Junho* 1992, exh. cat.
by Michael Tarantino

**1994**
'El rostro de Pirandello/The Face of Pirandello',
in *Urban Configurations*, by Gloria Moure, Barcelona

**1996**
'Anochecer', in Santiago de Compostela, Spain,
Centro Galego de Arte Contemporánea, *Medardo
Rosso*, exh. cat. by Gloria Moure

'Rein, I am sitting in this train station', in Zurich,
Museum für Gegenwartskunst Zürich, *Museum für
Gegenwartskunst Zürich*, exh. cat. by Arina Kowner
and Rein Wolfs

**1997**
'Zwei in einem/Two in One', In Zurich, Museum
für Gegenwartskunst Zürich, *Juan Muñoz: Monologe
und Dialogue/Monologues and Dialogues*, exh. cat.
by James Lingwood

**1998**
'My dear friend', in *Works in Architecture, Paul
Robbrecht and Hilde Daem*, by Steven Jacobs,
Architecture Monographs, no.1, Ghent: Ludion

'Welche Bedeutung hat Picasso für Sie heute?'
*du* 9 (September), 73

**2000**
'A Standard Introduction to Lectures', *Gagarin* 1,
no.1, 3–4

'Tägliches Leben in einem Mies van der Rohe-
Haus/Everyday Life in a Mies van der Rohe House',
in *Ein Ort der denkt: Haus Lange und Haus Esters von
Ludwig Mies van der Rohe. Moderne Architektur und
Gegenwartskunst/A Place that Thinks: Haus lange
and Haus Esters by Ludwig Mies van der Rohe. Modern
Architecture and Contemporary Art*, by Julian Heynen,
Krefeld, Krefelder Kunstmuseen

**2001**
With John Berger, 'Una correspondencia sobre
el espacio', *Arte y parte*, no.32 (April–May), 50–61

# Interviews with the Artist

*Interviews are listed chronologically by date of publication.*

**1984**
'Fragmentos de una conversación/Fragments from a Conversation', Jan Debbaut, in Madrid, Galería Fernando Vijande: *Juan Muñoz: Últimos trabajos*, exh. cat. Madrid

**1985**
'Juan Muñoz: "O jogo é entre a consciência e a impossibilidade"', Alexandre Melo: *Journal de Letras*, 19 March

**1987**
'Un dialogue entre Juan Muñoz et Jean-Marc Poinsot/A Conversation between Juan Muñoz and Jean-Marc Poinsot', in Bordeaux, Capc Musée d'Art Contemporain: *Juan Muñoz: Sculptures de 1985 à 1987*, exh. cat. Jean-Marc Poinsot

**1989**
'Obscuras paternidades/Obscure Parenthood ...', José-Luis Brea, The Hague and Amsterdam

**1990**
Interview by Maya Aguiriano, *Zehar*, no.6 (September—October), 4–6

Interview by Iwona Blazwick, James Lingwood, and Andrea Schlieker, in London, Institute of Contemporary Arts and Serpentine Gallery: *Possible Worlds: Sculpture From Europe*, exh. cat. Iwona Blazwick, James Lingwood, and Andrea Schlieker

Interview by Juan Vicente Aliaga and José Miguel G. Cortes, in *La creacion artística como cuestionamiento/ Artistic Creation at Stake*, José Miguel G. Cortes (ed.), Valencia

**1991**
'Fluiten in het donker', Jan Braet, *Knack*, no.48 (December), 111–12, 114, 118

**1992**
'Mis esculturas son autosuficientes', Octavio Zaya, *Diario 16* (Madrid), 15 May, Culture section

Interview by Zdenka Badovinac, in Ljubljana, Slovenia, Moderna Galerija: *Tišina: Protislovne oblike resnice/Silence: Contradictory Shapes of Truth*, exh. cat. Zdenka Badovinac

**1994**
Interview by Rafael Sierra, *El Mundo* (Madrid), 4 April

**1995**
'A Conversation, New York, 22 January 1995', James Lingwood, *Parkett*, no.43 (January), 42–7

**1996**
'En la tensión del silencio ...', Basilica Sariláqui: *Caos* (Apri–May). 76–8

'Una conversación, septiembre 1996/A Conversation, September 1996' (I and II), James Lingwood, in Madrid, Museo Nacional Centre de Arte Reina Sofía: *Juan Muñoz: Monólogos y diálogos/ Monologues and Dialogues*, exh. cat. James Lingwood, 1996: translated and revised as Zurich, Museum für Gegenwartskunst Zürich, *Juan Muñoz: Monologe und*

*Dialoge/Monologues and Dialogues*, exh. cat. James Lingwood, 1997

Interview by Rafael Sierra, *El Mundo* (Madrid), 9 November

**1997**
Interview by Simon Maurer, *Tages-Anzeiger* (Zurich), 3 February

'Me and a Man in a Room, Talking', Judith Palmer. *Independent* (London), 17 September

**1998**
Interview by Gianni Romano, Flash art (Italy), no.209 (April—May), 110–13

Interview by José-Luis Brea, Madrid, 27 September 1997: *Servicio público: Conversaciones sobre financiación público y arte contemporáneo*, Jorge Ribalta (ed.), Salamanca and Barcelona

**1999**
Interview by Walter Smerling, in Bonn, Kunstmuseum Bonn: *Zweitwander: Ausblick*, exh. cat. Dieter Ronte and Walter Smerling, Cologne

**2000**
'Artists on Art: Juan Muñoz on *Spiral Jetty* (1970) by Robert Smithson', by Martin Gayford, *Daily Telegraph* (London), 11 November

**2001**
'A Conversation, May 2001', Juan Muñoz and James Lingwood: *Juan Muñoz. Double Bind at Tate Modern*, London

Interview by Paul Schimmel, 18 September 2000: *Juan Muñoz*, exh. cat. Neal Benezra and Olga M, Viso,145–50

# Exhibited works

*Measurements are in centimetres, height before width and depth. Page numbers are given for works illustrated in the plate section.*

*Untitled* 1982
Iron, 85 x 64.5 x 63, Colecciones ICO, Madrid, p.6

*Untitled* 1983
Ink on paper, 21 x 15, Private Collection, p.3

*If Only She Knew* 1984
Iron, stone and wood, 176.5 x 33 x 33, Private Collection, New York, p.8

*Oreja* c. 1984
Painted clay and graphite powder, 8.2 x 5 x 2, Collection Julião Sarmento

*Spiral Staircase* 1984
Iron, 46.4 x 17.2 x 17.8, The Art Institute of Chicago, Partial and promised gift of the Neisser Family, Judith Neisser, David Neisser, Kate Neisser, and Stephen Burns in memory of Edward Neisser

*Spiral Staircase (Inverted)* 1984–1999
Forged iron, 48 x 18 x 18, Private Collection, p.5

*Untitled (Balcony with Death Notice)* 1984
Oil stick on paper, tape, white board, 69.9 x 49.9 Private Collection, p.13

*Untitled (Balcony with Fire)* 1984
Oil stick on plastic paper, tape, white board, 62.2 x 45.7, John J. Gallagher, p.10

*Untitled (Balcony with Smudged Right Side)* 1984
Oil stick on plastic paper, tape, white board, 55.9 x 44.5, Private Collection, p.12

*Untitled (3 Balconies with Time)* 1984
Oilstick on plastic sheet over a paper envelope on paper, 50.2 x 69.9, The Museum of Modern Art, New York, p.14

*Used Balcony (Small Balcony with Figure)* 1984
Steel and wood, 91.4 x 50.8 x 18.4, M Oshman, USA, p.7

*Minaret for Otto Kurz* 1985
Iron, wood and rug, Object: 120 x 30 x 40, Carpet: 100 x 200, Collection of Francis de Beir, pp.16–17

*Double Balcony* 1986
Iron, Top Balcony: 52 x 91 x 20, Bottom Balcony: 43 x 92 x 21, Collection Fondation Cartier pour l'art Contemporain, Paris, p.15

*Hotel Declercq I* 1986
Iron, Balcony: 70 x 100 x 30, Hotel Sign: 100 x 20 Courtesy Galería Pepe Cobo, Madrid, p.15

*Hotel Declercq III* 1986
Iron, Balcony: 50.8 x 92.7 x 19, Hotel Sign: 62.2 x 9.5 x 1.2, Collection of Linda and Jerry Janger, Los Angeles p.15

*Hotel Declercq IV* 1986
Iron, Balcony: 94 x 50 x 23, Hotel Sign: 96 x 15 x 2 Collection of Mimi Dusselier, Belgium, p.15

*Balcon para desear a Tatlin* 1987
Painted iron and steel, 114 x 121 x 29, Collection Rodriguez-Argüelles, Spain, p.72

*Estudios para la descripción de un lugar* 1987/1988
5 framed drawings (mixed media on fabric) and marble, Overall: 128 x 168 x 62.5, image, each: 122 x 102, Collection Julião Sarmento, p.43

*First Banister* 1987
Wood and knife, 7 x 200 x 8, Private Collection, p.20

*Hotel Declercq II* 1987-2000
Iron, Balcony: 45 x 92 x 19, Hotel Sign: 74.5 x 12 x 1.5 Private Collection

*I Saw it in Marseille* 1987
Wood and metal, 7 x 165 x 13 (2 pieces), Courtesy Galeria Pepe Cobo, Madrid, p.19

*The Wasteland* 1987
Bronze, steel and linoleum, Variable, Collection of Elayne and Marvin Mordes, Palm Beach Florida, p.23

*Dwarf with a Box* 1988
Terracotta and wood, 171 x 70 x 40, Tate. Purchased 1994, p.21

*Dwarf with Three Columns* 1988
Terracotta, overall 235 x 150 x 200, Rubell Family Collection, p.25

*Raincoat Drawing* 1988
Mixed media on fabric, 140 x 100, Private Collection

*The Prompter* 1988
Iron, papier-mâché, bronze, wood and linoleum Dimensions variable, Courtesy Marian Goodman Gallery, New York, p.26

*Ventriloquist Looking at a Double Interior* 1988-2001
Resin, motor, silicone and mixed media on fabric Drawings each: 146.5 x 100, Object: 63 x 25 x 25, Plinth: 107 x 150 x 30, Private Collection, p.30

*Wax Drum* 1988
Wax, metal and scissors, 30 x 40 x 40, Private Collection, Madrid, p.29

*Ballerina on Optical Floor* 1989
Bronze, wood and linoleum, Plinth: 120 x 50 x 50 Object: 58 x 50, Private Collection, p.47

*Large Raincoat Drawing III* 1989
Mixed media on fabric, 150 x 200 x 3.8 , Van Abbemuseum Collection, Eindhoven

*Raincoat Drawing* 1989
Mixed media on fabric 100 x 140, Private Collection, p.34

*Raincoat Drawing* 1989
Mixed media on fabric, 140 x 100, Private Collection, p.31

*Raincoat Drawing* 1989
Mixed media on fabric, 109.5 x 149.7, Tate, Purchased 2005, p.36

*Raincoat Drawing* 1989
Mixed media on fabric, 116 x 96.5, Private Collection, p.40

*Raincoat Drawing* 1989
Mixed media on fabric, 140 x 180, Bouwfonds Kunststichting, Hoevelaken, p.42

*Raincoat Drawing* 1989
Mixed media on fabric, 140 x 100, Collection of Melva Bucksbaum and Raymond Learsy

*Raincoat Drawing* 1989
Mixed media on fabric, 140 x 100, Private Collection, Courtesy of Ikkan Art International, New York, p.38

*Dos Bailarinas (Cocina)* 1989
Bronze, wood, scissors and black tiles, Plinth: 1480 x 1050 x 1050, Figure: 650 x 550, p.46

*Backs on Bronze* 1990
Bronze, 28 x 45 x 45 cm (each), Private Collection, p.51

*Raincoat Drawing* 1990
Mixed media on fabric, 150 x 121.9, Collection of Anita and Burton Reiner, p.32

*Back Drawing* 1990
Chalk and ink on canvas, 140 x 100, Kunstmuseen Krefeld

*Back Drawing* 1990
Chalk and ink on canvas, 140 x 100, Kunstmuseen Krefeld

*Back Drawing* 1990
Chalk and ink on canvas over board, 141 x 100, Courtesy Marian Goodman Gallery, New York

*Listening Figure* 1991
Bronze, 135 x 74 x 73, Van Abbemuseum Collection, Eindhoven, p.49

*Opposite Balconies* 1991
Steel and terracotta, 96.5 x 50 x 22 (each), Daros Collection, Switzerland, p.45

*Raincoat Drawing* 1991
Mixed media on fabric, 150 x 121.9, Private Collection, p.37

*Raincoat Drawing* 1991
Mixed media on fabric, 146 x 100, Private Collection, Belgium

*Window Shutters with Hinges* 1991
Iron and bronze, 154 x 104 x 6, Private Collection, p.39

*An Outpost of Progress* 1992
Mixed media on paper, 13 parts, 110 x 75 each, Private Collection, pp.54–7

*Back Drawing* 1992
Oil stick on canvas, 140 x 110, Mimi and Filiep Libeert

*Back Drawing* 1992
Oil stick on canvas, 140 x 100, Private Collection, Madrid, p.52

*Back Drawing* 1992
Oil stick on canvas, 140 x 100, Private Collection, Madrid, p.53

*Monument* 1992
Three bronze flags and artificial stone, 375 x 200 x 100, Lisson Gallery

*Raincoat Drawing* 1992–3
Mixed media on fabric, 125 x 102.5, Colecciones ICO, Madrid, p.41

*Stuttering Piece* 1993
Resin, cardboard and audio soundtrack, Dimensions variable, Aaron and Barbara Levine, p.44

*Arab* 1995
Mixed media, resin, leather and metal, 66 x 59.7 x 59.1, Hort Collection, p.65

*Portrait of a Turkish Man Drawing* 1995
Set of 3 drawings, oil stick on paper, 59 x 35 (each), Courtesy Zurich Development Center, Zurich, Switzerland

*Raincoat Drawing* 1995
Mixed media on fabric, 150 x 200, Collection Sanders, p.33

*Untitled (Mouth Drawing)* 1995
Oil stick on paper, 51 x 37, Private Collection

*Untitled (Mouth Drawing)* 1995
Oil stick on paper, 51 x 37, Private Collection, p.63

*Untitled (Mouth Drawing)* 1995
Oil stick on paper, 51 x 37, Private Collection, p.64

*Untitled (Mouth Drawing)* 1995
Oil stick on paper, 51 x 37, Private Collection

*Untitled (Mouth Drawing)* 1995
Oil stick on canvas, 51 x 37, Private Collection

*Untitled (Mouth Drawing)* 1995
Oil stick on paper, 51 x 37, Private Collection

*Untitled SF1* 1995
Oil stick on paper, 76 x 56, Private Collection

*Untitled SF2* 1995
Oil stick on paper, 76 x 56, Private Collection

*Untitled SF3* 1995
Oil stick on paper, 76 x 56, Private Collection

*Conversation Piece* 1996
Resin and steel cable, Dimensions variable, Courtesy Marian Goodman Gallery, New York, p.69

*Elevator* 1996
Motor, wood and metal, 99 x 30 x 17.8, Private Collection, p.73

*Loaded Car II* 1996
Iron, 60 x 150 x 60, Private Collection

*Shadow and Mouth* 1996
Polyester resin, cloth, pigment, wood and motor, Dimensions variable, Guggenheim Bilbao Museo, pp.76–7

*Will it be a Likeness?* 1996/2005
Video, 45 min, Private Collection

*Hanging Figures* 1997
Resin, rope and motor, Dimensions variable Private Collection, p.88

*A Man in a Room, Gambling* 1992/1997
Audio, 51 min, 33 sec, Private Collection

*Staring at the Sea I* 1997-2000
Polyester resin figures with cardboard masks and mirror, 157 x 55 x 65, Private Collection, p.79

*Towards the Shadow* 1998
Resin, 154.9 x 78.7 x 40.6, Private Collection, pp.82–3

*Towards the Corner* 1998
Wood, resin, paint and metail, 210 x 378.5 x 113, Tate. Purchased with assistance from Tate Members 2003, pp.80–1

*Crossroads Cabinet October* 1999
Steel, glass, mixed media, 248.9 x 80 x 25.1, Coleccion Es Arte Deleitosa, Madrid

*The Crossroads Cabinets: December 1999* 1999
Steel, glass, mixed media, 248.9 x 80 x 25.1
Jose Manuel Entrecanales

*The Crossroads Cabinets: July 1999* 1999
Steel, glass, mixed media, 248.9 x 80 x 25.1
Private Collection

*The Crossroads Cabinets: May 1999* 1999
Steel, glass, mixed media, 248.9 x 80 x 25.1, Private Collection

*The Crossroads Cabinets: January 1999* 1999
Steel, glass, mixed media, 248.9 x 80 x 25.1, Private Collection

*Many Times* 1999
Polyester and resin, Dimensions variable Private Collection, pp.86–7

*Seated Figures with Five Drums* 1999
Polyester resin, each figure 105 x 70 x 70, Private Collection

*One Figure* 2000
Resin, pigments and mirror, 110 x 60 x 50, Musée de Grenoble, p.85

*First Cabinet* 2000
Steel, glass, mixed media, 248.9 x 80 x 25.1, Private Collection

*Two Seated on the Wall* 2000
Polyester resin, iron and bronze, 80 x 90 x 45 Private Collection, front cover

*A Registered Patent: A Drummer Inside a Rotating Box* 2001–2, Audio, 21 min, Private Collection

Works illustrated in the plate section that are not exhibited

*Untitled (Double Balcony with Blinds)* 1984
Oil stick on paper, tape, white board, 46.7 x 67.9 The Art Institute of Chicago, Margaret Fisher Endowment, p.11

*Jack Palance à la Madeleine* 1986
Wood and knife, floor piece 80 x 80 x 44, wall piece 60 x 60 x 33, Fonds régional d'art contemporain des Pays de la Loire, p.18

*Back Drawing* 1990
Chalk and ink on canvas, 141 x 100, Collection of Mrs Wollecamp Vanthournout, p.50

*Raincoat Drawing* 1991
Mixed media on fabric, 121 x 150, Lambert Art Collection (LAC), Switzerland, p.33

*Raincoat Drawing* 1994
Mixed media on fabric, 149.9 x 149.9, Private Collection, p.35

*Winterreise* 1994
Silicone, polyester resin, steel, electric motor and wood, dimensions variable, Fonds national d'art contemporain, ministère de la culture et de la communication, Paris, p.59

*Five Seated Figures* 1996
Resin and mirror, overall 109 x 69 x 64, Collection Camille Oliver-Hoffman, p.71

*Sara with Billiard Table* 1996
Polyester resin, billiard table, light 126 x 268 x 180, Private Collection, p.67

*End of the Road: Chinese Figure with Curtain* 1997
Polyester resin, sand and canvas, 149.8 x 99 x 71.1, Private Collection, p.78

*Loaded Car* 1998
Steel, 61 x 152.4 x 50.8, Collection Camille Oliver-Hoffman, p.74

# Lenders and Credits

**Lenders**

Public:
The Art Institute of Chicago
Bouwfonds Kunststichting, Hoevelaken
Colecciones ICO, Madrid
Daros Collection, Switzerland
Fondation Cartier pour l'art Contemporain, Paris
Guggenheim Bilbao
Kunstmuseen Krefeld
Musée de Grenoble
The Museum of Modern Art, New York
Tate
Van Abbemuseum Collection, Eindhoven

Private:
Francis de Beir
Jose Manuel Entrecanales
Coleccion Es Arte Deleitosa, Madrid
Collection Sanders
Mimi Dusselier, Belgium
Courtesy Galería Pepe Cobo, Madrid
John J. Gallagher
Marian Goodman Gallery
Hort Collection
Linda and Jerry Janger, Los Angeles
Melva Bucksbaum and Raymond Learsy
Aaron and Barbara Levine
Mimi and Filiep Libeert
Lisson Gallery
Elayne and Marvin Mordes, Palm Beach Florida
M. Oshman, USA
Private Collection, Belgium
Private Collection, Courtesy of Ikkan Art
    International, New York
Private Collections, Madrid
Private Collection, New York
Anita and Burton Reiner
Collection Rodriguez-Argüelles, Spain
Rubell Family Collection
Julião Sarmento
Mrs Wollecamp Vanthournout
Zurich Development Center, Zurich, Switzerland

**Photo credits**

Plate illustrations:
Luis Asin, p.27
© Rita Burmester, p.43
Cathy Carver, pp.74–5
Peter Cox, pp.22–3
Kristien Daem, p.18
Michael Goodman, p.45
Hirshhorn Museum and Sculpture Garden,
    pp.19, 25–6, 45
Dexter Hodges, pp.5, 47, 51, 77, 86
John Kennard, p.60
Boris Kirpotin, pp.31, 40
Achim Kukulies, pp.54–7
Julian Lopez, p.39
Attilio Maranzano, pp.69, 78–9, 82
Courtesy Marian Goodman Gallery,
    pp.10–3, 71, 76, 80–1, 83, Cover
© Musee De Grenoble, Jean–Luc Lacroix, pp.84–5
Victor E Nieuwenhuijs, p.33 bottom
Julien Revis, p.15
Lee Stalsworth, pp.8–9, 32
Dimitri Tamviskos, pp.64–5
Tate Photography, pp.24, 140

Figure illustrations:
akg–images/ Erich Lessing, Fig.4
Artangel/ Stephen White, Fig.30
Peter Cox, Fig.10
Isabella Stewart Gardner Museum, Boston, MA,
    USA/ The Bridgeman Art Library, Fig.27
© Mike Kipling Photography/ Alamy, Fig.19
Courtesy Marian Goodman Gallery, Fig.7
Moviestore Collection, Fig.2
© Musee De Grenoble, Jean–Luc Lacroix, Fig.6
Museo Nacional del Prado, Madrid/ The Bridgeman
    Art Library, Figs 5, 25
© 2008, The Museum of Modern Art, NY/Scala,
    Florence, Fig.18
Real Monasterio de El Escorial/ The Bridgeman Art
    Library, Fig.3
Nic Tenwiggenhorn, Figs 14–5
Tate Photography, Figs 17, 20–1
Rod Tidman/ Tate Photography, Figs 11–3
TAT–Dramaturgie Frankfurt am Main/Wonge
    Bergman/Thamoas Bernstien, Figs.28–9
Antonio Zafra, Fig.1

**Copyright**

Juan Muñoz © the artist's estate
Katharina Fritsch © DACS 2008
Thomas Schütte © DACS 2008
Alberto Giacometti © DACS 2008

# Index

*Page numbers in italic type refer to illustrations.*

**A**

Akhmatova, Anna 95
Amon, Santiago 145–6
*Arab* 63
Arte Povera 95

**B**

*Back Drawings* 50, 52–3
*Backs on Bronze* 51
Bacon, Francis 95
*Balcon para desear a Tatlin* 70
Balkenhol, Stephan 95, 111
*Ballerina on Optical Floor* 47
Baroque 103, 113, 145, 146
Bateson, Gregory 146
Bayeau, Francisco 129
Beckett, Samuel 97, 117
Bellini, Gentile 129–30
   *Seated Scribe* 127–30; *fig.27*
Bellini, Giovanni 129, 130
Bellini, Jacobo 129, 130
Benjamin, Walter 108, 146
Berger, John 146
   *Will It Be A Likeness?* 131–7
Borges, Jorge Luis 96, 100, 105, 108, 109, 129
   *Funes, the Memories* 100
Borromini, Francesco 103, 145
Brecht, George 151
   *Silence* 151
Bresson, Robert 95
Bruno, Giordano 100, 108
Bryars, Gavin
   *A Man in a Room, Gambling* 105, 150–5
*Building for Music* 149
Buñuel, Luis 105
   *Un Chien Andalou* 99
   *My Last Sigh* 99

**C**

Chillida, Eduardo 95, 96
Conrad, Joseph 95
*Conversation Piece* 66–7, 102, 113
Cooke, Lynne 106
Cooper, David 146, 147
he *Crossroads Cabinets* 82
roydon Art College 150
villiés, François de 100, 122

   Salvador 95
   ier, Honoré 108
   rico, Giorgio 113, 124
   Edgar 123
   Denis 130
   of Syracuse 102

   kuk 122
   nas (Cocina) 46
   cony 15
   d 95, 103, 106, 107, 108–9, 118–19,
   —7; *figs.11–13, 20, 21*
   Marcel 143, 151
   rguerite 95
   arf with a Box 24, 124
*Dwarf with Three Columns* 25, 124

**E**

*Elevator* 71
Eliot, T.S. 95, 102
   *East Coker* 103
   *The Wasteland* 97, 107
Ellison, Ralph 95
*End of the Road: Chinese Figure with Curtain* 76
Erdnase, S.W. 151
*Estudios para la descripción de un lugar* 43

**F**

'The Face of Pirandello' (1994) 99, 105, 116
*Female Dwarf Looking at Herself in a Mirror* 124
*First Banister* 21
*Five Seated Figures* 69, 102, 115
Fluxus 151
Foucault, Michel
   'The Order of Things: An Archaeology of the
Franco, Francisco 95
Frazer, James George
   *The Golden Bough* 97
Fried, Michael 95, 130
Fritsch, Katharina 95, 111, 113, 114
   *Company at Table* fig.14
   *Dealer* 112; *fig.15*
   *Doctor* 112
   *Monk* 112

**G**

*Gatherings* 108–9
Giacometti, Alberto 95, 114
   *City Square* 114; *fig.18*
   *Standing Woman* 114; *fig.17*
Gober, Robert 95
Gould, Glenn 151
   *The Idea of North* 151
Goya, Francisco de 95, 122, 124–5, 129
   *Caprichos* 124
   *Cómicos ambulantes* 124
   *Disparate de los ensacados* 125; *fig.26*
   *Disparate furioso* 125
   *Los Disparates* 125
Grass, Günter 95
   *The Tin Drum* 99, 100
Guston, Philip 95

**H**

*Hanging Figures* 86, 125
Hanson, Duane 113
Hitchcock, Alfred 105
*Hotel Declercq* 15, 96, 106; *fig.9*

**I**

*If Only She Knew* 8, 9
Iglesias, Alberto
   'On a Registered Patent' 149
Iglesias, Cristina 142
'Isabella Stewart Gardner Museum Lecture' 127–30
*I Saw it in Marseille* 19, 115

**J**

*Jack Palance à la Madeleine* 18
James, William 151
*Jardin Bestiarium* 150
Joyce, James 95
*Juan Muñoz: Últimos trabajos* fig.1

**K**

Kafka, Franz 108
Kelley, Mike 95

**L**

Laing, R.D. 146
Lang, Fritz
   *Metropolis* 118
*Last Conversation Piece* 121
Lear, Edward 95
*Listening Figure* 49, 102
*Loaded Car* 72, 73

**M**

McCarthy, Paul 95
McEvilley, Thomas 101
Maclean, Bruce 150
Maclean, Wally 151
Malkovich, John 149
Mamet, David
   *House of Games* 97–8; *fig.2*
*Man Hanging from a Foot* 125
*A Man in a Room, Gambling* 105, 150–5; *fig.30*
Manet, Édouard 123
Mannerism 100
*Many Times* 84–5, 102–3, 111, 113, 115, 117, 121; *fig.6*
Miller, Henry 95
*Minaret for Otto Kurz* 16–17
Miró, Joan 95
Mondrian, Piet 95, 105, 145–6
Morris, Robert 95
Müller, Wilhelm 98

**N**

Newman, Barnett 95

**O**

*One Figure* 83, 102; *fig.7*
*One Laughing at the Other* 121
*Opposite Balconies* 45, 112
*Optical Illusion-Producing Rotating Toys* 148
*Oreja* 102
*An Outpost of Progress* 54–7

**P**

Passos, John dos 95
Patiner, Joachim
   *St Christopher* fig.3
Paz, Octavio 95
Picasso, Pablo 95, 123
Pirandello, Luigi 97, 99, 105, 116
   *Six Characters in Search of an Author* 117–18
*A Place Called Abroad* 117, 121
*Portrait of a Turkish Man Drawing* 60
*The Prompter* 26, 27, 99–100, 107, 108, 109,
   112, 122, 124, 150
Proust, Marcel 108

**R**

*Raincoat Drawings* 31–8, 40–2, 111, 115–16, 124
Ray, Charles 95, 111, 112, 114
*A Registered Patent* 149
Rietveld, Gerrit 146
Robertson, Giles 128, 129
Rodin, Auguste
   *Burghers of Calais* 122
Romano, Giulio 100, 108
Roth, Philip 95

# S

*Sara with Billiard Table* 64–5
Satie, Erik 152
Schimmel, Paul 105
Schubert, Franz
    *Winterreise* 98–9
Schumann, Robert 127
Schütte, Thomas 95, 111
    *Grosse Geister* 112; fig.16
    *Grosse Respekt* 115
'Segment' 116–17, 150
'self-portrait' 99, 126
Serra, Richard 95, 96
    'Juan Muñoz' 139
Seurat, Georges
    *Bathers at Asnières* 102, 113
    *The Echo* 102
*Shadow and Mouth* 74–5, 105
Shapiro, Joel 96
Simonds, Charles 96
Siza, Alvaro 95
Smith, Kiki 95
Smithson, Robert 95
    *Spiral Jetty* 145
*Spiral Staircase* 95, 103
*Spiral Staircase (Inverted)* 4, 5, 96
*Staring at the Sea I* 77, 102
Steinberg, Leo 101
Stella, Frank 96
Stevenson, Robert Louis 95, 127–8
Struth, Thomas 128
*Stuttering Piece* 44, 97, 116

# T

*Three Laughing at One* 121–2, 123; fig.22
Tietze, Hans 129
*Towards the Corner* 78, 79, 112, 115, 121
*Towards the Shadow* 80–1
Tsereteli, Zurab 122

# U

*Untitled (3 Balconies with Time)* 14
*Untitled (1982)* 6
*Untitled (1983)* 3
*Untitled (Balcony with Death Notice)* 13
*Untitled (Balcony with Fire)* 10
*Untitled (Balcony with Smudged Right Side)* 12
*Untitled (Double Balcony with Blinds)* 11
*Untitled (Monument)* 150
*Untitled (Mouth Drawings)* 61–2
*Untitled (Triple Balcony)* fig.8
*Used Balcony (Small Balcony with Figure)* 7

# V

Valéry, Paul 95
Vasari, Giorgio 129
Velázquez, Diego Rodríguez de Silva y 95, 121–5
    *Los borrachos* 123
    *El Bufón Calabacillas* 121–2; fig.23
    *The Dwarf Don Diego de Acedo, called 'El Primo'* 100;
    fig.4
    *The Forge of Vulcan* 123
    *Las Hilanderas* 123
    *Las Meninas* 101, 102, 121, 123, 125; figs.5, 25
*Ventriloquist Looking at a Double Interior* 30, 98
Vermeer, Jan 124

# W

*The Wasteland* 22–3, 97, 98, 107, 112, 123, 124; fig.10
*Wax Drum* 29, 99
Wells, H.G
    *The Time Machine* 118
*Will It Be A Likeness?* 131–7; figs.28, 29
*Window Shutters with Hinges* 39
*Winterreise* 59, 98–9
Wittgenstein, Ludwig 105, 107

# Y

Yalta Conference 'Big Three' 122; fig.24